Artistic Collaboration in the Twentieth Century

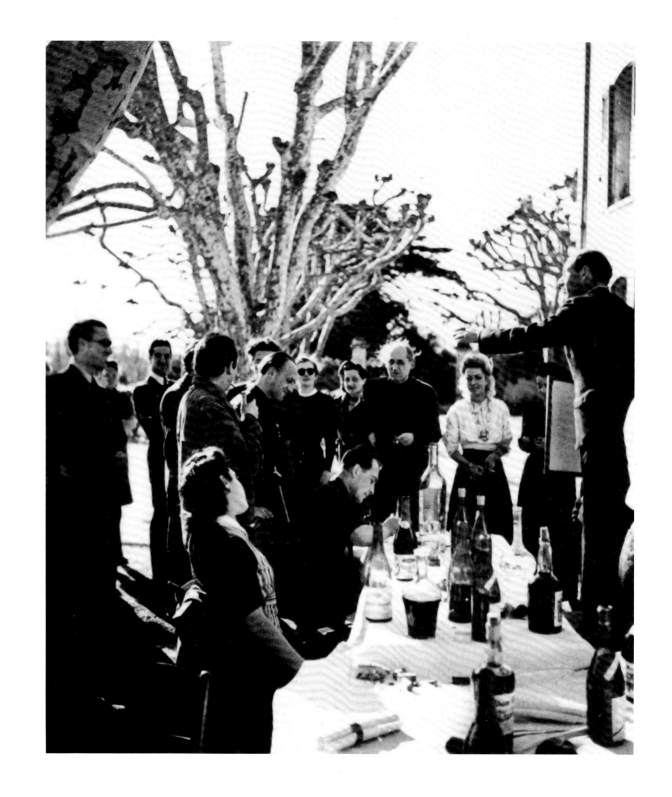

Cynthia Jaffee McCabe

with essays by
Robert C. Hobbs and David Shapiro

Artistic Collaboration
in the Twentieth Century

Smithsonian Institution Press Washington, D.C., 1984

Dates of the exhibition:

Hirshhorn Museum and Sculpture Garden
Washington, D.C.
June 9–August 19, 1984

Milwaukee Art Museum
Milwaukee, Wisconsin
November 18, 1984–January 15, 1985

J. B. Speed Art Museum
Louisville, Kentucky
February 21–April 21, 1985

Cover: Equipo Crónica, *El*, 1977 (cat. 97).

Frontispiece: Gathering of Surrealist artists at the Villa Air-Bel, Marseilles, 1940 (fig. 16).

This book was edited by Virginia Wageman, designed by Alan Carter, typeset by BG Composition Inc., Baltimore, and printed by Eastern Press, New Haven.

The paper in this book meets the guidelines for permanence and durability of the Committee on Production Guidelines for Book Longevity of the Council on Library Resources.

Library of Congress Cataloging-in-Publication Data
McCabe, Cynthia Jaffee, 1943-
 Artistic collaboration in the twentieth century.
 Catalog of an exhibition held at the Hirshhorn Museum and Sculpture Garden, Washington, D.C., June 9–Aug. 19, 1984, Milwaukee Art Museum, Milwaukee, Wis., Nov. 18, 1984–Jan. 15, 1985, and at the J. B. Speed Art Museum, Louisville, Ky., Feb. 21–Apr. 21, 1985.
 Bibliography: p.
 1. Group work in art—Europe—Exhibitions. 2. Avant-garde (Aesthetics)—Europe—History—20th century—Exhibitions. 3. Group work in art—United States—Exhibitions. 4. Avant-garde (Aesthetics)—United States—History—20th century—Exhibitions. I. Hobbs, Robert Carleton, 1946- . II. Shapiro, David, 1947- . III. Hirshhorn Museum and Sculpture Garden. IV. Milwaukee Art Museum. V. J. B. Speed Art Museum. VI. Title.
N6758.M36 1984 709'.04'0074014 84-3090

Photography Credits

Photographs were supplied by the owners of the works of art, with the exception of the following:
Micky Alechinsky, Bougival, fig. 42; Jorg P. Anders, Berlin, 4; C. Boeno, Paris, fig. 35; Tseng Kwong Chi, New York, fig. 30; A. C. Cooper, Ltd., London, 84; Bevan Davies, New York, fig. 36; D. James Dee, New York, fig. 38; Eeva-inkeri, New York, figs. 40, 41; Dirk Erdmann, Hanover, 12, 13; Gasull Fotografia, Barcelona, 92; Philippe de Gobert, Brussels, 72; Robert Golden, London, 37; Bill Hayward, New York, 6–9, 19–21; Gerhard Heisler, Saarbrucken, 76; Jacqueline Hyde, Paris, 44; Bruce C. Jones, Centerport, N.Y., 75; Cynthia Jaffee McCabe, Hirshhorn Museum and Sculpture Garden, fig. 44; Robert E. Mates, New York, 71; André Morain, Paris, 63, 67, 68, 82; Hans Namuth, New York, fig. 26; Pallas Photo, Chicago/Denver/Milwaukee, 47; Nathan Rabin, New York, 25; Walter Russell, New York, fig. 28; Foto Sachsse, Bonn, 74; John D. Schiff, New York, fig. 23; Sonnabend Gallery, New York, 103; Sotheby Parke Bernet, New York, 42; Speltdoorn, Brussels, 62, 65; Lee Stalsworth, Hirshhorn Museum and Sculpture Garden, 17, 50, 52, 90, 91, 99; Ken Strothman and Harvey Osterhoudt, Indiana University Art Museum, Bloomington, 26; Lorenzo Trento, Padova, 73; Tom Van Eynde, Berkeley, Ill., 35; Wolfgang Volz, New York/Dusseldorf, fig. 24; Etienne Bertrand Weill, Paris, 48, 49, 53–56; A. J. Wyatt, Philadelphia Museum of Art, fig. 25; Zindman/Fremont, New York, 88, fig. 39.

Contents

LENDERS TO THE EXHIBITION 7

FOREWORD 9
Abram Lerner

ACKNOWLEDGMENTS 11

INTRODUCTION 13

ARTISTIC COLLABORATION IN THE TWENTIETH CENTURY
The Period between Two Wars 15
Cynthia Jaffee McCabe

ART AS COLLABORATION
Toward a Theory of Pluralist Aesthetics 1950–1980 45
David Shapiro

REWRITING HISTORY
Artistic Collaboration since 1960 63
Robert C. Hobbs

CATALOG OF THE EXHIBITION 89

BIOGRAPHIES 193

BIBLIOGRAPHY 217

Lenders to the Exhibition

Collection Alechinsky, Bougival, France
Karel Appel, Monaco
Mr. and Mrs. E. A. Bergman, Chicago
Robert H. Bergman, Chicago
Merrill C. Berman, Scarsdale, New York
Sandy and Adrea Bettelman, Beverly Hills, California
Alberto Biasi, Padua, Italy
Anthony Caro, London
William N. Copley, New York
Max Clarac-Serou, Paris
Diego Cortez, New York
Brad Davis, Carbondale, Colorado
Douglas Davis, New York
Enrico Donati, New York
Guy Dotremont, Limelette, Belgium
Suzanne and Howard Feldman, New York
André Fougeron, Montrouge, France
Helen Mayer Harrison and Newton Harrison, Del Mar, California
Pamela and James Heller, New York
Jacques Hérold, Paris
André L'Huillier, Geneva, Switzerland
Marcel Jean, Paris
Mary Jane Kamrowski, Ann Arbor, Michigan
Alma H. Law, Scarsdale, New York
Conroy Maddox, London
Matta, Paris
Kenneth Noland, South Salem, New York
Lucio Pozzi, New York

Edouard Roditi, Paris
Leslie and Alice Schreyer, Washington, D.C.
Ned Smyth, New York
Lanfranco Bombelli Tiravanti, Cadaqués, Spain
Seven private collections

Berlinische Galerie, Berlin, Federal Republic of Germany
Fondation Arp, Clamart, France
Hirshhorn Museum and Sculpture Garden, Washington, D.C.
Hood Museum of Art, Dartmouth College, Hanover, New Hampshire
Indiana University Art Museum, Bloomington
Kunstmuseum with Sprengel Collection, Hanover, Federal Republic of Germany
Kupferstichkabinett, Kunstmuseum, Basel, Switzerland
Library of Congress, Washington, D.C.
Los Angeles County Museum of Art
Milwaukee Art Museum
Musée Picasso, Paris
Museum of Modern Art, New York
National Museum of American Art, Washington, D.C.
New Orleans Museum of Art
Paine Webber, New York
Philadelphia Museum of Art
Saarland-Museum, Saarbrucken, Federal Republic of Germany
Solomon R. Guggenheim Museum, New York

Staatliche Museen Preussischer Kulturbesitz,
 Nationalgalerie, Berlin, Federal Republic of Germany
Stadtisches Kunstmuseum, Bonn, Federal Republic of
 Germany
Stiftung Jean Arp und Sophie Taeuber-Arp,
 Rolandseck, Federal Republic of Germany

Annina Nosei Gallery, New York
Baumgartner Galleries, Washington, D.C.

Carmen Lamanna Gallery, Toronto, Canada
Ex Libris, New York
Galeria Cadaqués, Cadaqués, Spain
Galerie Bruno Bischofberger, Zurich, Switzerland
Galerie Maeght, Barcelona, Spain
Galerie St. Etienne, New York
Holly Solomon Gallery, New York
Sonnabend Gallery, New York
Staempfli Gallery, New York

Foreword

The idea of collaboration among visual artists is rarely entertained by the public. The perception of the artist as a loner confirms the generally accepted notion of the solitary genius.

This impression, however, does not seem to apply to the other creative professions. It is understood that scientists collaborate endlessly, and writers are known to have collaborated (Joseph Conrad and Ford Madox Ford, the Russians Ilya Ilf and Evgeni Petrov, for example), and as for composers, who would dare separate George from Ira Gershwin or Rogers from Hart?

Nevertheless, painters, sculptors, and other visual artists have collaborated and still do. Among mural painters, for instance, collaboration in the sense of individual creative contributions is not uncommon. In my youth I once assisted in the completion of a large mural on which two master artists had collaborated in conception as well as in design and execution. On a smaller scale and in a lighter vein, I knew a painter who one day was working from a model and struggling desperately to render her silk stockings convincingly. Another artist working at an adjoining easel, noting his dilemma, approached him and said, "Why don't you let me do the stockings. I'm terrific with silk." The result may not have been a masterpiece, but it surely was a collaboration.

Collaborations among visual artists were common enough once upon a time, although usually in a master-apprentice relationship. Indicating where he wanted a figure or a landscape to go, Rubens left it to Van Dyck or Jan Brueghel to execute. Even if the young Leonardo's angel in Andrea del Verrocchio's *Baptism of Christ* was intended to carry out the master's design, we tend to view it as a revealing collaboration. The Renaissance celebrated the individual, and it is understandable that master artists should have sought to protect their originality and consequently their patronage.

If we have inherited this perception of Renaissance singularity, it has been exaggerated even more in the intervening periods of industrial change. As individuality lost its primacy in every area of life, only a few fortunate ones were allowed the luxury of unique creative freedom. In the more popular arts, to which the public has more immediate access, collaboration is expected; films are made with dozens of collaborators, musicals require an equal number of contributors, the actor and dancer still need a troupe, and musicians play in ensemble. Only painters and sculptors are considered isolated alchemists, alone in their studios, creating aesthetic gold. Or so it seems.

This exhibition tells us that it is not altogether so, that collaboration between visual artists may not be as odd or infrequent as we have thought. Indeed, its frequency is rather surprising, given the myth-turned-reality of the

isolated genius. Perhaps the reason rests in the human psyche, the need to communicate—if not with the public then with other artists whose sympathies and aesthetic outlooks run parallel. In the twentieth century, collaboration among artists, poets, musicians, and others has seemed especially crucial, given the century's social upheavals and the radical aesthetic innovations that have deepened the chasm between artist and public.

The tendency before the First World War to view the new century as the beginning of a golden age, when mankind would be freed by science to realize a transcendent future, was especially attractive to visual artists who had begun to explore new art forms appropriate to this heady vision. When the war came it was almost welcomed by some as a means of worldwide purgation that would cleanse society of its vices. Their hopes were short lived, and as the war continued their dreams were shattered. Artists felt more isolated than ever.

The Dadaists gathered in Zurich, unified by their common reaction to the slaughter on the battlefields as well as by the new art they pioneered—a genus of collaboration by necessity. Although this exhibition deals chiefly with two or more artists executing a single work, we know that *ideas* are also developed collaboratively, even if the results remain individual—Picasso's and Braque's development of Cubism may serve as such an example. The Surrealists, in keeping with their aesthetic and in the face of physical displacement and threats to their lives, also banded together in a kind of brotherhood, collaborating as circumstance allowed. Their efforts in this country are also represented here.

It would be foolhardy to think that all examples of twentieth-century collaboration have been included in this exhibition. Nevertheless, a start has been made in exploring this fascinating phenomenon. We look to the future to uncover more examples that have been missed here owing to unavailability and perhaps even more to past practices of identifying collaborative works as by a single author. There is much research yet to be done into works unrecognized as collaborative. And it is hoped that this exhibition will nourish a climate more favorable to the concept of collaboration. Meanwhile, collaboration seems to be a flourishing practice, especially among those artists who share some form of social commitment and common concerns.

Abram Lerner
Director, Hirshhorn Museum and Sculpture Garden

Acknowledgments

Artistic Collaboration in the Twentieth Century has been an undertaking that, almost by definition, required the energies and expertise of numerous scholars, artists, and museum colleagues. Although only a few can be named on these pages, all have my deepest gratitude.

Robert C. Hobbs and David Shapiro have written major essays for the exhibition catalog, interpreting the subject in individual, provocative ways. Moreover, throughout the three-year genesis of the project, both have been valued and supportive allies.

Gerald Nordland, Director of the Milwaukee Art Museum, and Franklin Addison Page, former Director of the J. B. Speed Museum of Art, enthusiastically agreed to participate in the tour of the exhibition. Their endorsement, and that of Jesse G. Wright, Jr., now Director of the Speed Museum, is warmly appreciated. I am also most grateful to the lenders whose fine works of art will be seen in Washington, D.C., Milwaukee, and Louisville.

As preparations for the exhibition were progressing, in spring 1982, together with Josephine Withers, I conducted a graduate art history seminar on artistic collaboration at the University of Maryland, College Park. A John J. McCloy Fellowship from the American Council on Germany enabled me to pursue my research abroad in autumn 1982. Haide Russell, Cultural Counselor of the Embassy of the Federal Republic of Germany, was especially supportive of the project.

I would like to thank the many individuals who shared their specialized knowledge, among them Daniel Abadie, Rachel Adler, Ethel Baziotes, Albert Boime, Sherry Buckberrough, Fritz and Jean Bultman, Peter Busa, John Cage, Arthur Cohen, Alessandra Comini, Susan Davis, Jean Dupuy, Jimmy Ernst, Cynthia Field, Stephen Foster, Peter Frank, Cynthia Goodman, Gordon Hampton, Jane Hancock, Lynda Roscoe Hartigan, Geoffrey Hendricks, Antonio Honen, Gisela Hossman, Audrey Isselbacher, Janet Kaplan, Lillian Kiesler, Billy Klüver, Linda Konheim Kramer, Alma Law, Susi Magnelli, Steven Mansbach, Pierre Matisse, Robert Motherwell, Hans Namuth, David Noland, David Orr, Arno Penzias, Toby Quitslund, Marvin Sackner, Lillian Schwartz, and Maida Withers.

Contributing artists who responded patiently to numerous queries about collaborative works and background history include Pierre Alechinsky, Karel Appel, Arman, Bernard and François Baschet, Bernd and Hilla Becher, Elizabeth Voorh Cornell Benton, Alberto Biasi, René Brô, Hans Burkhardt, William N. Copley, Brad Davis, Douglas Davis, Enrico Donati, Gilbert and George, Richard Hamilton, Helen and Newton Harrison, Jacques Hérold, Friedensreich Hundertwasser, Marcel Jean, Gerome Kamrowski, R. B. Kitaj, Anna and Wolfgang Kubach-Wilmsen, Adolf Luther, Isamu Noguchi, Kenneth Noland, Gordon Onslow-Ford, Anne and Patrick Poirier, Lucio Pozzi, Dieter Roth, Salomé, Ned Smyth, Dorothea Tanning, Walasse Ting, Jean Tinguely, Bernar Venet, Jef Verheyen, and Susan Weil.

At Smithsonian Institution Press, publishers of this volume, Director Felix Lowe and Managing Editor Maureen Jacoby have been supportive of the project. Editor Ruth Spiegel shepherded the manuscript through the Press, and Designer Alan Carter is responsible for these attractive pages.

Hirshhorn Museum editor Virginia Wageman has had the arduous task of preparing this manuscript; she has labored with skill and forbearance. I am especially grateful to Exhibitions Assistant Deborah Knott Geoffray who has expended great effort coping with the myriad aspects of catalog and exhibition production; she has pulled together the many loose ends with unflagging dedication and enthusiasm.

Anna Brooke, Librarian, expertly organized the bibliography. Assistant Registrar for Exhibitions Meryl Klein coordinated the shipping and packing of loans for the Washington showing and subsequent tour; she and Registrar Douglas Robinson provided invaluable aid. The exhibition layout and installation have been skillfully handled by Joe Shannon, Chief of Exhibits and Design, and his staff, especially Ed Schiesser, production supervisor. Chief photographer Lee Stalsworth, his assistant Marianne Gurley, and photo archivist Francie Woltz speedily provided numerous illustrations. Sidney Lawrence and Carol Parsons capably handled public relations. Among the many other Hirshhorn Museum colleagues who have helped with this exhibition are Bob Allen, Denise Arnot, Charles Bobart, Jonette Butts, Frank Gettings, Peggy Gillis, Brian Kavanaugh, Monica Knudsen, Victoria Lautman, Ted Lawson, Jim Mahoney, Jody Mussoff, Roni Polisar, and Ellen Willenbecher.

During the development of the exhibition, several Hirshhorn Museum student interns and volunteers have provided enthusiastic and capable assistance. The interns were Susan Emmet Borja, Erin Stimmel, Eileen Evans Carr, Gordon Crock, Sophie Orloff, and Sarah Meyer; the volunteers, Sally Daniel, research aide, and Regina Hablutzel, our dedicated translator. In addition, Mostyn Bramley-Moore, a former Smithsonian fellow, served as a Scottish-based research scout.

Chief Curator Charles W. Millard and Executive Officer Nancy Kirkpatrick supplied administrative support. Deputy Director Stephen E. Weil, a valued source of stimulating ideas, provided initial support for this project.

Director Abram Lerner has my gratitude in ways that defy enumeration. My memories of the years shared here with him are indelible.

Cynthia Jaffee McCabe
Curator for Exhibitions, Hirshhorn Museum and Sculpture Garden

Introduction

Collaboration in the arts is a complex and exciting phenomenon. In the Renaissance, identifiable forms of collaboration included those between atelier master and assistants, artist and patrons, both religious and private, and two or more painters and/or sculptors working on a single object or an elaborate program of works. In the twentieth century, virtually every form of artistic activity has collaborative components. This exhibition and catalog represent an initial approach toward identifying the elements that underlie notable artistic teamworks.

"When three or more individuals gather together three or more times they will chose a group name and elect officers" is a truism of political organization known as Lowi's law. With respect to artists, an overriding impulse toward stalwart individualism generally precludes such formal collectivization. Nonetheless, the art world, especially in New York or such other major centers as Paris or Cologne, is itself a collaborative milieu in which the network of information about aesthetic trends, supply sources, and the conditions of the marketplace is ubiquitous.

This type of communalization, however, is rarely artistically productive. It is too amorphous. Artistic collaboration is a more finely controlled process, whether initiated spontaneously or with deliberation.

When two or more creative artists mutually generate provocative aesthetic ideas, a collaborative project may ultimately result. Painters, sculptors, poets, writers, choreographers, video artists, filmmakers, photographers, and composers can act together in teams to produce startling new works that would be inconceivable individually.

Most collaborative endeavors are joint works that combine the talents of individuals in diverse creative fields. Many such collaborations are widely appreciated, among them the stage sets designed by artists, including Pablo Picasso, Isamu Noguchi, David Hockney, and John Cage. Other, less well-known collaborations involve painters, among them Robert Motherwell, and their printmakers.

The present exhibition focuses on collaboration in the visual arts by visual artists—the one facet of artistic collaboration that has been previously unexplored in a major forum. The contributing catalog essayists, Robert C. Hobbs and David Shapiro, have directed their comments to both intermedia and visual arts collaborations. Hobbs has chosen to look intensely at the recent scene, Shapiro at the theoretical structure of collaboration.

While the early years of the twentieth century witnessed collaborative endeavors, these tended to be traditional in form. Most, indeed, were studio productions planned by established figures and executed by assistants. However, in the aesthetic ferment that paralleled the political upheaval preceding World War I, the first notable vanguard collaborations were produced.

Most Dadaists, Surrealists, and members of the Russian avant-garde were involved in collaborative activities.

13

With the outbreak of World War II, the avant-garde-in-exile introduced participatory events to the emerging artists of the United States.

In the late 1940s and early 1950s, Europe slowly reemerged on the international art scene. Independent team projects such as the twin murals by Friedensreich Hundertwasser and René Brô of 1950 (see fig. 43) were created, but the most impressive corpus of collaborative projects was produced by the artists of the Cobra group, among them Pierre Alechinsky, Karel Appel, Christian Dotremont, and Asger Jorn, beginning in 1948 and continuing to the present. The Nouveaux Réalistes, including Arman, Niki de Saint Phalle, Daniel Spoerri, and Jean Tinguely, emerged in the mid-1950s; several of them, too, are currently engaged in extensive co-productions.

Thus, in addition to looking retrospectively at past artistic collaborations, this exhibition and catalog emphasize their continuity with important contemporary collaborative objects and events.

Cynthia Jaffee McCabe

Artistic Collaboration in the Twentieth Century
The Period between Two Wars

Throughout the twentieth century, artistic collaboration has been a vital component of avant-garde development, heretofore little recognized.

Out of the threads of interrelationships, the fabric of art history, like that of life, is spun. Camaraderie, friendship, mutual interests and ambition, the dynamism of nascent art movements, and proximity amid wartime or other disruptive conditions are all incentives toward the creation of collaborative works of art. From Dada on, virtually every major aesthetic movement has been enriched by important team contributions. Concentrated in Europe until World War II, collaborative partnerships now dot the international art map.

To Europeans, therefore, the concept of communal art is taken for granted: artists and artisans, they recognize, have created joint projects since at least the Middle Ages. However, four decades cannot erase the implications of the word "collaboration" for those who survived the Holocaust in Belgium, France, the Netherlands, and the other occupied nations and thus identify the term with their countrymen who actively sympathized with the Nazi conquerors. Theirs is a gut reaction absent in people who spent the war years in a virtually unthreatened United States.

Thus, in a total reversal of the European situation, most Americans consider the term "artistic collaboration" to be politically neutral, but find the concept surprising, if not threatening, since it challenges their cherished image of the artist as solitary creator.

What, then, do we mean by "artistic collaboration"? In its classic sense, the concept of artistic collaboration involves two or more painters, sculptors, printmakers, performance artists, or video artists gathering together, pooling ideas, and with equal participation creating an object. The Dadaists and the Russian avant-garde were the first two groups in this century to produce significant numbers of "classic" collaborative works. Jean Arp and Sophie Taeuber-Arp, who were among the founders of the Dada movement in Zurich during World War I, created duo-works for twenty-five years. The Russian brothers Georgii and Vladimir Stenberg probably worked together on three-dimensional constructions that they exhibited as individually made objects; simultaneously, they also designed numerous lithographs that were co-signed.

From the 1960s on, the idea of long-term collaboration has been an increasingly important factor in the art world. Teams such as Bernd and Hilla Becher, Gilbert and George, Helen Mayer and Newton Harrison, Anna and Wolfgang Kubach-Wilmsen, and Anne and Patrick Poirier are known almost exclusively for their joint productions.

Sustained collaboration among vanguard artists dates from the period of cultural and political ferment in Europe preceding the outbreak of World War I. In 1910 the Italian Futurists, led by Filippo Tommaso Marinetti, pioneered modern collaborative performance as a means of disseminating the messages in their strident manifestoes; infatuated with "speed and love of danger,"[1] they advocated both artistic reform and Italian militarism. However, their zeal did not initially extend to collaborative art projects, and the war effectively decimated their small group.

The war also claimed the lives of Franz Marc and Auguste Macke, two leading German Expressionists who, in

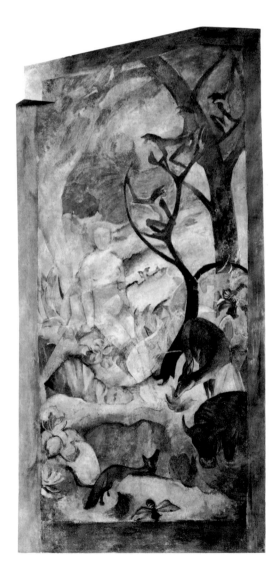

1912, created an important team fresco entitled *Paradise* (fig. 1). In both subject and composition this work presaged by sixty-five years a seminal collaborative environment by Brad Davis and Ned Smyth, *The Garden* (cat. 108). Davis and Smyth did not know about *Paradise*; created in the attic studio of Macke's home in Bonn, the fresco, which is now permanently installed in the Westfälischen Landesmuseum für Kunst und Kulturgeschichte, Münster, was first discovered, overpainted, in 1980.

Paradise is noteworthy not only for its theme and early date but also for its creators' records, which carefully—and perhaps uniquely—document the collaborative process. Macke and Marc first met in early 1910, "a moment of fundamental political and sociological change when everywhere young artists propagated and tried to enforce new perceptions and concepts," according to Ernst-Gerhard Güse of the Westfälischen Landesmuseum. "It was a time of discussions and controversy, of group formations and programmatic exhibitions. The correspondence of the two artists related to important events in this rejuvenation among the arts."[2]

Having seen a series of Marc's animal lithographs at the Galerie Brakl in Munich, Macke made a spur-of-the-moment decision to visit him. Their rapport was immediate. As Marc later wrote, "I think it was a fantastic stroke of luck to finally find a colleague of such spiritual and artistic convictions— bravo. How pleased I would be if we were able at sometime to place our paintings side by side."[3] The idea of a collaborative project was thus Marc's. Its realization became possible when Macke moved to Bonn, where his new home had a fairly spacious attic studio. In 1912 the two friends traveled together to see the avant-garde Sonderbund exhibition in Cologne and then to visit galleries and museums in Paris; there they met Robert Delaunay and learned firsthand about his influential color theories. On their return to Bonn, they began planning the fresco. Abandoning Marc's proposed theme, the passage through the Red Sea, they turned to that of Adam and Eve. Limited by the dimensions of the attic's sloping eaves, they worked with oil pigments directly on the wall.

From surviving sketches and notes, we can deduce that Marc painted the landscape and animals, and Macke the human figures. However, as Güse remarks, "the wasp on the bottom was, according to a legend in Macke's family, put in by Maria Franck," Marc's companion.[4]

When Marc and Macke visited Robert Delaunay in Paris, they may well have met Sonia, his wife, also a painter, who was then at work on a collaborative project with the poet Blaise Cendrars. The result, the Delaunay/Cendrars edition of *La Prose du Transsibérien et de la petite Jehanne de France* (cat. 1), was announced in October 1913; one of the most spectacular early-twentieth-century examples of artistic/literary collaboration, its legacy can be traced through the Kiesler/Breton *Ode to Charles Fourier*, 1945 (cat. 39), to the O'Hara/Rivers *Stones*, 1957–60 (cat. 78), as well as many contemporary artists' books.

La Prose du Transsibérien is a long poem that evokes a seemingly endless train trip from Moscow through Siberia to the Sea of Japan, a subject of special appeal to Sonia, who was Russian by birth. The poem was written in the simultaneous style that then excited not only the Delaunays and other members of the School of Paris, but also the

Italian Futurists and German Expressionists. As Robert explained:

> Literary simultaneism is perhaps achieved by contrasts of words.
>
> [*La Prose du*] *Transsibérien* [*et de la petite*] *Jehanne de France* is a simple contrast (a continuous contrast which is the only one that can reveal the profundity of living form).
>
> [*La Prose du*] *Transsibérien* [*et de la petite*] *Jehanne de France* permits a latitude to sensibility to substitute for one or more words, a movement of words, which forms the form, the life of the poem, the simultaneity.[5]

Working side by side with Cendrars, Sonia created a simultaneous framework for the poem, so that words and art maintain discrete spaces, yet flow into one another harmoniously. The design of the final book has been described as "a syncopated combination of languid arcs and abrupt triangles, paisley pods and sturdy rectangles. Like the poem, it varies in rhythmic movements as consistently as it varies in hues, tones, and contrasts of colors. . . . The steam of the train, the motion of its wheels, the change of the landscape, the voices of passengers are all images evoked but not stated by this unique combination of color and form."[6]

By the time the Delaunay/Cendrars edition of *La Prose du Transsibérien* was gaining recognition, World War I had erupted on the Continent. A new and intense period of artistic collaboration would follow.

The outbreak of the war had an immediate impact upon the young avant-garde artists, many of whom were subject to military draft in their respective countries. For those who were able to escape conscription, neutral Switzerland offered sanctuary. It was here, in Zurich, that Dada was born as a direct literary and artistic response to the carnage and upheaval in Europe. As Jean (Hans) Arp, one of the movement's founders and Modernism's quintessential collaborator, stated:

> In Zurich, in 1915, disgusted by the butchery of World War I, we devoted ourselves to the Fine Arts. Despite the remote booming of artillery we sang, painted, pasted, and wrote poetry with all our might and main. We were seeking an elementary art to cure man of the frenzy of the times and a new order to restore the balance between heaven and hell.[7]

Arp's presence in Zurich was a result of wartime conditions. He had arrived in Paris after a visit to his home in Strasbourg, then German controlled, just as the Franco-German border was being closed. As a military-age Alsatian, he was in a precarious position, and thus, according to legend, he left for Switzerland on the last train to leave the French capital.[8] In Zurich he joined the Dadaists, whose headquarters, the Cabaret Voltaire at No. 1, Spiegelgasse, had been founded by the German writer Hugo Ball as an artists' cooperative.[9] Here, in addition to Arp, gathered a group of European artists and intellectuals, including Richard Huelsenbeck, then a young writer and medical student, writer Walter Serner from Germany, and poet Tristan Tzara and painter Marcel Janco from Rumania, among others. When painter Hans Richter, newly

discharged from the German army, joined them in September 1916, he observed:

> The Cabaret Voltaire was a six-piece band. Each played his instrument, i.e. himself, passionately and with all his soul. . . . I still cannot quite understand how one movement could unite within itself such heterogeneous elements. But in the Cabaret Voltaire these individuals shone like the colours of the rainbow, as if they had been produced by the same process of refraction.[10]

Arp's more flamboyant colleagues enjoyed his quiet, witty contributions to Cabaret Voltaire performances, which included recitations of his own poems such as "kaspar is dead." They also respected his serious devotion to art, or in Huelsenbeck's phrase, his "rigid idealism."[11]

In 1916 Arp and the Dutch painter Otto van Rees received a commission to paint a pair of murals over the entrance to the new Pestalozzi School. However, their collaborative abstractions so enraged parents and Zurich city officials that they were ordered overpainted. "This was done," Richter noted, "and *Mothers, leading children by the hand* lived on the walls where the work of Arp and Van Rees died."[12]

At this time, Arp was working on a series of paper collages made of cut-out abstract forms. One day, according to Huelsenbeck, while the two Dadaists were discussing the law of chance and the problem of simultaneity, Arp decided to experiment "with pieces of paper, letting them fall to the ground and then pasting them together in the order they had chosen themselves."[13]

Historian Dawn Ades has confirmed that "several of Arp's collages in 1916 bear the qualifying title 'arranged according to the laws of chance'; they are a direct development of the geometric works made in close collaboration with Sophie Taeuber, in which a paper-cutting machine was used to eliminate the personal and accidental, to create 'impersonal, severe structures of surfaces and colours.' "[14]

Sophie Taeuber, Arp's future wife, was a Swiss-born painter and dancer (fig. 2). In Zurich, Arp would later recall, they were "collaborating on collages, some of which, dating from 1918, still exist [cat. 4]. As early as 1916 Sophie Taeuber had been doing colored-pencil drawings which anticipated collages."[15] Utilizing Sophie's skill with fabrics, the couple also created an elegant, functionless *Dada Object* (cat. 5).

By Armistice Day, November 11, 1918, the Cabaret Voltaire group had disbanded. However, the idea of community had been instilled in the Zurich Dadaists, and Arp, for one, disseminated its message. In Huelsenbeck's words, "The topic of cooperation as an experience was always present while we worked together in the dada group, and not only then but also later Arp was intensely interested in it. He related it to the idea of complete objectivity, *la réalité nouvelle*, a notion the full impact of which came out years after."[16]

Berlin was as immersed in the war as Zurich was detached from it. In Berlin, according to Richter, the Dadaists were drawn into "a real revolution, and they decided to join in. There was the sound of firing in the streets and on the rooftops. Not only art but all thought and

Figure 2
Jean Arp and Sophie Taeuber-Arp with Taeuber-Arp's marionettes,
Zurich, 1918. Photo courtesy Harry N. Abrams, Inc.

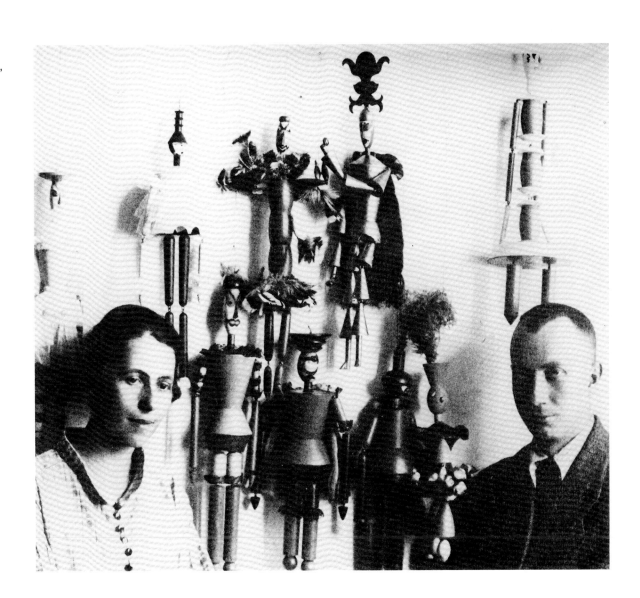

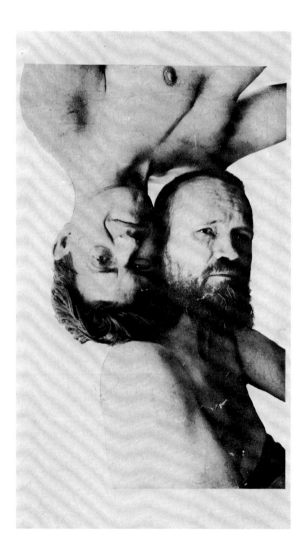

all feeling, all of politics and society, had to be drawn into Dada's sphere of influence."[17]

When Richard Huelsenbeck returned to Berlin from Switzerland in January 1917, he found two distinct but interconnected Dada groups. The first faction was dominated by Raoul Hausmann, who collaborated with his colleagues Hannah Höch (cat. 11) and Johannes Baader (fig. 3). The second, more clearly leftist, consisted of George Grosz and the brothers John Heartfield and Wieland Herzfelde. Both groups were involved in public, often collaborative, activities; demonstrations, exhibitions, magazines, broadsides, and a new art form, photomontage, were all used as vehicles of expression.

Although photomontage was the invention of Grosz and Heartfield, their claim of primacy was heatedly disputed. Thus Grosz later attempted to clarify the record:

> In 1915 Heartfield and I had already made interesting experiments with photo-pasting-montage. At that time we founded the Grosz-Heartfield Combine (at Südende in 1915). I concocted the word *Montör* for H., who went about always in the same old blue suit and whose activity in our partnership recalled engineering assembly ("*montieren*") more than anything else.[18]

The date given above must have been erroneous, as Grosz was away fighting in the German army until the following year. A second version of the story seems more accurate:

> In 1916, when Johnny Heartfield and I invented photomontage in my studio at the south end of the town at five o'clock one May morning, we had no idea of the immense possibilities, or of the thorny but successful career, that awaited the new invention.

> On a piece of cardboard we pasted a mischmasch of advertisements for hernia belts, student song-books and dog food, labels from schnaps- and wine-bottles, and photographs from picture papers, cut up at will in such a way as to say, in pictures, what would have been banned by the censors if we had said it in words. In this way we made postcards supposed to have been sent home from the Front, or from home to the Front. This led some of our friends, Tretjakoff among them, to create the legend that photomontage was an invention of the "anonymous masses." What did happen was that Heartfield was moved to develop what started as an inflammatory political joke into a conscious artistic technique.[19]

Dada-merika (fig. 4), one of the works signed by the "Grosz-Heartfield Combine," expressed the team's ardent infatuation with the United States. Now lost,[20] this montage combined two-dimensional elements such as newspaper clippings and trolley tickets with three-dimensional ones including a ruler, a kitchen knife, tufts of hair, and coins. Another related work, *Comings and Goings in Universal City around Twelve-O-Five Midday* (fig. 5), incorporated Grosz's drawings as well as images from American magazines that Grosz obtained from a brother-in-law in San Francisco.

To the ranks of new magazines proliferating in Berlin, Grosz and Heartfield, jointly and independently, contributed several of their own, under the imprint of Malik-Verlag, Wieland Herzfelde's publishing house. Among these periodicals were *Die Pleite* and *Neue Jugend* (fig. 6), which

Figure 4
George Grosz (American, b. Germany, 1893–1959) and John
Heartfield (German, 1891–1968), *Dada-merika*, 1919, facsimile
reproduction of lost photomontage. Akademie der Kunste, Berlin,
German Democratic Republic.

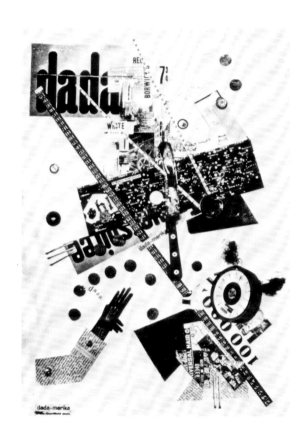

dada-merika

showed Heartfield's interest in modern typography and layout, and the highly sophisticated *Der Dada* (cat. 6, 7, 8). A photograph of Hausmann reciting and a group of montage portraits of other Dadaists appeared in special number 3 of *Der Dada* (cat. 8), whose trio of editors signed themselves with the intertwined names "Groszfield," "Hearthaus," and "Georgemann."

Hausmann and Huelsenbeck, who later vied with one another for recognition as the founder of Berlin Dada, have each been credited with the idea of creating a comprehensive Dada handbook, known as *Dadaco* (cat. 10), which was to have been published by Kurt Wolff in Munich. Only a few collaborative trial sheets from the massive project were preserved when, predictably enough, it proved unfeasible. One such work, a collage and photomontage by Hausmann and Hannah Höch, *Dada Cordial* (cat. 11), contained characteristic inscriptions, including: "The Dada Club has instituted a bureau for newly independent states."[21]

A more overt statement against intensifying political pressures, a dummy of a German officer fitted with the head of a pig, dominated the main gallery of the First International Dada Fair (Erste International Dada-Messe; see cat. 9), held in Berlin, in June 1920. All of the city's Dadaists contributed to the event, which proved to be the climax of that movement in Berlin.

The Cologne branch of Dada had an official collaborative title, Central W/3 (Central Weststupid 3), chosen by its three founding members, Max Ernst and Johannes Theodor Baargeld, both residents of the city, and Jean Arp, who joined them in early 1920. A short-lived but highly

influential movement, Cologne Dada related less to its politicized Berlin counterpart than to the Paris art world. As Ernst described the situation:

> Contrary to general belief, Dada did not want to shock the bourgeoisie. They were already shocked enough. No, Dada was a rebellious upsurge of vital energy and rage; it resulted from the absurdity, the whole immense *Schweinerei* of the imbecilic war. We young people came back from the war in a state of stupefaction, and our rage had to find expression somehow or other. This we did quite naturally through attacks on the foundations of the civilization responsible for the war. . . . Our enthusiasm encompassed total revolution.[22]

After his lifelong friend Arp, Ernst would become this century's most prolific collaborator. By 1918, this son of a Cologne painter was already a committed, if still searching, Modernist. Before the war, Auguste Macke had introduced him to the art and theories of Delaunay and the School of Paris, and he had met Grosz and Heartfield in Berlin. Now his radical sentiments led him to link up with Baargeld (literally "cash"; really Alfred Gruenwald), a Communist and the artist-son of one of Cologne's richest bankers.

In February 1919 Baargeld launched a weekly newspaper, *Der Ventilator*; Ernst was co-editor. Fervently antigovernment and probably proto-Nazi, *Der Ventilator* reached a paid circulation of twenty thousand by its fifth issue; then it was banned by the British occupation forces. Its successor, *Die Schammade*, more Dadaist and far less political, was basically Ernst's creation, although again the elder Gruenwald was the financial backer.

Figure 5
George Grosz and John Heartfield, *Comings and Goings in Universal City around Twelve-O-Five Midday*, c. 1919, facsimile reproduction of lost photomontage. Akademie der Kunste, Berlin, German Democratic Republic.

Figure 6
George Grosz and John Heartfield, *Neue Jugend*, periodical, June 1917. Merrill C. Berman, Scarsdale, New York.

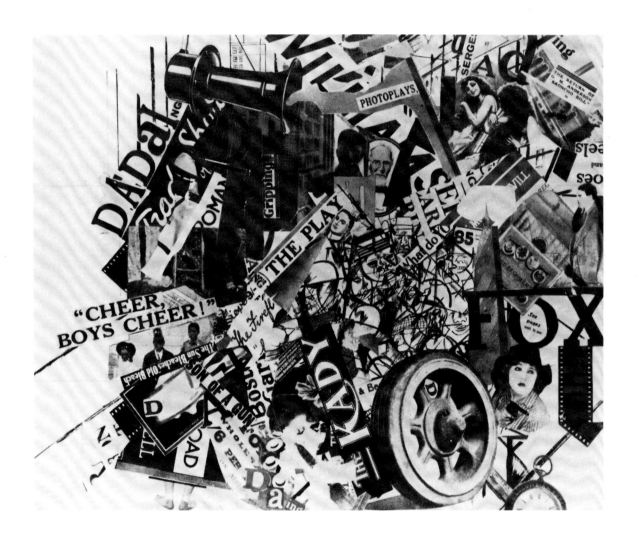

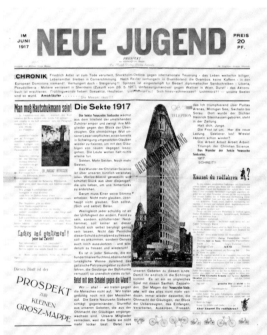

The team's collaborations were not limited to publications. According to Georges Hugnet:

Beginning in 1919, Baargeld and Ernst, who were painting spontaneously, without premeditation, joined Arp in a work in a profoundly Dada spirit, the importance of which they did not realize. Here it was less the result that counted than the intent inherent in the act of creation. Dada destroyed the individual personality: Baargeld and Ernst worked together on paintings, each unaware of what the other was doing. Once, after Arp had expressed regret at not having done certain collages by Ernst, Ernst proposed that they both sign them. From this Dadaist pact was born a whole series of collages in collaboration called "Fatagaga," an abbreviation for "Fabrication de tableaux guarantis gazométriques" [fabrication of pictures guaranteed to be gasometric].[23]

Thus *Physiomythological Flood-Picture* [*Switzerland: Birthplace of Dada*] (cat. 12) bears a dual signature, while only Ernst signed *Here Everything Is Still Floating*, another well-known Fatagaga collage (fig. 7). "Ernst has said that he alone executed the collages, and that Arp and Baargeld only suggested the titles, a claim which appears to be supported by stylistic analysis," Diane Waldman asserts.[24] A closely related work is *Augustine Thomas and Otto Flake* or *Otto Flake Synthesizes the Art of the Corset with a Taste of the Refinement of the Material and of the Metaphysical Meat, While Arp Prefers the Meat of the Flowers of Evil* (cat. 13), which Ernst and Louise Strauss Ernst, then his wife, created together.

In April 1920, Ernst, Arp, and Baargeld organized a Dada Vorfruhling[25] in the back rooms of the Brauhaus Winter, which could be reached only through the men's lavatory. Visitors were urged to destroy works offensive to them, and damaged or stolen objects were constantly replaced. Closed by the police, the show was reopened a month later, when it turned out that an image of Albrecht Dürer's 1504 engraving *Adam and Eve*, which appeared in one of Ernst's collages, was the work that most provoked the public ire.

The collaborative link between Cologne Dada and Paris was established in May 1921 when, at the invitation of André Breton, Ernst had an exhibition at the Galerie au Sans Pareil, which included several of the Fatagaga collages.

At the First International Dada Fair in Berlin, the Grosz-Heartfield Combine displayed a poster proclaiming "Art is dead. Long live the Machine Art of Tatlin." These words were taken from "Tatlinism or Machine Art" by Konstantin Umanskii, the first article on contemporary Russian art to appear in the West since the outbreak of war. Published in *Der Ararat*, a Munich periodical, the article contained preliminary information about this leading Constructivist's projected *Monument to the Third International*. Moreover, in discussing Tatlin's previous work, Umanskii was able to convey the first picture of collaborative art in the new Communist society. Particularly relevant was the commission Tatlin received in early 1917 to design the interior of the Café Pittoresque in Moscow. In Camilla Gray's words: "As he was virtually incapable of working on his own, he invited Georgy Yakulov, just back from the front badly wounded but full of enthusiasm for the idea to join

Figure 7
Max Ernst (French, b. Germany, 1891–1976) and possibly Jean
Arp (French, b. Germany, 1886–1966), *Here Everything Is Still
Floating*, 1920, Fatagaga collage, pasted photoengravings and
pencil on paper. Museum of Modern Art, New York.

Figure 8
Georgii Yakulov (Russian, 1882–1928), *Design for Decorations at
the Café Pittoresque*, 1917, pencil on paper. Musée National d'Art
Moderne, Paris.

24

Figure 9
Konstantin Medunetzky, Georgii Stenberg, and S. Ya. Svetlov at
the *Obmokhu* (Society of Young Artists) exhibition, Moscow, 1921.

him on it [fig. 8]; he also recruited his new friend [Alexander] Rodchenko. All three contributed to the decoration of the café, which became a typical centre of this crazy war-time art world."[26] Thus, despite Umanskii's declaration that "a babbling Dadaism would be impossible in Modern Russia,"[27] the Café Pittoresque became Moscow's version of the Cabaret Voltaire.

As was the case in all facets of society, collective action was the hallmark of art in the period following the Revolution of 1917. According to Stephanie Barron: "During these years there was an unprecedented interaction among artists working in different media: poets and musicians painted, painters designed for the theater, they collaborated on illustrated books, painters and sculptors designed utilitarian objects, and many proclaimed their ideas in manifestos. Men and women worked together in astonishing numbers; many artists were married to one another, or related by family."[28]

In addition to this pervasive communality, the art of the Russian avant-garde had specific collaborative components, such as the Tatlin/Yakulov/Rodchenko installation. Two of the period's most gifted collaborators were the brothers Vladimir and Georgii Stenberg. Eighteen and seventeen years of age respectively in 1917, they contributed propaganda posters to the revolutionary effort. For May Day the following year, together with Konstantin Medunetsky (fig. 9), they produced agit-prop decorations for Moscow sites including the Napoleon Theater and the Railroad Workers Club.

Founding members of the Obmokhu (Society of Young Artists), the Stenbergs showed their "Constructions of Spatial Apparatus," identified by titles such as *KPS-11* (cat. 15), at all the Obmokhu exhibitions, and again with Medunetsky, in a Constructivist exhibition at the Café of the Poets in 1920. These open-form sculptures of wood, iron, glass, and steel exemplified the Constructivist concern with volume rather than plane and with the use of nonart materials.

But were the works collaborative? Alma Law, the leading authority on the brothers who has conducted interviews with Vladimir (who died in 1981; Georgii was killed in an accident in 1933), Georgii's widow, and their few other surviving colleagues from that period, has no definitive answer. For, although Georgii and Vladimir signed the three-dimensional works individually, the two shared the same studio, materials, and ideas, and had a closely knit relationship. Moreover, despite his activities in other areas, Vladimir produced no sculptures of note after Georgii's death. Indeed, as Law learned from Vladimir, the reason for the individual signatures was largely economic. In Russia in 1920, the Stenbergs made an assessment that would prove prophetic: they realized that experiential art by more than one artist simply would not sell.[29]

Extending their Constructivist principles into a new medium, the Stenbergs pioneered modern film poster design (cat. 19, 20, 21). There is no question of joint attribution here: their posters and other graphics, including book illustrations and theater programs (cat. 18), were clearly signed "2 Sten 2" or "2 Stenberg 2." In at least one instance, when they worked together with Yakov Ruklevsky on the poster for Vladimir Gardin's *Poet and Tsar*, their logo was a "3" inside a triangle.

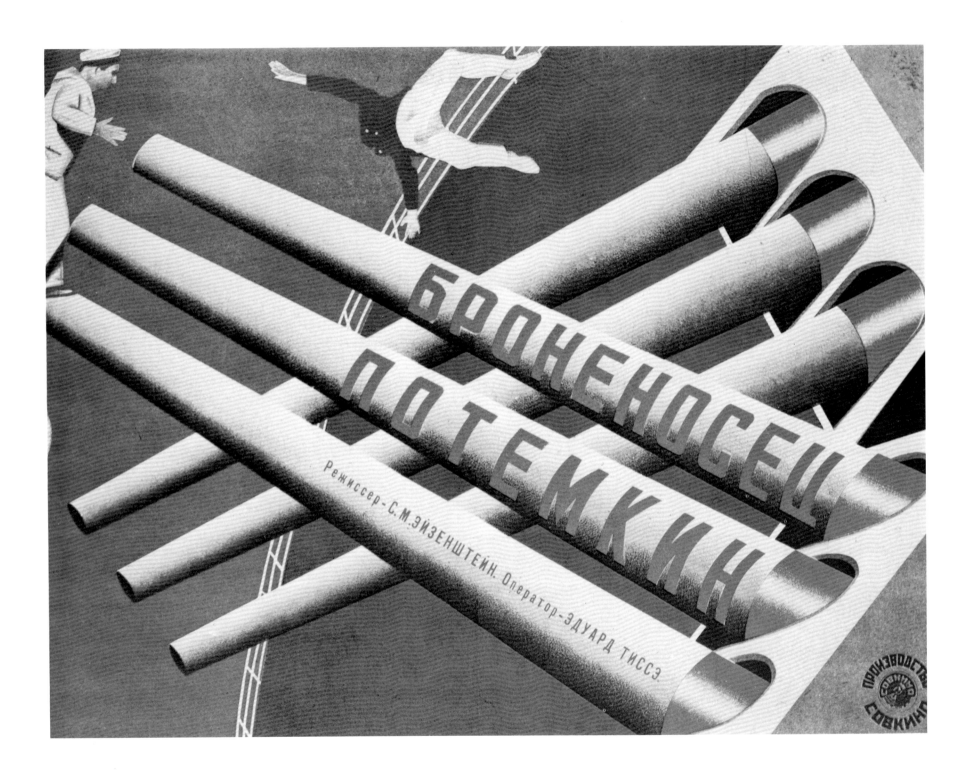

Figure 10
Georgii Stenberg (Russian, 1900–33) and Vladimir Stenberg (Russian, 1899–1982), *Battleship Potemkin*, 1927, film poster. Private collection.

Recognizing the propaganda value of its domestic films and the box office income generated by foreign ones, the Soviet government actively promoted the neophyte industry. One of the earliest classics of Soviet cinematography was Sergei Eisenstein's *Battleship Potemkin*; of several posters for this work, the Stenbergs' (fig. 10), done in 1927, a year after the film's release, was the most memorable. Mildred Constantine and Alan Fern have described this poster, which depicts a pivotal moment in the film, the man overboard incident:

All extraneous elements have been eliminated, leaving the two sailors and the opposing diagonals of the guns to tell the story and attract the viewer. Indeed, one's sense of space and scale and direction are so destroyed by this design that it is virtually impossible to see the poster in any way except as a compelling visual construction relating to the collision of bold forces. . . . It must be clear by now that the Brothers Stenberg were among the most inventive and versatile poster artists working for the Soviet cinema in the 1920s.[30]

Like Constructivism, Suprematism was an important Russian contribution to the international avant-garde with significant collaborative components. Indeed, the founder of the movement, Kasimir Malevich, a mystic who aimed at the ultimate nonobjectivity in painting, participated in many joint projects. The most fruitful of these collaborations were with painter, musician, and publisher Mikhail Matiushin.

In July 1913, Malevich participated in the First All Russian Congress of the Singers of the Future (Poet-Futurists), held at Matiushin's dacha in Finland. There he and his host, together with poet Alexei Kruchenykh, drew up plans for a Futurist opera, *Victory over the Sun* (fig. 11). For this landmark work of collaborative theater, a sung drama about the triumph of modern man and his energy sources, Kruchenykh wrote the libretto, Matiushin composed the score—which included the firing of a cannon, the stamping of machines, and the crushing of an airplane—and Malevich created the costumes and sets.

Having first presented his Suprematist paintings in 1915 at the exhibition *The Donkey's Tail, 0-10* in Moscow, Malevich was active as a teacher in revolutionary Russia. In 1920, invited by Marc Chagall, he joined the faculty of Vitebsk Free Art Studios, the leadership of which he soon assumed. Together with colleagues, including El Lissitzky and Ilya Chasnik, he organized an artists' collective, Unovis (Affirmers of the New Art), to promulgate Suprematist principles.

When the Unovis group dissolved in 1922, Malevich went to Petrograd. At the newly established Ginkhuk (State Institute for Artistic Culture), he chaired the Formal-Theoretical Department, while Matiushin headed the Research Department of Organic Culture. Matiushin, by this time, had formulated his own theories of color, form, and perception, which he termed "spatial realism." His pupils, especially several members of the Ender family, worked on problems of color in motion. "Because of the collaborative nature of the Ginkhuk enterprise—in which the artists worked closely with one another to solve a set of common problems—and because few of their works are signed, it is

Figure 11
Scene from *Victory over the Sun* performed at the Los Angeles
County Museum of Art, September 1980. (Directed by Robert
Benedetti; produced by the California Institute of the Arts,
Valencia, California, and the Los Angeles County Museum of Art.
Original production supported in part by a grant from the Shubert
Foundation.)

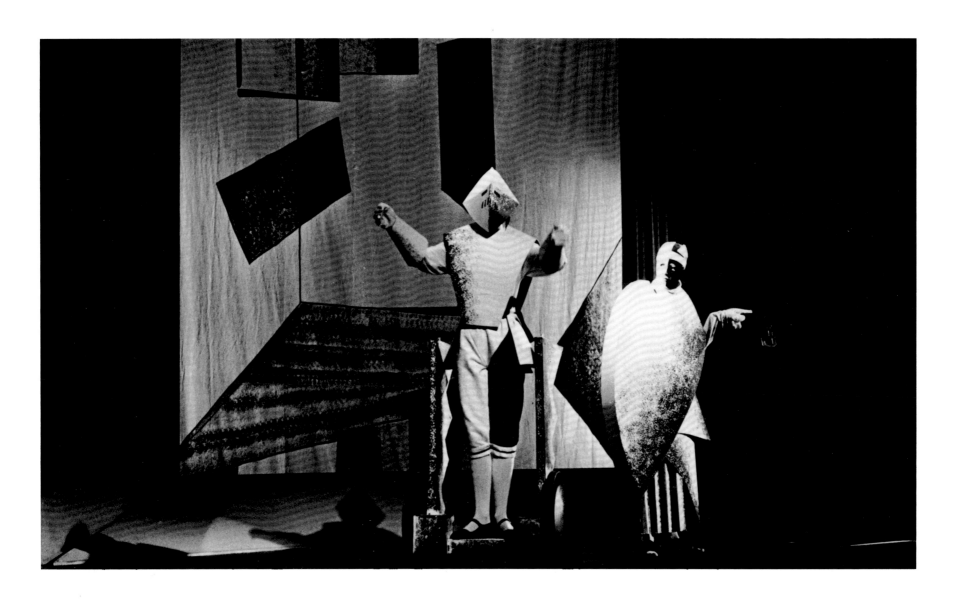

Figure 12
Hans Richter (American, b. Germany, 1888–1976), reconstructed partial score for proposed Richter/Kasimir Malevich Suprematist film, 1969, colored inks on paper. Jay Leyda, New York.

Figure 13
Hans Richter, *Theo van Doesburg*, c. 1950, colored inks on paper. Hirshhorn Museum and Sculpture Garden, Washington, D.C., gift of Hans Ruppel and Ursula Lawder, 1982.

often difficult to make confident attributions," Angelica Rudenstine has stated.[31]

In Petrograd, after a hiatus of almost a decade, Malevich and Matiushin again collaborated. Together they produced an extensive series of color studies (cat. 16, 17), which were exhibited in Moscow in 1924. When Malevich traveled to the West for the last time in 1927, for solo exhibitions in Warsaw and Berlin, he doubtless brought with him, along with didactic charts prepared by his students and the color tables of the Matiushin group, examples from this collaborative series. In Germany, after meeting Walter Gropius at the Bauhaus and arranging with László Moholy-Nagy for the publication of his treatise, *The Non-Objective World*, as Bauhaus Book II, Malevich visited Hans Richter to enlist the latter's aid in producing a collaborative Suprematist film (fig. 12). When his visa expired, he was forced to return to the USSR. The film project died, and the works of art, many of which were subsequently acquired by the Stedelijk Museum, Amsterdam, were entrusted to the care of an architect friend.

In the early 1920s Russian artists participated in an extraordinary networking of the European avant-garde. The first major exhibition of Soviet art to be seen in the West was held at the Galerie van Diemen, Berlin, in the fall of 1922. The previous year Lissitzky had met both Arp and the Hanover artist Kurt Schwitters, with whom he later worked on the Dada publication *Merz*.

In 1922 Schwitters came in contact with Theo van Doesburg, a leading proponent of the Dutch De Stijl movement who, as I. K. Bonset or Aldo Camini, wrote Dada tracts and poetry. Together Schwitters and van Doesburg

embarked on a performance tour; *Small Dada Soirée* (cat. 14) announced one of their evening events. As Richter, who often depicted his colleagues in drawings and sketches (fig. 13), has related:

After Does had once experienced Dada, he threw himself into it wholeheartedly. With his wife—the pianist Nelly Van Doesburg, who played modern music—and with Schwitters, he executed a unique Dada tour of Holland, in which Does appeared as orator and expounded the Spirit of Dada. In these expositions, he was interrupted from time to time by a member of the audience who gave a very realistic imitation of a barking dog. When the audience made ready to eject the enormously tall gentleman who was doing the barking, the speaker on the platform introduced him as Kurt Schwitters. He was not ejected, but took his place on the platform where he uttered a variety of other noises, as well as barking and reading more or less naturalistic poems like *Anna Blume* or the splendid *Revolution in Revon*.

This stratagem never failed in its purpose of arousing the public from its good natured complacency.[32]

In Hanover, Schwitters created the extraordinary *Merzbau*, a construction that eventually occupied his entire home. Incorporated into its hollow spaces were objects dedicated to Arp, Lissitzky, Malevich, van Doesburg, the Russian Constructivist sculptor Naum Gabo, Bauhaus architect Ludwig Mies van der Rohe, and other colleagues. Most of these figures attended the Congress of International Progressive Artists in Düsseldorf in May 1922. Dissatisfied with the rhetoric generated at this large gathering, Richter,

Lissitzky, and van Doesburg planned their own International Congress of Constructivists and Dadaists, which was held in Weimar in September. While the latter two organizers, together with Bauhaus artist and photographer László Moholy-Nagy, "dedicated themselves to constructing a collective utopian future,"[33] in Steven Mansbach's words, this dream, like Dada itself, soon died.

According to poet, physician, and polemicist André Breton, Dada's unmourned demise occured in 1921. If his report was somewhat premature in light of events elsewhere in Europe, Paris, never a strong Dada bastion, was clearly ready for a new credo. Thus, the following year, the term "Surrealism" first appeared in print. In 1924 the movement was officially launched when Breton issued the First Surrealist Manifesto with its formal definition: "SURREALISM. noun, masculine. Pure psychic automatism, by which one intends to express verbally, in writing or by any other method, the real functioning of the mind."[34] As envisioned by Breton, noted William Rubin, "the movement was intended to function as the spontaneous expression of affinities between independent collaborators";[35] in the enthusiasm of the moment, the inherent untenability of this objective was simply overlooked.

Jean Arp and Max Ernst, newly arrived in Paris from Cologne, easily made the transition in their work from Dada to Surrealism. Breton's countryman Marcel Duchamp, who had left Paris in 1914 because "I hadn't anyone to talk to. It was frightfully lonely,"[36] returned quietly from New York seven years later, together with his friend, longtime American expatriate photographer Man Ray. Although never a formal member of the Surrealists, Duchamp was a highly respected intermittent participant and inveterate collaborator.

Among those who became official adherents during Surrealism's first official year were Joan Miró and André Masson. Yves Tanguy, a merchant seaman turned painter, became a Surrealist in 1925. It was at Tanguy's Paris quarters that Surrealism's most famous collaborative works, the Exquisite Corpses (cadavres exquis; cat. 22–26, 28–33, 37, 38) were invented.

In an essay entitled "The Exquisite Corpse, Its Exaltation" (1948), Breton described the genesis of the genre:

The *Exquisite Corpse*—if I remember rightly, and if I may so express myself—came into being some time during 1925 in the old house, since pulled down, that was number 54 of the rue du Château. In this establishment, Marcel Duhamel . . . provid[ed] free board and lodging for his friends Jacques Prévert and Yves Tanguy, who, at that stage of their careers, excelled chiefly in the art of living and of enlivening the atmosphere with their high spirits. Benjamin Péret, too, made a long stay in this house, where absolute non-conformism and unsparing disrespect were the order of the day. . . .

When the conversation about the day's events began to flag, or our imaginations had exhausted the possibilities of amusing or scandalous interventions in the world around us, we usually started playing *games*. . . . We were by no means averse to the idea of making use of certain children's games for which we rediscovered the enthusiasm of our tender years, but a vastly enhanced

enthusiasm. Looking back on this period, and trying to analyse the almost incredible effectiveness which our participation in this field of activity sometimes yielded, it seems quite clear that basically the principle of the *Exquisite Corpse* is identical to that of word-games such as "Consequences." Certainly nothing could have been easier than to create drawings by this method, using the same system of folding the paper and hiding the already inscribed contents.

EXQUISITE CORPSE.—*Game of folded paper which consists in having several people compose a phrase or a drawing collectively, none of the participants having any idea of the nature of the preceding contribution or contributions. The now classical example, which gave its name to the game, is the first phrase obtained in this manner:* The exquisite—corpse—shall drink—the young—wine. *(Dictionnaire abrégé du surréalisme.)*

. . . What, in fact, excited us in these composite productions was the conviction that, at the very least, they were stamped with a uniquely collective authority and that they were endowed powerfully with that power of *drifting with the current* which poetry should never undervalue. With the *Exquisite Corpse* we had at our disposal—at last—an infallible means of sending the mind's critical mechanism away on vacation and fully releasing its metaphorical potentialities.[37]

The first published Exquisite Corpses, both written and drawn, appeared anonymously in the October 1927 issue of *La Révolution surréaliste*. These Exquisite Corpses were, in a sense, the offsprings of Ernst, Arp, and Baargeld's Fatagaga collaborations. In addition, as manifestations of the laws of chance, they were related also to Arp and Taeuber-Arp's Dada works. "The important thing about their *cadavres exquis* was, for the surrealists," notes J. H. Matthews, "the *arrival of the surprising image*."[38]

In a movement rent from its inception by internecine warfare, it was the group of artists and writers closest to Breton who, together with their various spouses and companions, most often participated in Surrealist games. In the late 1920s these game players included Miró, Tanguy, Man Ray, Péret, Max Morise, Pierre Naville, Jacques Prévert, and Paul Eluard, as well as Breton himself and his friend Suzanne Muzard (cat. 22–25).

By 1930, when the periodical *Le Surréalisme au Service de la Révolution* (*SASDLR*) began a troubled three-year history, the only members of Breton's original team still working with him were Ernst, Tanguy, Péret, Eluard, Louis Aragon, and René Crevel. However, the Surrealist network was expanding internationally, and new recruits arrived in Paris to augment depleted ranks.

Salvador Dali was an electrifying newcomer who, together with his colleagues Luis Buñuel and René Char, joined the Surrealists in 1929. On December 3 of the following year, the Buñuel-Dali film, *L'Age d'Or* (see fig. 27), was screened privately in Paris; after the showing was violently broken up by the League of Patriots and the Anti-Jewish League, the film was banned by the police.

In 1931 when Dali was asked by Breton to provide a topic for "Communal Action," he proposed "the Surrealist object," and, as Dawn Ades has stated, "a whole phase of surrealist activity was inaugurated and recorded in

SASDLR."[39] *SASDLR*, no. 3, December 1931, was largely devoted to Dali's topic. Dada objects, especially Duchamp's ready-mades—one of which, *With Hidden Noise* (cat. 3), had been done in New York in 1916 with the assistance of Walter Arensberg—as well as Ernst's collages, works by Pablo Picasso, and the Exquisite Corpses were all acknowledged as important antecedents. In addition, recent objects by Alberto Giacometti, Valentine Hugo, Gala Eluard, Dali, and Breton were reproduced in the magazine.

Dali's own contribution to the collaborative oeuvre, an adaptation of Picasso's etching *Surrealist Figures* (cat. 27), was done around 1933. In June of that year, a month after the demise of *SASDLR*, a Surrealist exposition was held at the Galerie Pierre Colle; included were ten Exquisite Corpses.

Two years later a remarkable series of Exquisite Corpses (cat. 29–33) was created in Barcelona. In a statement entitled "The Rewards of Leisure," artist-historian Marcel Jean, one of the participants, described the collaborative process:

> In July 1935 I happened to be in Barcelona with Oscar Dominguez and his two friends, the painters Remedios Varo and Estéban Francès. What was there to do in that super-active city—which went to sleep during the siesta hours? But it woke up again in the evening and we strolled along the Ramblas where crowds filled the café terraces until late at night, clapping hands to call the waiters so that we imagined that they were cheering us as we passed by. Down the slopes of the Citadel, on the Paralelo, innumerable parties were dancing the sardana, that charming group dance that only Catalans can perform properly. What was there to do for four not very affluent surrealists, after they had explored the Barrio Chino and devoutly visited Gaudi's Parc Güell and his unfinished "art nouveau" basilica, the Sagrada Familia?
>
> One main relief against ennui had always been, among surrealists, to draw what we called "cadavres exquis"—a variation of the well-known game of "consequences"—and in Barcelona we soon resorted to that famous diversion, introducing, however, a different technique: to the surprises of blind collaboration we added the charms of "collage." The successive contributions which were to build up the final image were not drawn by hand but we borrowed them, ready-made and in bright colors, from illustrated advertisements in out-dated magazines. We cut out figures of personages, objects, animals, etc., and pasted the cuttings on a sheet of paper; then, according to the rules of the game, each participant masked his own "collage" and handed over the sheet to the next contributor. And we noticed that, on the gay unexpected images we obtained, colors assembled at random often did match and enhanced, it seemed to us, the relations that revealed themselves between the individual elements of our collective picture.
>
> The process was rather exciting and we made "cadavres" out of corpses of bygone publicity until our supply of old magazines was reduced to shreds. Each of us shared a certain number of these "exquisite" compositions which brought new poetical discoveries to the already infinitely varied repertory of the game.[40]

Figure 14
Arshile Gorky (American, b. Turkish Armenia, 1904–48) and Hans
Burkhardt (American, b. Switzerland 1904), *Abstraction*, 1936–37,
oil on canvas. Jack Rutberg Gallery, Los Angeles.

In July 1936, exactly twelve months after the four artists played Surrealist games, civil war erupted in Spain, and political skies elsewhere began to darken. In Paris, Surrealism foundered on the issue of its relationship to the Communist party. The short-lived Popular Front of Communists and other anti-fascist factions enlisted the allegiance of many artists, including Marcel Gromaire and Jacques Lipchitz, who jointly produced a design for a chariot for a Popular Front parade (cat. 34).

In isolationist America in 1936, despite intense revulsion against Franco's death tactics, few artists could possibly foresee a generalized war. Thus, when Arshile Gorky and his former student Hans Burkhardt produced a pair of abstract canvases (cat. 59; fig. 14), their collaborations were devoid of political content.

In 1939, however, Gorky, himself a survivor of the Turkish massacre of the Armenians three decades earler, reacted intensely to the situation abroad. On September 1, as his friend sculptor Isamu Noguchi has related:

> The occasion was when Arshile Gorky and De Hirsh Margules were visiting my studio on 10th Street. We had been playing over some old drawings of mine for lack of paper, improvising in our turns. Suddenly on the radio came news of Hitler's invasion of Poland. The drawing we were then dabbling on was at once seized by Gorky and completed by him. The final mark[s] of his fingers were impressions made by pressing his fingers into the red paste used for seals in the Orient. His finger marks attest to their origin. The black crayon marks are also his signature overlaid on to my more geometric base.[41]

By 1940, while George Grosz, who like many German colleagues had immigrated to the United States in the early 1930s, was contributing to collaborative anti-Hitler posters and murals (fig. 15), most of the avant-garde artists who had stayed in Paris were fleeing south to the "unoccupied zone," just ahead of the Nazi invaders.

In Marseilles, refugee center of unoccupied France, the Surrealists reassembled. Having served as a military physician, Breton moved to Marseilles when the army was disbanded under the terms of the Franco-German Armistice; he, his wife Jacqueline Lamba, and daughter Aube found sanctuary in the Villa Air-Bel outside the city. Here he was joined by Masson and his family, as well as Ernst, who had been incarcerated as a German national in Les Milles, a French concentration camp. At Les Milles, Ernst and Hans Bellmer had experimented with the Surrealist process known as decalcomania and together produced several collaborative works.

Other Surrealists who gathered in Marseilles included Wifredo Lam, Victor Brauner, Jacques Hérold, Dominguez, Varo, and Péret. On Sundays they all met at Air-Bel (temporarily renamed "Château Esper-Visa") to hold auctions of their art (fig. 16), create Exquisite Corpses and other collective drawings (fig. 17), and participate in Surrealist games. Led by Jacqueline Lamba, the group also produced a deck of modern tarot cards, the *Jeu de Marseilles* (figs. 18, 19).

At the Villa Air-Bel, Breton, Ernst, and Masson were guests of the American-based Emergency Rescue Committee and its European representative, Varian Fry.

Figure 15
George Grosz, far right, Yasuo Kuniyoshi, kneeling, with Harry
Sternberg and Jon Corbino, left, at work on a figure of Hitler (now
destroyed) for an anti-Nazi rally, New York, 1940.

Figure 16
An auction of Surrealist art at the Emergency Rescue Committee's
Villa Air-Bel outside Marseilles, 1940. Benjamin Péret and
Jacqueline Lamba Breton are standing at far end of table.

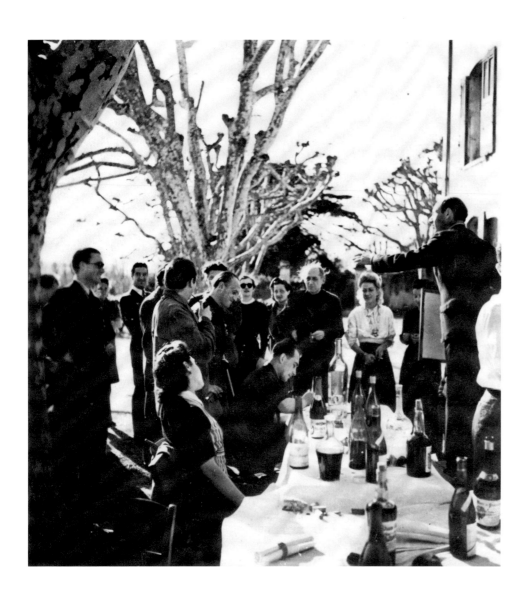

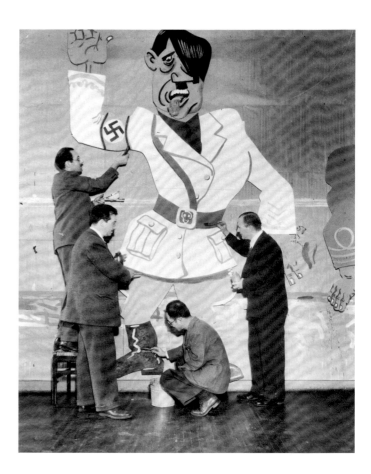

Figure 17
André Breton (French, 1896–1966), Jacqueline Lamba Breton, and Wifredo Lam (Cuban, 1902–82), *Collective Drawing*, 1940 (Marseilles), colored inks and crayons on paper. Musée Nationale d'Art Moderne, Paris.

Figure 18
Jacqueline Lamba Breton, "Baudelaire, L'Amour," from *Jeu de Marseilles*, 1941, tarot cards created together with André Breton, Oscar Dominguez, Max Ernst, Jacques Hérold, Wifredo Lam, and André Masson. Jacqueline Lamba Breton, Paris.

Figure 19
Jacques Hérold (French, b. Rumania 1910), "Sade, La Révolution," 1941, tarot card from *Jeu de Marseilles*. Jacqueline Lamba Breton, Paris.

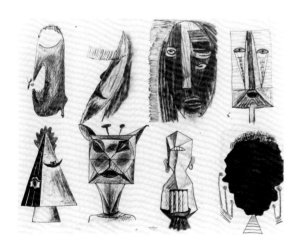

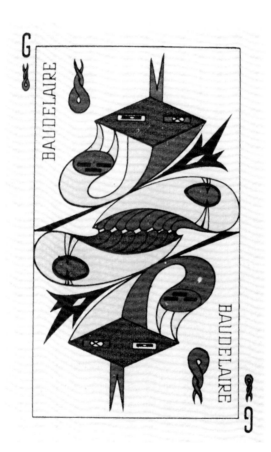

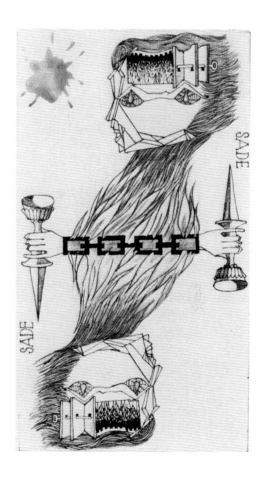

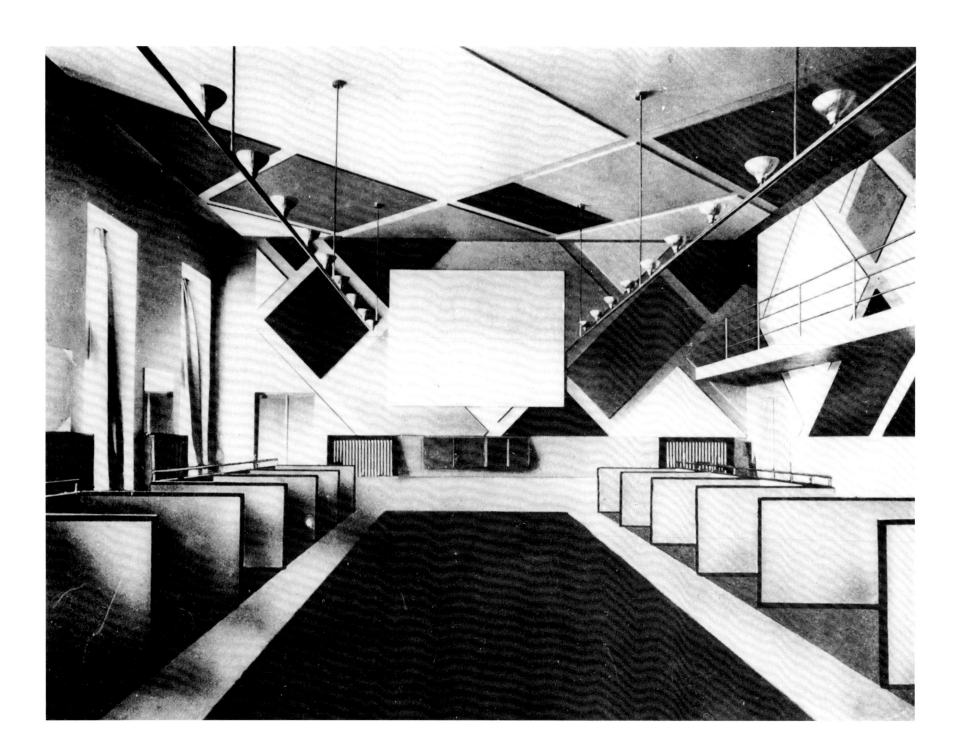

36

Figure 20
Cinema-dance hall in the Café Aubette, Strasbourg, designed by
Theo van Doesburg with Jean Arp and Sophie Taeuber-Arp, 1928.

Fry's task was to obtain visas and facilitate the escape of as many leading European intellectuals as possible before the Nazi vise closed on Vichy France. With their collaborative games and colorful personalities, the Surrealists, "the entire Deux Magots crowd, as mad as ever,"[42] in Fry's phrase, were among his favorite "clients."

Also on Fry's list of imperiled artists were Jean Arp and Sophie Taeuber-Arp who had left Meudon, outside Paris, for sanctuary in Grasse, which they reached in 1941 via Nérac in Dordogne and Veyrier in the Savoie.

It had been a commission for a collaborative project, the decoration and furnishing of the Café Aubette in Strasbourg (fig. 20),[43] that provided the Arps with the funds needed to build their home in Meudon in 1928. They worked on the Café Aubette between 1926 and 1928, together with Theo van Doesburg, who described it in a special 1928 issue of the Dutch periodical De Stijl.

Since, for economic reasons, the couple had often been separated during the twenties, "this Meudon period was particularly happy and fruitful for both of them. The days flowed rapidly by, filled by the passionate interest that they took in their mutual works and experiments," Gabrielle Buffet-Picabia, a close friend, later recalled.[44]

In the mid-1930s Arp and Taeuber-Arp resumed the intense artistic collaboration that had characterized their initial Zurich years. While the duo-drawings and paintings related to Le Siège de l'air, a book of Arp's poems (cat. 50, 51), dimly echoed the Dada works that they had created "according to the laws of chance," their three-dimensional objects such as Marital Sculpture (cat. 48) and Signpost (cat. 49) exemplified the biomorphic forms of Surrealism.

In Grasse the Arps shared a house with Sonia Delaunay, while friends, the Italian painter Alberto Magnelli and his wife Susi, lived in nearby La Ferique. With Susi Magnelli as observer, the others made a remarkable series of collaborative drawings (cat. 53–55) for a portfolio of lithographs (cat. 52), about which Arp later wrote:

These lithographs are collaborations. Sonia Delaunay, Sophie Taeuber, Alberto Magnelli, and I did them, sometimes two of us together, sometimes three or four of us. They are duos, trios, quartets. Four instruments create a harmonious consonance. Four people blend, submerge, submit, to attain a plastic unity. The lines of one hand furrow the color spaces constructed by a fellow hand. Shapes join together and live naturally as do organs in a body. An alloy is cast into a bell and rings out.

1941. We found ourselves in Grasse. The constellations bringing those four artists together were especially favorable to the realization of joint work, for the tragic hours during which these lithographs were conceived compelled modesty, the sacrifice of all vanity, the effacement of any overly individual expression.[45]

Susi Magnelli recently added her own reminiscences:

As neighbors and friends during the war, the Arps and Sonia Delaunay didn't live far from us. The lithographs were made partly in La Ferique, but also at the house of the Arps and Sonia Delaunay. They made them together, or each made a drawing and passed it on to the other artist. There were no rejections. The collaboration was

done rapidly—I think in one to two months. Except when Arp was away in Marseilles for several days to seek a visa for the United States, no one left.[46]

Lithographic plates were made from several of the "Four from Grasse" works in 1942. Then, at a time when collaboration had an ominous double meaning, their Swiss printmaker was seized and killed by the Gestapo. Delaunay managed to save the original drawings, and an edition of colored lithographs from them was finally published in Paris in 1950 (cat. 52).

Meanwhile, Varian Fry's efforts on behalf of the Arps proved futile. Since Jean Arp came from Alsace-Lorraine in the so-called forbidden zone, it was impossible to document the fact that he had no police record; thus the U.S. Department of State rejected his visa application. However, the couple had an option available to only a few refugees; they could cross the border into Switzerland, Sophie Taeuber-Arp's birthplace. Recognizing the imminent danger to Sophie, who was Jewish, they traveled, largely on foot, to artist Max Bill's Zurich home in December 1942. There Sophie died of accidental asphyxiation on January 13, 1943.

Arp's profound and sustained grief found expression in such poems as "Sophie Dreamed Sophie Painted Sophie Danced" of 1944 as well as in works of art that recapitulated the team's entire collaborative career. In 1947 Arp reassembled one of their Dada collages (cat. 57), and in 1960, six years before his own death, he produced a series of nine plaques based on Taeuber-Arp's final drawings (cat. 58). As Richard Huelsenbeck wrote:

When I visited Arp in his home in Meudon [in 1953] . . . we [sat] in the garden room, which also served as a living room, and which offered a view of the edge of the forest. Here in this room, Sophie Taeuber's paintings and constructions hang on the walls. Arp lost his wife prematurely. She was everything for him, a companion, a colleague, a beloved, and a mother. Overwhelmed with gratitude, he helped bring about her fame. Arp is Taeuber and Taeuber is Arp.[47]

When Huelsenbeck arrived in the United States in 1939, he found the country fundamentally inhospitable to Dada's basic impulses. "We dadaists were representatives of a historical period that needed cynicism to transform itself," he wrote.[48] Clearly, he did not make the connection between the European movement that he had led and New York Dada, which in the previous war had been characterized by such Duchampian objects as the assisted ready-made *With Hidden Noise*.

Duchamp was one of the last of the Emergency Rescue Committee's artist-clients to obtain a U.S. visa before the Nazis occupied Vichy France. With his arrival in New York in June 1942, the ranks of the Surrealist-in-exile were virtually complete. The American art world was more congenial to the Surrealists than to Huelsenbeck, and they, in turn, made fundamental contributions to it. By continuing to produce participatory Exquisite Corpses and create other joint paintings and objects as well as to organize group exhibitions and launch publications in New York, the Surrealists transferred the concept of artistic collaboration to the young artists of their host nation.

One of the first Surrealists to cross the Atlantic, Chilean-born Matta Echaurren was particularly influential. After leaving Paris in 1939, he, his close friend Gordon Onslow-Ford, and Estéban Francès spent time producing Exquisite Corpses; Onslow-Ford has described one of their characteristic works (cat. 37):

This *cadavre exquis* was made in July or August 1939 while we were staying at Château Chemillieu. At that time Matta was in his *psychological morphology* period. Estéban and I were close to him in preoccupation, and were painting *inscapes* (landscapes of the unconscious, beyond dream). This *cadavre exquis* is in a style more literary than those used in our paintings. We made it sitting round a table as a game after dinner, when we gambled for drawings and poems which were often made at the same time.

This personage is part equine, part bird, part sacred heart, part human, part sea monster; a boat with a lateen sail gives a Mediterranean touch. The unconscious sympathy between the participants has aligned the head, body and legs in the same direction. The head made by Matta dominates the personage and stares at some unknown person or situation out of view to the left, with a mixture of bravado, animosity and fear.[49]

Soon after arriving in New York the following year, Matta, perhaps the youngest of the Paris exiles, became friendly with several American painters including Robert Motherwell, William Baziotes, Jackson Pollock, Lee Krasner, and Gerome Kamrowski. Motherwell has commented:

There were two forms [of Exquisite Corpses], one was writing and the other was drawing. I participated several times in the drawing kind, I'm sure, with Matta, and I think once with Matta and Lam; I remember being startled. . . . What you would do is fold over the paper in three parts and then it would be decided by chance or however that somebody would draw to the shoulders, and then somebody would draw to the groin, and then somebody to the legs; but it was always folded so that nobody could see the other two parts except the first person. Then the second person would just leave two lines where they had ended the body visible so that you didn't put the legs way over here, but otherwise you had no conception of what the [previous] person's thing was.

The other thing was to make automatic poetry. Baziotes and his wife and I and my wife and Pollock and Lee Krasner met twice in my place and made automatic poems; you are just sitting in a circle and each person would just say a sentence and I would write it down. The first ones were pretty much jabberwocky, and so then I suggested, which was not really a Surrealist idea, that we choose some very general subject. . . . As it happened, one of those two nights, it was pouring and I had a top floor apartment on Eighth Street facing MacDougal. It was a real thunderstorm, we were very aware, and it was pouring on the roof and ear shattering in a way, so one of the things I remember suggesting was rain. Everybody just said a sentence and then I put them in order and that was quite a beautiful poem.[50]

With Matta as their guide, Baziotes, Kamrowski, and

Figure 21
Max Ernst (French, b. Germany, 1891–1976), cover for *VVV* (New York), no. 1, June 1942. National Gallery of Art, Washington, D.C.

1942 NUMBER ONE

Pollock explored the realm of psychic automatism in painting. Their experiments resulted in a collaborative work (cat. 61), which Kamrowski later described:

> Baziotes [who] was enthusiastically talking about the new freedoms and techniques of painting and noticing the quart cans of lacquer asked if he could use some to show Pollock how the paint could be spun around. He asked for something to work on and a canvas that I had been pouring paint on and was not going well was handy. Bill then began to throw and drip the white paint on the canvas. He handed the palette knife that he was dripping to Jackson and Jackson, with his intense concentration, was flipping the paint with abandon. . . .
> Baziotes had obviously made his point. Jackson was puzzling the thing out and was more or less relaxed about it so we just stopped.[51]

In November 1940 Matta and Onslow-Ford announced plans for an American Surrealist magazine, which, however, never appeared. Thus it was left to Breton, who arrived from Marseilles via Lisbon in February 1941, to establish an exile publication. *VVV* was available to subscribers in June 1942 (fig. 21). David Hare, a young American sculptor and photographer, served as editor; Breton and Ernst, and later Duchamp, constituted the editorial board. The second issue of this striking publication included color reproductions of the *Jeu de Marseilles* tarot cards together with Breton's account of their creation.

Despite these literary activities and a broadcasting position with the French language section of the Voice of America, the Surrealist leader was despondent. As Ades has written:

> The months in Marseilles had been marked by an almost childlike cheerfulness compounded of defiance, scorn and hope; the communal games played there by the surrealists were still continued in New York, as Charles Duits, the young Harvard student who joined the surrealists noted in *André Breton a-t-il dit passe*, but their morale and that of Breton in particular had altered considerably. Wrenched for the first time out of his element, with Surrealism, which had always been in opposition to the society in which it lived, now left in a vacuum, Breton was faced with the need to assess the position of Surrealism and determine its current relevance."[52]

Able to work enthusiastically with other European-born colleagues such as Frederick Kiesler (cat. 39; fig. 22), Breton nonetheless steadfastly refused to learn English and was thus unable to transmit Surrealism's credo to the younger Americans.

Duchamp, by contrast, adapted readily to the city he had first visited in 1914. Four months after disembarking from the SS *Serpa Pinto*, he created a labyrinthine installation utilizing sixteen miles of string for *First Papers of Surrealism*, a major exhibition whose title was a direct reference to an immigrant's first citizenship papers (fig. 23). Sponsored by the Coordinating Council of French Relief Societies, the show included Ernst, Tanguy, Masson, Matta, and Onslow-Ford among the European contingent as well

Figure 22
Frederick Kiesler (American, b. Austria, 1896–1965), *André Breton*, 1945, pencil on paper. Lillian Kiesler, New York.

Figure 23
View of *First Papers of Surrealism* exhibition, Whitelaw Reid mansion, New York, October–November 1942, sponsored by the Coordinating Council of French Relief Societies. The twine webbing installation was designed by Marcel Duchamp.

as Americans including Hare, Motherwell, and Alexander Calder.

Five years later, Duchamp, together with the Italian-born painter Enrico Donati, produced *Please Touch*, one of the most provocative objects of Surrealism's American phase. Initially created in plaster (cat. 40), this model of a woman's breast was reproduced in foam rubber in an edition of 999 for the cover of *Le Surréalisme en 1947* (cat. 41).

Ernst, too, in the late 1940s, felt at home in the United States. With his new wife, Dorothea Tanning, he moved to Sedona, Arizona. There, one evening, for mutual amusement, Ernst, Tanning, and artist-collector William N. Copley constructed a charming *Toy Theater* (cat. 42).

By this time World War II had ended, and many exiles, among them Breton and Masson, made a return journey across the Atlantic to Europe. With their departure, and the immersion of the young American artists in the newly ascendant movement, Abstract Expressionism, the initial heroic phase of modern artistic collaboration came to a close.

Chance and calculation are the two poles of twentieth-century artistic collaboration. From the inception of World War I to the aftermath of World War II—the period discussed in this essay—unpremeditated collaborations predominated and, indeed, were intrinsic parts of two of the most important avant-garde movements. Both Dada, a nihilist anti-art response to moral and material chaos, which revered the laws of chance, and Surrealism, an interwar manifestation of universal malaise that exalted the role of the unconscious, had major impact because of their collaborative components. Significantly, Jean Arp and Max Ernst, the two pivotal collaborators of this epoch, each contributed to Dada and Surrealism independently, in artistic partnership with one another, and in collaboration with many other artists.

The immediate post–World War II period was transitional. The newly dominant American art, although it had been nurtured in collective isolation and had matured when Surrealism reached our shores, was emphatically individualistic. In Europe, however, both the Cobra group and the Nouveaux Réalistes had inherent collaborative elements. During this time, too, the first technologically oriented teams were being formed.

In the last twenty-five years, precisely calculated team collaboration has become a familiar phenomenon both in the art marketplace and in major museum exhibitions. Similarly, collaborative performance, a hallmark of early-twentieth-century Modernism, has re-emerged as a significant factor on the international art scene. In sum, the phrase "artistic collaboration," with its manifold connotations, has become a shibboleth of our time.

NOTES

1. RoseLee Goldberg, *Performance: Live Art 1909 to the Present* (New York: Abrams, 1979), p. 10.

2. Ernst-Gerhard Güse, *Die Gemälde von Franz Marc und August Macke im Westfälischen Landesmuseum Münster* (Münster: Westfälischen Landesmuseums für Kunst und Kulturgeschichte, 1982), p. 10 (translation by Regina Hablutzel).

3. Ibid., p. 8.

4. Ibid., p. 20.

5. Sherry A. Buckberrough, *Sonia Delaunay: A Retrospective* (Buffalo, N.Y.: Albright-Knox Art Gallery, 1980), p. 32.

6. Ibid., p. 34.

7. Jean Arp, *Arp on Arp: Poems, Essays, Memories* (New York: Viking, 1972), p. 232.

8. Cited in R. W. Last, *Hans Arp: The Poet of Dadaism* (London: Oswald Wolff, 1969), p. 28. The source is given as Ernst.

9. Richard Huelsenbeck, *Memoirs of a Dada Drummer*, trans. Joachim Neugroschel (New York: Viking, 1974), p. 19.

10. Hans Richter, *Dada: Art and Anti-Art*, trans. David Britt (New York: Abrams, 1978), p. 27.

11. Huelsenbeck, *Memoirs of a Dada Drummer*, p. 64.

12. Richter, *Dada*, p. 26.

13. Huelsenbeck, *Memoirs of a Dada Drummer*, p. 98.

14. Dawn Ades, *Dada and Surrealism Reviewed* (London: Arts Council of Great Britain, 1978), p. 67.

15. Arp, *Arp on Arp*, p. 272.

16. Huelsenbeck, *Memoirs of a Dada Drummer*, p. 98.

17. Richter, *Dada*, p. 101.

18. Quoted in Herta Wescher, *Collage*, trans. Robert E. Wolf (New York: Abrams, 1971), pp. 142–43.

19. Quoted in Richter, *Dada*, p. 117.

20. Letter from Mrs. John Heartfield, Berlin, German Democratic Republic, to Cynthia Jaffee McCabe, September 15, 1980 (translation by Regina Hablutzel).

21. Quoted in Wescher, *Collage*, p. 138.

22. Quoted in Diane Waldman, *Max Ernst: A Retrospective* (New York: Solomon R. Guggenheim Museum, 1975), p. 21.

23. Georges Hugnet, "The Dada Spirit in Painting," in Robert Motherwell, ed., *The Dada Painters and Poets: An Anthology* (New York: Wittenborn, 1967), p. 157.

24. Waldman, *Max Ernst*, p. 26.

25. Literally, "Dada Early Spring."

26. Camilla Gray, *The Great Experiment: Russian Art 1863–1922* (New York: Abrams, 1962), p. 196.

27. Konstantin Umanskii, *Neue Kunst in Russland 1914–1919* (Potsdam and Munich, 1920), p. 51; cited in Christina Lodder, *Russian Constructivism* (New Haven: Yale University Press, 1983), p. 235.

28. In Stephanie Barron and Maurice Tuchman, *The Avant-Garde in Russia, 1910–1930: New Perspectives* (Los Angeles: Los Angeles County Museum of Art, 1980), p. 13.

29. Alma Law, conversation with the author, April 1983. See Law, *The Stenberg Brothers Film Posters* (New York: Ex Libris, forthcoming).

30. Mildred Constantine and Alan Fern, *Revolutionary Soviet Film Posters* (Baltimore: Johns Hopkins University Press, 1974), pp. 8, 12.

31. In Margit Rowell and Angelica Zander Rudenstine, *Art of the Avant-Garde in Russia: Selections from the George Costakis Collection* (New York: Solomon R. Guggenheim Museum, 1981), p. 75.

32. Richter, *Dada*, p. 144.

33. Steven A. Mansbach, *Visions of Totality* (Ann Arbor, Mich.: UMI Research Press, 1979), p. 118.

34. Cited in William S. Rubin, *Dada, Surrealism, and Their Heritage* (New York: Museum of Modern Art, 1968), p. 64.

35. Ibid., p. 107.

36. Arturo Schwarz, *The Complete Works of Marcel Duchamp* (New York: Abrams, 1969), p. 144.

37. André Breton, "The Exquisite Corpse, Its Exaltation," in idem, *Surrealism and Painting*, trans. Simon Watson Taylor (New York: Harper and Row, 1972), pp. 288–90.

38. J. H. Matthews, *The Imagery of Surrealism* (Syracuse, N.Y.: Syracuse University Press, 1977), p. 143.

39. Ades, *Dada and Surrealism Reviewed*, pp. 259–60.

40. Statement by Marcel Jean, "The Rewards of Leisure," July 5, 1983, typescript, Hirshhorn Museum and Sculpture Garden Library.

41. Statement by Isamu Noguchi, "Regarding the Collaborative Drawing by Isamu Noguchi and Arshile Gorky," July 22, 1983, typescript, Hirshhorn Museum and Sculpture Garden Library.

42. Varian Fry, *Surrender on Demand* (New York: Random House, 1945), pp. 115–16. See also Cynthia Jaffee McCabe, " 'Wanted by the Gestapo, Saved by America': Varian Fry and the Emergency Rescue Committee," in Jarrell R. Jackman and Carla M. Borden, eds., *The Muses Flee Hitler: Cultural Transfer and Adaptation, 1930–1945* (Washington, D.C.: Smithsonian Institution Press, 1983), pp. 79–91.

43. Seriously altered by its owners, the Café was ultimately destroyed by the Nazis as an example of "degenerate art."

44. Quoted in Carolyn Lanchner, *Sophie Taeuber-Arp* (New York: Museum of Modern Art, 1981), p. 13.

45. Arp, *Arp on Arp*, p. 257.

46. Statement by Susi Magnelli, August 16, 1983 (translation by Howard Sugar), typescript, Hirshhorn Museum and Sculpture Garden Library.

47. Huelsenbeck, *Memoirs of a Dada Drummer*, p. 101.

48. Ibid., p. 80.

49. Statement by Gordon Onslow-Ford, "Notes on a Cadavre Exquis Made by Matta, Estéban Francès, and Gordon Onslow-Ford," August 2, 1983, typescript, Hirshhorn Museum and Sculpture Garden Library.

50. Robert Motherwell interviewed by Robert C. Hobbs and Cynthia Jaffee McCabe, Greenwich, Connecticut, March 1982.

51. Letter from Gerome Kamrowski to William S. Rubin, Museum of Modern Art, New York, April 10, 1975.

52. Ades, *Dada and Surrealism Reviewed*, pp. 376–77.

David Shapiro

Art as Collaboration
Toward a Theory of Pluralist Aesthetics
1950–1980

Collaboration may be said to be a mode analogous to collage. The best collaborations of the Dadaists and Surrealists, as well as of the members of the so-called New York school of poetry, emphasize the theme of abruptness, of textural changes, and of the sense of rupture and discontinuity. The Romantic irony of collage is its insistence on unity in multeity—a word invented by Coleridge for multiplicity—but collaborative modes trespass conventional senses of unity. Collaboration may be thought of in the aesthetician Walter Benjamin's (1892–1940) phrase as a defensive system against the shock of the modern city.[1] In systems theory, collaborative cultural modes are those of "open systems" with feedback mechanisms for correction and anticipation of the future. The idea of the coterie has been defended by a critic of the stature of Lionel Trilling, and while he was frightened of the counterculture of the 1960s as Modernism in the street, he was sensitive to the militancy of the epoch's avant-garde. Taking the defiant content of twentieth-century Modernism seriously, he was frightened by its anti-hierarchical and irrationalist demands. But the avant-garde does not necessarily mean the return of the primal impulses as horde, nor can the avant-garde, that is, adventurous novelty in culture, be suppressed by its announced death in neo-conservative circles. While assessing the role of individual and group in collaborative modes is as delicate as the problem of form and content and is constantly imbricated and ambiguous, there is no sign that transgressive collaborative modes will cease. We may even see in Christo's groups (fig. 24) the practice of collaboration for its own sake: the carnival of free association.

In the beginning was a collaboration or lack of collaboration. Each quotation or misquotation of the modern allusive spirit may be regarded as an act of collaboration. Recently, the theoretical work of Rosalind Krauss, Douglas Crimp, and Craig Owen has gone toward underlining an art that appropriates even complete works, and these critics have deplored eclectic quotation as loosened and inappropriately comfortable acts of collage. We see collaboration with all the tenses, past, present, and future, as an impure series of intransigent acts of unaccommodating collaboration. The "preventive aesthetician" attempts to enforce an artistic purity that is neither psychically nor socially realistic or healthy. The artists of our time have produced notorious matrices in which "purity" and "danger" have functioned as parts of an experience of the field. Criticism too is a collaborative act of negative capability.

We must establish a theory of collaboration to counteract some of the more extreme Romantic and modern versions of individual creation. Kenneth Koch, in his little-known issue of *Locus Solus*,[2] made a pioneering effort to bring together Oriental, Surrealist, and contemporary collaborative literature. Our work is a kind of analogue to this, but not merely to underline specimen works produced by collaboration, but to indicate the aesthetics that have led to the necessity of communality.

We will employ systems theory to underscore the dynamic processes involved. Style itself is a form of group dynamics, and the myth of the hero has vitiated too much art history, as a "history without names" has also obscured the real individuality involved in groups. Helen Durkin's

work in group communication,[3] along with that of Gregory Bateson and Jay Haley, will function as an analogue and a reminder that art in groups can be therapeutic in no minor sense.

The "agonistic" aesthetics of Harold Bloom will be scrutinized and rejected for a theory that is receptive to an erotics of influence. As Meyer Schapiro in his pedagogy and essays has constantly called criticism in art a communal collaborative endeavor, we will attempt to see generativity as dialogue rather than a game of conflict. We will differentiate different types of collaboration and suggest that it has functioned, though sometimes repressed, as a central mode of aesthetic production. The best of modern art in Picasso and Braque, Johns and Rauschenberg, will be seen to partake in a conscious way in the spirit of collaboration.

We may think of all of Modernism as crystallizing in great collaborative movements: Impressionism, Post-Impressionism, Cubism, Fauvism, Expressionism, Futurism, Orphism, Vorticism, Dada, Suprematism, Surrealism, Abstract Expressionism, Pop art, Minimalism, earthworks. It is a cliché to realize that these movements were communal and not the motions of a single mind in a kind of solitude. But I think it is well to recall that the greater myth of the hero sometimes deforms this communal sense, and we begin to have a van Gogh without Gauguin, a Cézanne who does not sign himself student of Pissarro, an Orphism without the marriage of Sonia and Robert Delaunay and collaborating poets, Dadaism without the pacifistic friendships involved throughout, Abstract Expressionism without the collaboration of Gorky and de Kooning,

earthworks without the fierce alliance of Serra, Holt, and Smithson. The myth of the hero promulgates a Robert Smithson or Jackson Pollock in the splendor of a private, interior, essentially bourgeois space that their works attempted to disrupt. Thus, a formalist critic such as Michael Fried can see the great works as essentially antitheatrical by avoiding the public issue of collaborative style as theater itself: game, conflict, ludic illumination. It is for this reason that Fried cannot contemplate an entire style such as de Stijl or Bauhaus, because his aesthetics lack the terms of system and collaboration. The connoisseurship of masterpieces by Clement Greenberg is another way of avoiding the multiple truth of system and collaboration. The masterpiece is an idealism masquerading as the analogue of perfection in palpability. The artists however speak of imperfections.

I know of no aesthetic that is dominated by the concept of collaboration, except the most recent experiments in the "reception" critiques of Hans Robert Jauss,[4] derived in part from Wilhelm Dilthey (1833–1911) and a suggestion or two of Walter Benjamin and the Frankfurt school. Where Plato had isolated forever the apprehension through the dialectic of the good and beautiful, and our own age has de-Platonized itself into the finding of the shattering of such a romance in immanence and nominalism, in finite desire and its absences, the critique of reception puts forth a notion of life's irritable genius as one of biological system and aggregation, of what the French philosophers Gilles Deleuze and Felix Guattari, working in collaboration, have called the rhizomatic, the anti-hierarchical conspiracies between systems of desire.[5] What does this imply, in common sense

terms, for the Anglo-Saxon raider raised on empirical notions? It implies that art is *not* dominantly sensuous self-reflexion, it is not primarily social weapon, it is *not* an opaque mirror, but it is a public mode of affiliation that is not adjustment. Art is not the making of fine objects, as the Bloomsbury critic Roger Fry or Clement Greenberg might lead us to suppose; and all their vaunted values disclose a limited connoisseurship that must forever be revised, and not simply in the light of a vicious relativism. Art is not reparation along the lines of the great British psychoanalyst of "object relations," Melanie Klein, or her disciple Adrian Stokes, nor is it struggle with the Father, nor is it purposeless purpose. Art is a dynamic and functions to produce autonomy and balance. No art is private, and each art is inflected by its sense of the addressee. Where the addressee has seemed to slip away, as in much twentieth-century lyric painting and poetry, the very absence of the receiver is the theme and this absence is of course not absolute. Franz Kafka and Robert Ryman receive their audience and only then is the aesthetic act consummated and continued.

Much of Meyer Schapiro's classic essay "Style" (1953)[6] is taken up with subtle and searching investigatory hypotheses concerning personality and group "personality" as regards stylistic change. He has always shown a remarkable tact toward the possibility of collective expressions, and yet he has tried to avoid too rigid and credulous schemes. The idea of the "great personality" is discussed as a partial explanatory mode and one particularly suited to certain periods and certain groups. But the sense of the "family" of great artists at particular times is also underlined. Schapiro alludes to the problem of explaining swift cultural change with current notions of group dynamics. We might say that a further underlining of art as collaborative and essentially part of such a group dynamic might aid in such an articulation, along with the increasing subtlety of group and systems psychology.

Too often, as with political theorists, libertarian goals are seen in opposition to egalitarian desires. The poet Henri Michaux, another producer of a "composite art" of poetry and calligraphy, has called Surrealism a great permission. The aesthetic activity of groups is one of a disciplined permission. Sonia Delaunay and Blaise Cendrars created a work dedicated to the myth of the train and the Eiffel Tower (cat. 1), and their collaboration also reinvents the mode of medieval illumination and its work of many hands. Ananda Coomaraswamy has deposed Western aesthetics for its reliance on the ego and spoke of a return to an ideal egoless craftsmanship. Surely, Jean Arp and Sophie Taeuber-Arp commence in their peaceful collages (cat. 57) work that announces random shapes as allegories of co-existence. Here, man does not try to master nature or be in the center of it, but lets the biomorphic be its own subject. On the other hand, George Grosz and John Heartfield (cat. 7–9) thought of collaboration as resistance, and their use of photomontage, here as elsewhere in individual work, is against the menace of the Nazi degradation of the idea of association to the horde mesmerized by the Leader. With the Dadaists and Surrealists, it is important to note how difficult it was for anyone to assert himself as leader. Tristan Tzara and André Breton attempted this role in various ways and with partial and comedic lack of success and a variety

of excommunications. Marcel Duchamp's decision to test the Société Anonyme with his difficult *Fountain* yields a sense of how unhappy he was with any hierarchical group. Duchamp left the Société when they repressed his sculpture, but we see how pressed Duchamp was toward collaboration in games such as chess (fig. 25) and games whose rules defied or upset all rules.

Our time has presented us with some of the greatest specters of involuntary collectivism. Stalinism and Fascism have produced monstrosities of the kind of entranced group and its murderous xenophobia that both Freud and Reich investigated. Part of the darker task of any aesthetic of collaboration is to underline modes in which the collective derives none of its power from the individual but tends toward the dessication of the individual. In Michel Foucault's promises of a "disappearance" of the subject, we hear an unfortunate echo of the collectivist ideologies of our century.[7] The elective affinities of which an aesthetic of collaboration speaks reaches its limit in the negative of the blind group. Elias Canetti speaks in his work *Crowds and Power*[8] of the terrible moment of stampede in which individuals see each other in panic as the very fire they are fleeing. The danger of groups has always been perceived by political theoreticians as this mobilized horde and its antilibertarian corollary. Voluntary collaboration constantly checks its health by the increasing autonomy and equality of its members. The horde witnesses a loss of ego power. The collaboration in health between artists increases tolerance and flexibility.

It might be thought that Stalinism would give rise to an unfettered individualism as its antidote, but it is clear that the Cubo-Futurists who suffered most under Stalin and his caricature of a realist standard were still alive to the notion of the collaborative as resistance. Boris Pasternak, that most musical of Cubo-Futurists, constantly announced in his autobiography *Safe Conduct* (1931) his sense of his life as a collaboration with Vladimir Mayakovsky in another key. *Doctor Zhivago* (1956), his enormous novel of reparation and guilt, underscores again and again his theme of interdependence. At one moment in the novel, the Doctor says that there is no such thing as death for an individual exactly because we are multiple individuals constantly changing in our various roles. Pasternak announces a kind of resurrection or eternity through such multiplicity. It is not for nothing that he concludes *Safe Conduct* with the suicide of Mayakovsky. Emile Durkheim has a dismal phrase in his classic work *Suicide* (1897) that self-destruction is the voluntary decision to leave the group. There is no doubt that Pasternak saw his own endurance and survival in the face of persecution as part of a collaborative debt to those who could not speak. His *Doctor Zhivago* is purposely cast in realistic tones to suggest that he is collaborating with public norms of morality and dignity. However, even this so-called realistic novel is unified by lyric imagery of snow and tree and reminds one of the Constructivists in the way that it reduces the Tolstoyan realistic novel to an allegory of repetition and difference. (This is one of the reasons it fails to satisfy an audience looking for a more nearly Tolstoyan matter.) Note that John Ashbery, Fairfield Porter, Kenneth Koch, and Frank O'Hara were devoted to the reading of

Safe Conduct and learned from Pasternak and Russian artists the resistance to false collectivity found in an ideology of friendship or "personism."

We would like to make an aesthetic out of the psychological ramifications of Durkin's examination of "the group."[9] We begin with Freud's sense of the person as no longer master of his own house: that central humiliation. We proceed, with insights from the psychoanalysts of the ego, Heinz Hartmann and Ernst Kris,[10] to a sense of the person as constantly adapting his narcissism inside a world. The world as group is yet another way of adapting the insights of the Existentialists to the dynamics of a theory of systems. The Swiss existential analyst Ludwig Binswanger has divided the analysis of being into the world of things (*Umwelt*), with the world of relations (*Mitwelt*), with the world of self-relations (*Eigenwelt*).[11] We may say that the exaggeration in the art of our time has been to predispose an aesthetic to any of these things, and that a false serenity is the result of an undue leaning to a balance among them (here Paul de Man has criticized Binswanger for a too therapeutic approach to art[12]). Durkin has underlined the group as a means toward freedom. We see collaborative modes in art as a mature modality for insisting on those qualities harped upon by Meyer Schapiro in his analysis of the Armory Show and much Modernism. Art is not necessarily, in Jurgen Ruesch's sense, therapeutic communication, but it is always collaborative and signifying.[13] If we are condemned to meaning, in Maurice Merleau-Ponty's classic phrase, we are condemned to public meanings, to groups, systems, and to fields of dynamic desire. Harry Stack Sullivan's interpersonal theory here yields to a kind of interpersonal aesthetics.[14] It is no wonder that O'Hara called his collaborative poetics a personism, though a parodistic one. It seemed a parody, because collaboration does so much to call into question the Romantic notion of the isolated individual.

Collaboration may be thought of as the undoing of the negations of the self that Gregory Bateson made so much of in his work on the system of schizophrenic families.[15] Bateson described a mutual double bind whereby family members misinterpreted and penalized each other in a constant round of "misreadings." As a matter of fact, such double binds do begin to resemble the idea of an *agon* in aesthetic tradition limned by Harold Bloom. However, we may say that collaboration is exactly the reverse of this process.

The schizophrenic is noted by Bateson to delete the first person and the addressee from his speech, as if afraid of being punished by his awareness of context. Collaboration or the undoing of social and psychic double binds makes us exactly aware of the process itself and context; and the context is relatedness. Claes Oldenburg established this in a funny set of antinomies in which he contrasts the isolated artist, paranoid in his studio, with the tolerance and flexibility demanded in truly collaborative settings. Friedrich Hölderlin's late mad poems betray schizophrenic rigidity by the absence of the addresser or the addressee; his search for purity had become an involuntary and fearful rigidity. Gilbert and George (cat. 103–105) have explored ways in which usually penalized forms of eroticism might become

playful and acceptable, sensuous, serious, and intelligible. John Cage and Merce Cunningham have attempted to undo the role of illustration in dance; such "illustration" is usually nothing more than mawkish trivialization, a form of invalidation. Nonillustrative music during dance permits the dance to breathe without being penalized by the heavy-handed "authority" of the musical reply.

One of the basic texts in considering a theory of collaboration is the issue of *Locus Solus* that emerged in 1961 under the joint editorial direction of John Ashbery, Kenneth Koch, Harry Mathews, and James Schuyler. Each one of the editors was a poet, playwright and/or fiction writer with particular links to the world of art, and each one had done some art criticism. The issue, with translations of Chinese poetry, Japanese linked verse, Provençal collaborations, metaphysical poetry, Futurist and Surrealist contributions, Burroughs's cut-ups, and some contemporary conspiracies, is a not-too-veiled manifesto for a new pragmatic, kinetic, pluralist aesthetic.

The Lautréamont quotation used as as epigraph in the *Locus Solus* issue was one especially chosen by Koch to indicate his rupture with the idea of individualism and individual angst, made so much of by an expressionist critic such as Harold Rosenberg during the years of "action painting": "La poésie doit être faite par tous. Non par un. Pauvre Hugo! Pauvre Racine! Pauvre Coppée! Pauvre Corneille! Pauvre Boileau! Pauvre Scarron! Tics, tics et tics."[16] The art of the future is seen as a utopia of communality, of group dynamics, and of systems. The Romantics are isolated, as in their own mannered laments and apostrophes, as false heroes of a meager isolation. The

issue initiates the theme that collage is already a form of collaboration with a piece entitled "To a Waterfowl"[17] in which each line is taken from disparate masters of the tradition: Donne, Milton, Tennyson, Shelley, Keats, Stevens, Pound, etc. And this multiple collage is unsigned.

While Koch has suggested, in conversation, that Ashbery is the author of this collage, it is in its anonymity that the poem is most suggestive, reminding one of the sense that "The Waste Land," a species of collaboration between Pound and Eliot, had established the idea of fractured vistas and multiple voices as a way of playing with the tradition. In "To a Waterfowl," unlike "The Waste Land," the tradition is not seen as a golden height to which the present is a sordid aftertaste. The revolutionary tone of the poem and indeed the whole issue of *Locus Solus* was one that was a premonition of Pop art and its anticanonic use of the popular. Collaboration is a way of mocking the kind of interiority that the Romantic lines point toward. A surface is created in which the idea of psychological "depth" is mocked and a theme of system takes over: "She dwells with Beauty—Beauty that must die,/Or the car rattling o'er the stony street."[18] Keatsian solicitude for melancholy is interrupted by a passage of mere event. The result is a ludic collaboration, a deflation of tones reminiscent of Cubist collage as in Max Jacob and Picasso.

If Pop art's demolition of the idea of psychological depth has had little severe criticism in our time, little placement for a truer understanding, Koch's issue must be regarded as a form of criticism. Oriental collaboration is presented as an analogue to the hedonism of the New York poets and painters, for example, Sei Shonagon and the Empress

Sadako's "Poem about Saisho": "More than the cuckoo's song that she went out to hear/The memory of a salad lingers in her head."[19] Like Pound before him but for different reasons, Koch turned to the Orient to find, not images of rarity, historical personages, political themes, but examples of a colloquial, low, humiliated diction coming from the annihilation of false ideas of boundaries or genres. In Basho, Bonsho, Fumikuni, and Kyorai's linked verse, one finds an aesthetics of the nondescript, where trousers drenched in the stream are as significant as the evening moon. The thing-ness of these poems relates to the kind of Minimalism that was to emerge in American poetry and art in this period. As a matter of fact, Robert Lax's extremely truncated poems of single, reiterated, trancelike iterations were first published in another issue of *Locus Solus*.[20] These poems look forward to the collaborative so-called wallpaper music of the collaborative groups in Philip Glass and Steve Reich, both composers influenced by Oriental modes that depend on the preference for an objective presentation of music as thing rather than effusion of the individual psyche.

It was important to show that the Romantic tendency toward the hypostatization of the individual was one cultural and historical mode. Just as M. M. Bakhtin reminded the Russian Cubo-Futurists of the dialogical character of Dostoevsky's best prose and the carnival sense in Rabelais,[21] so the élan of Koch was to point editorially toward the materialistic tradition of a communal aesthetics. Provençal poetry was one example where the competitive sense of artists singing with and against each other could be underlined. Collaboration in Koch's sense does not delete the notion of conflict or rivalry but makes it part of

the width of the experience of the communal. Collaboration is seen in Abraham Cowley and Richard Crashaw as a question and answer, a plastic dialogue concealed in the forms of the Metaphysical lyric.[22]

Koch included passages from the prose of André Breton and Paul Eluard, and I think that it is most significant to recall that Surrealism has its profound impact upon contemporary art and poetry through the School of New York aesthetic and its infiltrations. Robert Motherwell, in his anthology of the Dadaists,[23] did not sufficiently underline this kind of communal work, though his anthology was instrumental in beginning a capacious view of the defiant group activities of the Dadaists. Placing the Surrealist collaborations in a context of Chinese, Japanese, Provençal, Renaissance, and Romantic collaborations was in itself a Surrealist act of intransigence and strangeness. The work of Breton is not seen as a moment of idiosyncratic revolt, but as part of a wide antitradition. The delirium of the Surrealists, to use their own preferred term, is adapted and made to seem everyday. This is not to say that it is made less explosive or subversive; by radical connection (a connectivity that Breton loved to praise and underline in his lists of Surrealists, *avant la lettre*), Surrealist collaboration is made to seem a necessary and normal activity where Dadaist anthologies before made them seem like adolescents in a bizarre commune that could not survive.

Ashbery has said of his work (and this might stand for much Pop art and collaborative contemporary work) that it takes the idea of the marvelous in Surrealism and makes it a norm. Of course, it is in the best of the Surrealists

themselves that this pantheism, this antinomian defiance is felt. And if the marvelous is to be found everywhere, it should be a shareable, public language rather than a solipsistic burden.

When we reread the Surrealist documents, it is important to see the connection between them, scriptural injunctions, the profanations of the Marquis de Sade, and our own generation's use of the graffiti statement as political admonition. "What you find belongs to you only as long as you hold out your hand"[24] is a pithy comment on property and its hallucinatory mode. "Lie as you bite the judge's ermine"[25] links up with the whole tradition of Daumier, caricature, and Rimbaudien defiance. Much of Surrealism was a reversal of the platitudes of ecclesiastical authority concerning obedience: "Correct your parents. . . . Seal the real love letters you write with a profaned host."[26] The Surrealist proverbs of Paul Eluard and Benjamin Péret are significant collages, little essays on the relation of wit and the unconscious: "Elephants are contagious./Rinse the tree. . . . /Beat your mother while she is young. . . . /A dream without stars is a dream forgotten."[27] It is not that the "I" is tabooed, because then it might be said to be everywhere but merely suppressed. The elaborate effort of the Surrealist, like that of Rimbaud, who collaborated on some of his most fabulous sonnets with Verlaine ("Les Stupra" or "The Pollutions by Lust") was to seek an aesthetic of the field, of polarizing zones, refuting the monological manias of the Romantics. One of the most successful presentations, therefore, was the explicit game of question and answer, precursor of John Cage and random surprise,

in which Breton and Yves Tanguy took part: "B: What is painting?/T: A little white puff of smoke./B: What is Brittany?/T: A fruit eaten by wasps."[28] Art is seen here as having its natural condition in the playful dialectic, and, as in the Exquisite Corpses (cadavres exquis), no mere congruence is required. What is acceptable is the rupture, the slip, the fracture, something underlined fifty years later by Deleuze and Guattari in Anti-Oedipus.[29] Their "desiring machines" are analogues of surrealist collaborative games.

The Exquisite Corpses presented in the Locus Solus issue by Koch announce the utopian theme of orgiastic, antinomian bliss, that bliss that interrupts bourgeois rotundities and mere pleasures: "The exquisite cadaver shall drink the new wine./Sex without end goes to bed with the orthodox tongue./Mouffetard Street, trembling with love, amuses the chimaera who is firing at us."[30] The theme is one of resurrection in scenes that Walter Benjamin would call profane illumination. The enigma who might assassinate the group is the parental authority and its revenges. There is a species of price to pay for cultural de-sublimation, as Freud had warned. One is the slide into too easy clichés of the unconscious, and the other is the utopian streak made into the dogmatic by a new pope: Breton, for instance. Whether collaborative antidogmatics could be sterilized or made hygienic in a new canon is part of the pathos of both Surrealism and New York school poetry and art.

It is notable that Koch's collaboration issue contains cut-ups of Rimbaud by Burroughs and Gregory Corso. Rimbaud already announces in his Illuminations that he has seen and

Figure 26
Frank O'Hara (seated) and Larry Rivers in Rivers's New York studio
engraving plate 12 of *Stones*, 1958.

done enough with the otherness of the "I." Here even the apocalyptic Rimbaud is reduced to something more everyday and idly abrupt. Ashbery and Koch harped on the theme that rules were part of collaborative pleasure, and in certain obsessive collaborations they created hilarious rules in which each line contained a button or a flavor or a color. These poems are the truest analogues and even critiques of Red Grooms and Oldenburg: "The root beer went floating by./You could see the coke on the dazzling mountaintops of Trieste./Anna lay pinned to the roadbed by a milk truck marked 'Chillicothe'—/How recently she'd been dancing to the strains of 'Pittsburgh Lemonade'!"[31]

Koch emphasizes, in his essay in *Locus Solus*, the sense that collaboration is part of the practice of "free association," a way of inspiration, of entering Baudelaire's *inconnu* or Rimbaud's visionary new.[32] He admits that Chinese collaboration, while "polite, civilized" lacked the significance of Surrealist ventures but emphasizes Japanese linked verse as a major mode. The practical advantages of dramatic collaboration are underlined, but Koch could also have averred that drama is always already an activity of the group, and that the architectural masque of Ben Jonson and Inigo Jones had truly underlined a dialectic of body and soul in music and poetry and architecture. Koch dichotomizes between the reasonable questions and answers of the Baroque poets and the irrational dialectics of the Surrealists. Romantic collaboration is deposed as being, not too paradoxically, too much of a devotion to unity. Koch and the collaborators of the years between 1950 and 1980 emphasized, like the dynamic group theorists of the time,

the autonomy of the individual within the field. The Romantics could not collaborate well because they felt it would necessitate a demolition of autarchy and autonomy. In the best collaborations, O'Hara and Larry Rivers (fig. 26 and cat. 78), Jasper Johns and O'Hara, Frank Gehry and Richard Serra, for example, the individuals maintain their own peculiar flavors and resonances but struck by the new alliance into odd forms that could never have been discovered by any of the "players" singly. It is significant, moreover, that Koch regards the revising of an already existing text as collaboration. The Duchampian gesture of mustaching the *Mona Lisa* is the profane precursor, but the sense that revision is collaboration has enormous theoretical implications.

One of the primary lessons of the recent Post-Structural debates has been the decentering of the issue of "creator." In Michel Foucault's seminal essay, "What Is an Author," the question is vexed, until one senses that Foucault vehemently derides the "privileged moment of *individualization*"[33] in favor of an approach that locates discourse and aesthetics more pragmatically. Foucault senses that the idea of the single subject is a form of exclusion, of limiting a work to an expressive or ejaculatory mode. Instead of the canonic questions that are usually asked of a work of art's authenticity and originality, he suggests the following suggestive modes of interrogation:

What are the modes of existence of this discourse? Where has it been used, how can it circulate, and who can appropriate it for himself? What are the places in it

where there is room for possible subjects? Who can assume these various subject functions? And behind all these questions, we would hardly hear anything but the stirring of an indifference: "What difference does it make who is speaking?"[34]

Foucault's indifference to originality or authenticity is a troubling matter. The recent meditation by Jacques Derrida on Meyer Schapiro's work shows the kind of radical scepticism and its vagaries that this kind of critique can engender.[35] Schapiro holds to a luminous and referential reading of a particular van Gogh and deposes Heidegger's meditation as loose, wrongheaded, and imprecise. Derrida attempts to make van Gogh into an enigma and his paintings of shoes into a nonreferential problematic. Here, the disappearance of the producer has perhaps been too fashionably unsettled, and tactless misreadings have replaced the "collaborative" act of critique.

Certain genres of art are already canonically placed under the sign of "a working friendship," the title of the correspondence between Richard Strauss and Hugo von Hofmannsthal. Opera, film, and architecture, for example, generate an aesthetic that is properly multiple, discontinuous, collaborative, oriented more to the idea of a system of group dynamics than to the expression of the individual. It is significant to see how the *auteur* theory of film is one of the modes by which an essentially problematic product of film industry can be made to situate itself more or less within the lyric mode of romantic expressivity. Luis Buñuel, Carl Dreyer, Yasujiro Ozu, and Ingmar Bergman replace as names a history of

collaboration, compromise, filiation, and flux. Buñuel and Dali's film, *L'Age d'Or* (fig. 27), is one instance where the collaboration produces a work of art perhaps richer and stranger than either of the individuals could have produced singly at the early moment in their career.

Roman Jakobson has spoken of art as a constant underlining of a palpable message rather than the dominance of an addresser and addressee, but he writes in a classic essay on poetics that there is no aesthetic communication without an addresser.[36] Witness, however, that the addresser may be multiple, unknown, or anonymous, and also that the essence of this communicative schema is the collaboration between reader or viewer or receiver and the emitters of the message. In architecture's art of dwelling, we have a privileged mode in which the plural sense of producer and dwellers must be palpable unless the mythos of master-builder and "single client" overrides. Architecture is a collaborative opera, and its pragmatics are the dominance of reception.

One of our strongest misreaders today is Harold Bloom, who has suggested that every poet fights a kind of war to become a strong poet in the face of the belatedness of his arrival on the scene of generativity. He suggests ratios of domination between artists, and also that artists be understood in the oedipal anxiety of their wresting for strength: "The poet as poet is taken over by a power with which he has chosen to wrestle. It is not essentially a matter of passivity. . . . It reaches beyond the ordinary understanding of oedipal identification to those primary internalizations which are and yet cannot be."[37] His primary metaphor is that of an *agon* and a contest of spirits in

consuming and transforming the precursor.

We choose to see an erotics of influence, a joy of influence, a harmony, and an integrating play of influence. The belatedness of Bloom may be seen as a melancholy or elegiac problematic, or it can be seen as part of the scene of wonder on which the artists arrive upon the "givens" of the world. The artist in the wise passiveness attributed to him by Wordsworth and the negative capability ascribed to him by Keats remains inside the uncertain given lateness of his collaborative mode with world and language not self-made but public and plural. The task of collaboration is one of communal and often carnivalesque magnanimity through form. Bloom has substituted a history of heroes for a history of generous public systems of reparation, compensation, and endowment.

There is no doubt that some collaboration between strong master and disciple can lead to pathos, problematic identification, and dessication. Robert Liebert, in his recent and suggestive psychoanalytic study of Michelangelo and his images,[38] contributes pages filled with the pathos of Michelangelo's relations to younger men and apprentices. And he is most suggestive when he underlines the fact that in Michelangelo's epoch all collaborated consciously or unconsciously with the master; none could escape this horizon. At any rate, Michelangelo seems to have used Sebastiano del Piombo as his "deputy" in a fight against Raphael. Liebert presents the horrors of the dependency of Sebastiano on Michelangelo. Liebert's sense of the weakness of this collaboration, however, is one that aids a positive sense of the mode, because he underlines that Sebastiano came as an infant without strong boundary-feelings to this master. These are works, moreover, not of a collaborative kind but of a father-son variety that is closer to the sad truth that Harold Bloom has been forcing on all aesthetics. Here the weakened belated artist is wrestling with the grandfather figure and loses in an *agon* of his aesthetic soul. As Liebert indicates in summarizing Michelangelo's rapports with other artists: "Michelangelo's relationships with some of the artists he encountered at various points in his career seem to indicate that he required continuous affirmation of both his artistic and his personal worth. . . . The fruits of these collaborations therefore contain some elements that were not within Michelangelo's own painting vocabulary. In the process, however, the collaborators were diminished as independent beings."[39] Liebert concludes that the early family history of Michelangelo excluded him from true collaboration and condemned him to the circle of envy and threat. The agonistic was a deformation, indeed.

Much of Quentin Anderson's magisterial study of "the imperial self" in American culture is taken up with those writers, like Walt Whitman and the recent Allen Ginsberg, who seem to deny the limits of a self in its relations with differentiated others. Anderson writes of our notoriously pantheistic bard: "The existence of other persons is only marginally and thinly established in Whitman's works, and the terms in which all but a very few appear are genteelly or sentimentally conventional."[40] Trilling was to lament the absence in American fiction of social thickness, of manners richly surveyed with a sense of the obdurate weight of the "conditioned self." We may say that the act of collaboration was the act most centrally refused by these imperial selves,

these undifferentiated consciousnesses. A possible reply of the antinomian, nevertheless, is that the catalogs of Whitman are exactly collaborative identifications without limit. The limitlessness, however, and its mechanical sense of rapport is the problem, however, for commentators as varied as D. H. Lawrence and Anderson. Whitman never suffers the limitation or the pathos of relation, except in some of his more masochistic love letters. We may say that he is a useful example for us in remembering that collaboration is not mystical identification. Collaboration is a finite marriage with materialistic and investigatory bias. The social and conditioned self collaborates in filiations and responsible subordinations and defiances; the imperial self sends out a message to itself that never ceases sending without listening. Collaboration would then be a form of listening. The thought of Whitman collaborating is a useful absurdity. The thought of Rauschenberg condemned to isolation is another provocative absurdity.

Instead of Harold Bloom's aesthetics of misprision, creative misunderstandings and swerves away from precursors and wrestling for strength, we accept Meyer Schapiro's view of seeing as critical, communal, imperfect, a series of hypotheses that is open to the future. It is not that there is no truth, but there is no final truth. The critic and artist do not swerve away from the past, but collaborate with the past, and thus is tradition both a moral and aesthetic rejuvenation. Tact rather than misprision is the possible creative act par excellence, and empathy rather than wrestling makes Benjamin's sense of commentary a stronger mode than the transumptions of Bloom.

The melancholy Freudian struggle that Bloom enacts is not the truth of the communal build-up of styles. Chartres was not created by swerve, misprision, and solipsistic *askesis*. The work of Johns has been seen pejoratively as a mere marriage of Rauschenberg, Duchamp, and de Kooning, but perhaps great art is exactly a collaborative synthesis. It is this that T. S. Eliot wanted to underline in his "Tradition and the Individual Talent" in its praising both of novelty and adventure and of filiation.[41] We cannot serve the tradition by erasing it, as Rauschenberg discovered in his struggle with de Kooning (fig. 28). The de Kooning that continued to linger in the collages of Rauschenberg fecundates his work more than the erasure and its intransigence. Johns's homages to Duchamp are part of his strength, not of his weakness.

Some of our strongest young practitioners have made collaboration the sign of their refutation of the modern ego once called so tinny and percussive by Jacques Barzun. Ron Padgett has collaborated with Jim Dine, and they have traded their relative positions as poet and draftsman in a series of lithographs (fig. 29). Padgett learned from Roy Lichtenstein how to fill in comic strips, but made an even more deadpan series of cartoons based on Nancy and Sluggo cartoons. With Ted Berrigan he published both a magazine biased toward collaboration, *C Magazine* of the 1960s, and also an entire volume entitled *Bean Spasms*, in which the authors presented both individual and collaborative works without identification. Padgett's extreme comedic sense of collaboration is seen also in his defacement of certain older poems. In a Stephen Crane poem, "A Man Saw a Ball of Gold," he changes one word and thus transforms by the most minimal means a didactic

Figure 29
Jim Dine (American, b. 1935) with Ron Padgett (American, b. 1942), *Peoria*, 1970, from *Ooo La La*, portfolio of fifteen lithographs. Courtesy Petersburg Press, London.

lesson on desire and impossibility into a seamless web of affirmation. Padgett's appropriations precede by a decade or two those of Sherrie Levine and raise the specter of originality and authenticity, but with a more certain touch and parodistic depth. Much of what is called Post-Modern in the criticism of Rosalind Krauss, Douglas Crimp, and Craig Owen could already be found in the photomontages of the New York school of poets and painters twenty years before the Metro Gallery's "picture" painters or the photographers Cindy Sherman and Sherrie Levine. The devastating parody of originality in *C Magazine*'s rehearsals of Surrealist exercises in communality demonstrates that the "Post-Modern" is a difficult snark to locate in time. At any rate, perhaps the sense of collaboration is a more disruptive one than that of appropriation. Collaboration is one of the surest means to expropriate the myth of origin and authenticity.

In our own day, the young graffiti artists function as an indication of the dynamics of a group in an eruptive aesthetics. The young graffiti artists seem to be the most archaistic in their setting down of "tags" or their own names, but have actually been inspired to invent a "situationist" escapade in which conspiratorial techniques are as expressive as personal identification. Keith Haring, a young art student in the 1970s at the School of Visual Arts in New York, was inspired by this activity to insert himself and his drawings in public space, and he has been the most recent example of a marriage of high and low art, since he was informed by the Cobra group and by all the Modernism of Dubuffet long before he was misread as a graffiti artist. Recently, at Wave Hill in its summer sculpture projects,

Haring showed a plastic representation of a Venus of Botticelli thoroughly covered with his marks and that of the collaborator in this case, "LA2" or "Little Angel Two" (fig. 30). He writes of this collaboration:

> The contrast between our lines was exciting. There is something uniquely satisfying to me in the fusion between our two styles of drawing. It is a delicate balance between the archaic and the extremely modern, classical and psychedelic at the same time. We pursued our collaborations on vases, pillars, paintings and found objects. "Street tags" were finally placed in a context where people were forced to see them as art.[42]

Whereas the collaborations of Johns and O'Hara or of Johns and Samuel Beckett were liaisons of the utmost delicacy, privileging the poignant privacy of the creators, the young artists revel in a profane exteriorization. Here collaboration is a political act, if playful with the implications that only city-scale can compete with this *horror vacui*. Carnival as collaboration is reborn in these neo-primitive experiments.

A theory of collaboration is a kind of modest theodicy in which stylistic arrogance is that which arrogates to itself the position of creator-out-of-nothing. The theory establishes the collaboration of all tenses, as Proust found a confusion of tenses in the convoluted experience of love and jealousy. The painters of our time have rediscovered in Pound's admonition to "make it new" an ancient quotation and mistranslation. The sense of collaboration is one of a systematic appropriation and denigration of originality and isolation. We think of Franz Kafka, for example, not entirely

in his solitude but in his reading for friends, in his relation to Max Brod, in his most systematic letters to Felice, Milena, and his sister, in his systematic dread of the father, in his rediscovery of a potent Jewish tradition, in his genial nights at the Yiddish theater, of his dry and expressionist drawings that are his own attempts to multiply himself. Collaboration is a sign of our sense of the rhizomatic and decentered, to place it within the terms that Gilles Deleuze reserves for a polemic against hierarchies. The poet and designer Edwin Schlossberg has said that he prefers the word "conspiracy" to "collaboration,"[43] and one thinks of the artists of our time as awakening to a consciousness of system and group dynamics as a form of the almost criminal intelligence that Freud said was required of genius. Freud was not only the author of the text on the idea of the group, but the man who best understood a need for filiation and legislating camaraderie, as in his constant creation of the church of psychoanalysis with its discipleships. If the translator Arthur Waley was correct that the subject of Chinese art and poetry is friendship, we are witness to a return to such a suggestive theme.

We may now understand Rauschenberg, Cage, and Cunningham as a supremely generative nexus in our epoch. Cage uses Zen Buddhism to offset his lack of psychoanalysis and is led to the sense of egoless collaboration. Rauschenberg and Cunningham both choreograph events with a new metonymic displacement: Cunningham on stage, Rauschenberg on stage and on canvas and in objects. Rauschenberg is willing to embrace technology affirmatively and collaborate with engineers in

participational schemata. Cage affirms the idea of group system in his collaborations with such violinists as Paul Zukovsky and in his writings underlining Thoreau, Gandhi, and Buckminster Fuller. All three of them avoid the individual sensualism of the Expressionists; all three are close to a global bias in their work despite all discontinuity. All three embrace the arts of probability but without a deletion of discipline and devotion. As a matter of fact, Cage thinks of his career as commencing with his decision to abandon architecture and devote himself to music, but he has antidogmatically worked in all genres, and is a species of comedian of the antigeneric and collaborative. These three revive, without its melodramatic terms of superstitious clairvoyance, the tradition of Surrealist collaboration. They show the relation of wit to consciousness rather than the rare and marvelous. They function as a denial that the best art must be absorptive, in Fried's terms, antitheatrical if painterly, or one of objecthood and self-reflexivity. In them, *aboutness* is cast in doubt, indeed, and Cézanne's doubt is reinstigated as a social, public, performative mode. Thus, the doubt can be understood as that of the self conducting its adventures in finitude, growth, and pleasure.

It is important to note that collaborative modes do not exclude the poignancies of privacy. Two of the creators most associated with the exquisite theme of the marginal self are Johns and Samuel Beckett, and together they produced the extraordinary book *Foirades*, or *Fizzles*. The two men created an intricate network of symbolic correspondences, and Johns's body parts took on an

added sense of the mutilations spoken of by Beckett's hypochondrical narrators. Johns and Beckett did not change themselves or their work in a suppressing or repressing function that Freud attributes to herd behavior, but their collaboration illuminates and informs and deflects both oeuvres. One does not have to think of Rilke's pious sentiment of love as two solitudes touching to regard these two artists as end-game collaborators. Their work is, in a sense, an elegy to collaboration or an homage to the old symbolist idea that the universe is a forest of correspondences. Johns found his most private possessions in the group's givens of flag, target, and numeral. Beckett's sense of privacy multiplied itself in *Waiting for Godot* into the perseverations of two companiate clowns. Johns and Beckett offer us a consoling sense of the zero-degree theatricality that still produces a full sense of relatedness.

It is *not* in "Post-Modernism" where the attack on origins and the individual begins. Jorge Luis Borges is already a master of the attack on authenticity and its clichés and decides, he once averred, against random schemata because they promote vanity. He collaborates with many authors and speaks highly of this mode of mingling and inventing fictive authors. Gertrude Stein is another who proceeds from psychological narrative to a poetic of discontinuity and pluralism. A true student of William James, her works are collaborations with voices like Alice B. Toklas and collaborators among the French poets. Her work is an analogue of the Surrealism she professed to disdain. Pound may be cited by Krauss for his "Make it

new," but the apothegm is known by Pound to be a quotation and a translation as well as a mistranslation and a utopian scheme. Pound spent his life amid the persona. And this is as true of Picasso as of Pound. While some have claimed the Post-Modern as the terrain that attacks individuality, we may think of Stravinsky's collaborations, like those of Balanchine and Picasso, as notorious parodies of individual psychology. Picasso and Braque function as the supreme lesson of modern collaboration, that the best work shall proceed when the idea of the psyche is nearly extinguished. Vito Acconci's most recent participational works (fig. 31) are extensions of this norm of the collaborative, what Ashbery has called in reference to Jean Hélion and Francis Ponge a "religion of the outsides" of things. The renunciation of Kierkegaardian interiority is in order. It is important that Kierkegaard based his life on the renunciation of collaboration and marriage. Aesthetic equilibrium, however, is found in modern realism exactly in "the marriage of reason and squalor" (as in the title of a Frank Stella painting).

It is perhaps in collaboration that the art of our time receives its persuasions against what Adorno has called "the authoritarian personality."[44] If Meyer Schapiro is correct, and he is, that the central theme of modern art is defiance and libertarian zeal, then the mode of collaboration is the conspiratorial form par excellence for a tolerant and flexible art. Frank O'Hara, at once curator of modern art and subversive poet, practised fetishistically the act of collaboration, in lithographs with Rivers (see fig. 26 and cat. 78), in inspired improvisations with Michael Goldberg, in

Figure 31
Vito Acconci (American, b. 1940), *Fan City*, 1981, mixed media
installation at the Hirshhorn Museum and Sculpture Garden,
Washington, D.C.

poetry, and in movies and in theater. For him, the
collaboration mirrored the mosaic of the city. Baudelaire's
essential pathos and masochism, as limned too austerely
by Jean Paul Sartre, is here vitiated by the immediacy of the
marriage of the sister arts.

Roger Caillois has differentiated games and has said of
them that they do not disappear as quickly as empires
because of their seeming insignificance.[45] In his
classification of social games, Caillois might have put art as
one of his "games of vertigo," that is of companionate
intoxication like the carnival. Art is certainly this as much as
a game of simulation and mimicry. But it is perhaps as a
counter-game, a game to end games, that art's play must
be understood. Art as play has a way of marking off the
aesthetic terrain in a way that our own experience of
Duchamp and Rauschenberg has undermined. Art has
resisted in our epoch efforts to keep it uncontaminated,
unproductive play. The result may be as insidious as
Warhol's enucleation of business or as edifying as the
sociological carnivals of Christo, but all proceed by
analyzing liberty within a fraternal psychology. As there is
no psychoanalysis without a group, transference, and
resistance, there is no art without fraternity, collaboration,
and conspiracy.

Much has been made recently of the technological fact
that the nuclear bomb has made the nation state seem
archaic and dangerous and the sense of survival has
rendered the world "interdependent." It is possible that the
growth of collaborative zeal on the part of artists, as in the
experiments between artists and engineers at Expo 1970 in
Osaka, are attempts to vitiate the more nationalistic

boundaries of style and generate an anti-imperial aesthetic in our day rivaling antinuclear movements. Collaboration is then one of the modes of aesthetic survivalism in the face of common and transcendent danger. While Jonathan Schell, in *The Fate of the Earth*,[46] made one of his arguments the weakness of art itself in a nuclear age, the weakness of an art that could not contemplate the loss of a future without demoralization, we may say that the strongest collaborations of our time do seem emblematic of a protest against imperial war. A paradox emerges in such an age: the individual-become-a-pariah forms voluntary associations to reassert the individual. Resentment against systems without subjects forces the moment in which there is a historical eruption of the voice. Collaboration in our epoch is a polyphony of real, historical, and conditioned voices speaking of their common predicament in subjugating systems. As John Cage has spoken of a demobilization of language, these collaborations aim at a demobilization and disarmament of man. The human is reinstated as an allegory of collaboration. He who does not collaborate is a god or a beast.

NOTES

1. Walter Benjamin, *Charles Baudelaire: A Lyric Poet in the Era of High Capitalism* (London: New Left Books, 1973).

2. *Locus Solus* 2 (Summer 1961), published in Lans-en-Vercors, France, is entirely devoted to literary collaborations.

3. Helen Durkin, *The Group in Depth* (New York: International Universities Press, 1966).

4. Hans Robert Jauss, *Towards an Aesthetic of Reception*, trans. Timothy Bahti (Minneapolis: University of Minnesota Press, 1982).

5. Gilles Deleuze and Felix Guattari, *Anti-Oedipus* (New York: Viking, 1977).

6. Meyer Schapiro, "Style," 1953; reprinted in Morris Philipson and Paul J. Gudel, eds., *Aesthetics Today* (New York: New American Library, 1961), pp. 137-71.

7. Michel Foucault, *The Archaeology of Knowledge*, trans. A. Sheridan Smith (New York: Pantheon, 1982).

8. Elias Canetti, *Crowds and Power* (New York: Continuum, 1982).

9. See note 3, above.

10. Heinz Hartmann, *Essays on Ego Psychology* (New York: International Universities Press, 1965); Ernst Kris, *Psychoanalytic Explorations in Art* (New York: International Universities Press, 1962).

11. Ludwig Binswanger, "The Existential Analysis School of Thought," in *Existence: A New Dimension in Psychiatry and Psychology*, ed. Rollo May et al. (New York: Simon and Schuster, 1958), pp. 191-213.

12. Paul de Man, *Blindness and Insight: Essays in the Rhetoric of Contemporary Criticism* (New Haven: Yale University Press, 1971), pp. 36-50.

13. Jurgen Ruesch, *Therapeutic Communication* (New York: Norton, 1973).

14. Harry Stack Sullivan, *Interpersonal Theory of Psychiatry* (New York: Norton, 1968).

15. G. Bateson et al., "Toward a Theory of Schizophrenia," *Behaviorial Science* 1 (1956): 251-64.

16. "Poésies: Préface à un livre futur," in *Locus Solus* 2 (Summer 1961): 5.

17. Anonymous, "To a Waterfowl," in ibid., pp. 7-9.

18. Ibid., p. 9.

19. Ibid., p. 12 (trans. Arthur Waley).

20. *Locus Solus* 3-4 (Winter 1962): 85-91.

21. M. M. Bakhtin, *Problems of Dostoevsky's Works* (Leningrad, 1929).

22. "On Hope: By Way of Question and Answer, between A. Cowley and R. Crashaw," in *Locus Solus* 2, pp. 39–43.

23. Robert Motherwell, ed., *The Dada Painters and Poets: An Anthology* (New York: Wittenborn, 1967).

24. André Breton and Paul Eluard, "The Original Judgment," in *Locus Solus* 2, p. 63 (trans. John Ashbery).

25. Ibid.

26. Ibid., p. 65.

27. Paul Eluard and Benjamin Péret, "Surrealist Proverbs," in ibid., p. 67 (trans. Kenneth Koch).

28. André Breton and Yves Tanguy, "Question and Answer Game," in ibid., p. 68 (trans. Kenneth Koch).

29. See note 5, above.

30. Paul Eluard et al., "Cadavres Exquis (Samples)," in ibid., p. 68 (trans. Kenneth Koch).

31. John Ashbery and Kenneth Koch, "New Year's Eve," in ibid., p. 166.

32. Kenneth Koch, "A Note on This Issue," ibid., pp. 193–97.

33. In Josue V. Harari, ed., *Textual Strategies: Perspectives in Post-Structuralist Criticism* (Ithaca: Cornell University Press, 1979), p. 141.

34. Ibid., p. 160.

35. Jacques Derrida, *La Véritée en Peinture* (Paris: La Flammarion, 1978), pp. 291–436.

36. Roman Jakobson, "Linguistics and Poetics," in *Style in Language*, ed. Thomas A. Sebeok (Cambridge: MIT Press, 1960).

37. Harold Bloom, *The Breaking of the Vessels* (Chicago: University of Chicago Press, 1982), p. 66.

38. Robert S. Liebert, *Michelangelo: A Psychoanalytic Study of His Life and Images* (New Haven: Yale University Press, 1983).

39. Ibid., p. 200.

40. Quentin Anderson, *The Imperial Self: An Essay in American Literary and Cultural History* (New York: Knopf, 1971), p. 103.

41. In T. S. Eliot, *The Sacred Wood* (1920; reprint, New York: Methuen, 1960).

42. "About LA2," in *Keith Haring*, exh. cat. (New York: Tony Shafrazi Gallery, 1982), p. 20.

43. Conversation with the author, 1983.

44. T. W. Adorno and Else Frenkel-Brunswick, *The Authoritarian Personality* (New York: Norton, 1982).

45. Roger Caillois, *Man, Play, and Games*, trans. Meyer Barash (New York: Schocken, 1979).

46. Jonathan Schell, *The Fate of the Earth* (New York: Knopf, 1982).

Robert C. Hobbs

Rewriting History
Artistic Collaboration since 1960

Often when we wish to be official, we say "history decrees," or else we use the more casual "according to history" and "historically speaking." We invoke history to prove that we are right, but also we assume that there is a correct path to follow. If we can only read enough books and assemble enough facts, the true historical route will be discerned. And when we talk about "rewriting history," I think we often wish to find new facts that will present us with a way of re-evaluating events. If we could find a letter by Napoleon that would clarify his motives and shed light on his character, then we might be able to comprehend the significance of the French Empire and understand its relevance for nineteenth-century politics.

I realize that I am exaggerating for effect and trying to make a point that is sometimes acknowledged but too often forgotten: history is a creative reconstruction of events and not simply a chronicling of facts, even though facts are essential. History is created anew each generation to provide that generation with a *raison d'être* or, even better, with an opportunity to exercise its assumptions by testing them in the past. Even though enlightened historians sometimes do discover new documents that shed light on significant events, more often they dwell on known documents that had previously not been deemed important because they had not supported prevailing theories. A historian, searching through archives for material relating to Napoleon, would probably believe individuals to be the primary initiators of events and would be known as a subscriber to the great person theory. While such notables are important, they are not always self-selected. A Marxist historian might well examine the economic reasons for the

French Revolution and the ways it helped to change people's attitudes so that they first wanted to get rid of the monarchy and set up a democracy based on reason, and then later, paralleling the Romantic fashion, they believed a single strong leader to be the most expedient form of government. And historians currently influenced by Post-Structuralism might decide that there is no history, only metahistory: a rereading of earlier historians to determine their cultural biases and come to terms with a few of our own. Such historians would take the tactic that I am currently assuming and would look at unquestioned assumptions of historians as key factors in understanding the history of a particular time. In *Metahistory*, Hayden White has shown that history is a fiction—a significant and controlling illusion—that adheres to a number of strategic devices characterizing a period.[1] We therefore read history not to learn facts but to learn about the means of positing those facts, to see how early historians followed particular narrative schemes such as comedy and tragedy and used linguistic devices such as metonymy or irony to structure their work. In our media-dominated age, we are concerned with secondary media rather than the primary events. Less interested in understanding Napoleon the man and the way he changed world order, we recognize the difficulty of coming to terms with him and now wish to examine those people who studied him, to discern their assumptions and strategies and hopefully to construct a convincing history built on history, on metahistory.

Of course, our own ideas about history are ultimately as limited in their approach as the views of those people who subscribe to the great person theory—an approach that

accords with a desire to see human beings change world order. When we see a subscriber to the great person theory in the present, such as Barbara Tuchman, we are all intrigued, I think, because we so desperately want to believe that individuals do control the world and that history is not mindless attrition, some effect caused by innumerable people unsuspectingly reacting to a sequence of events. We like logic and the force of human emotions, and we want to be convinced that Napoleon was important, because, lurking under that conviction, is the assumption that if he can initiate world events, then, perhaps, we too can have an effect, however small, on the world around us.

The great person theory has enjoyed a wide following, but this approach is historically rooted in the Romantic period. If we divide the world into two types as did people in the nineteenth century, we might say that the Romantic wishes to distill the universal in personal terms whereas the Classicist values group order and rationally verifiable assumptions about reality. The former obeys personally intuited directions, while the latter subscribes to societal-based attitudes. The former approach has given rise to the great person theory, and the latter one is a necessary assumption of Marxist historians. In the last few years, the former has become more and more the prerogative of popularizers, and the latter serves as the basis for the approach of historians who use census reports, local history archives, and statistical summaries to catch the flavor of human drift. There has been an "Upstairs Downstairs" reversal of history. We are now more concerned with the so-called real people—the butlers, cooks, and maids—than with the gentry. We tend to look at

history as attrition rather than as a whim, and we are more and more attuned to how large numbers of people participate in world events rather than how the few are motivated and affected. Napoleon is beginning to appear more the creation of the people, the nexus of their desires, than a willful individual: he may act but he is also very definitely acted upon.

Even though historians have generally accepted social history as a legitimate approach and are finding it a fruitful means for sifting through past events, art historians have been reticent to give up their beliefs in individual genius. For all intents and purposes, art history is still locked into the great person theory, which is more appropriate to the Romantic era and the nineteenth century than the Post-Structuralist movement. Art history's concern for quality is the most probable reason for its retarded growth. In art history we dwell on the unique and invoke genius with great regularity. While all important works are unique and significant and artists might well exhibit in their pieces the type of inspiration that we generally deem genius, they do subscribe to dominant styles—form languages that they learn to speak—and later improvise and finally alter. When we subscribe to the concept of genius, we may be attempting to record the awe that we feel before an important work of art and the consequent reverence we have for an artist's abilities, but we do not, I believe, adequately deal with the situation at hand: we mystify and shroud much more than we clarify. Some Marxists and a few historians of architecture and photography have helped to make inroads in the overruling concept of genius, but as important and as revealing as their studies have been, they

are still too few in number.[2] We need more studies of vernacular architectural styles, for example. It would be extremely worthwhile to know more about the common suburban split-foyer home, about its origins, development, and involved system of signs. The study that University of Syracuse professor Grace Seiberling is making of the compositional devices and subject matter of nineteenth-century British amateur photographers is, to my way of thinking, most elucidating.[3] In an era when an aristocracy was the norm, we might look to specific individuals as originators of new ideas, but in our corporate and media-dominated world, new concepts are frequently spearheaded by committees. We still have great contemporary works of art, but I would speculate that they are no longer the creation of individuals: to saddle an artist with the responsibility of creating *ex nihilo* is absurd and inhibiting. Artists respond to established form—to conventional styles in painting and sculpture. When they create in these media, they can assume an established way of looking and reacting to the world. When artists innovate, they do not originate a totally new language. Rather, they find a means to alter the existing one, and their works become critiques of this language. When they make works, they assume a certain type of viewer response, and when viewers in the form of critics or historians write about works of art, they give artists necessary feedback—they complete the communicative act that constitutes art. In this system the work of art is a response to a pre-existent attitude as well as an initiator of new responses. Artists create art, but culture, which is a dialogue, is created by all. If we fetishize a work of art into a masterpiece and an artist into a genius, we

break off the dialogue because we remove the art from the level of discourse and make it absolute. We discourse about art to comprehend its special qualities, and we can come to know these qualities by testing and differentiating them. To function, art must participate in a dialogue; if it doesn't, it becomes, as Marcel Duchamp pointed out, an exercise that may be universally valid as form but no longer available as content.

This exhibition is an initial step in changing some predominant ideas about artistic genius and masterpieces. Positively it seeks to reposit our predominant paradigm about artistic creation and to suggest that not all artists create in a divine frenzy, that not all art is akin to Moses's clay tablets, that not all important art is an absolute, an ultimate commodity that must be appreciated but not studied as a historical manifestation. And negatively because it seeks to establish the fact that works of art by committee can be just as important as those conceived by one person, that a corporate identity is just as important as is a unique one, this exhibition may persuade people that art is still concerned only with masterpieces and geniuses. If it simply substitutes the group for the individual without causing us to reassess basic attitudes about art's meaning, we would lose a rare opportunity to look at art's function and see how it establishes and maintains connections between people. Art is, of course, a visual means of communicating with people so that they can digest discrete aspects of reality, see themselves in relation to the new forms of reality, and be transformed by them. The artist transforms the visual language and is changed by his or her transformation, as well as by the recorded responses of

critics and the impromptu reactions of friends. To exist, art must have an audience and a means of feedback so that artists can know if they are communicating what they think they are creating. Each new work of art is a critique of old art and also of verbalized response; it is an attempt to come closer to a specific view of reality.

Before discussing particular forms of artistic collaboration that have occurred since 1960—my assigned task—it would be beneficial to examine briefly some reasons why we have wanted to keep our artists individuals. Recently, I had the opportunity to see how some collectors treat artists as individuals. At a Sunday afternoon gathering in a small town near Cologne, West Germany, some prominent collectors were holding a fund-raising benefit for a German artist living abroad. Although all the collectors were dressed in a chic but conservative manner, the artists were outfitted almost like clowns. For them a special license existed. Like the proverbial king's fool, his appointed court wit who had free rein to speak and joke even with the king, the artist in modern society is expected to advertise his or her nonconformity. Artists do not have to adhere to our standards of decorum and dress, but they must meet our now clichéd standards of artistic individuality. They must be unique, and yet they must follow the rules we have evolved for unique people, which is nonconforming dress and a familiar manner even with strangers. Picasso understood this need of a bourgeois public to see its sages as fools when he clowned regularly for interviewers and photographers. Andy Warhol, sporting silver hair and regulation denims, used to ask interviewers if he had lied enough. And Robert Motherwell bemoans the fact that he is

Bob to everyone. In addition to being kings' fools, artists may also be equated with rulers of certain ancient societies who had absolute autonomy as long as they never touched ground, i.e., prosaic reality. If they dared to break this taboo, they would be immediately killed. Likewise contemporary artists are geniuses if they conform to our expectations of uniqueness. But if they resemble us too closely, artists throw in jeopardy our own values. We seem to need individuality in the form of artists and works of art—in the form of unavailable, acted out dreams. Thus artists compensate for our largely undifferentiated society and offer us alternatives which they may take seriously or parody but which we have permitted and also helped to create.

In our consumer-oriented society where individuality is equated with taste and is essential to the perpetuation of the marketplace attitudes that determine our world, we have a superficial rather than an in-depth concept of individuals and their uniqueness. It's almost as if, with the population explosion of the 1940s and 1950s, people have become cheap and human values less prized. When artists appear as clowns and eccentrics, they both tempt and repel us. We may fantasize about their lifestyles and yet, I suspect, we really do not wish to participate in anything so unconventional: we perversely like to read about Picasso's many wives, Jackson Pollock's alcoholism, Arshile Gorky's suicide, Joseph Beuys's political battles, and Carl André's asceticism, but we want to contemplate them from afar. Even though Beuys continually reminds us that we need a political system to free us and enable us to develop our creative selves, I think we tame his ideas by becoming fixed

on his antics and by considering him a magician with many more tricks to pull out of his felt hat. We speak of "creative" in hallowed tones, but rarely do we want to create, if creation involves radically re-evaluating ourselves and our world and facing the fact that there may be no reasonable answers. Creative enrichment is for children, senior citizens, and the institutionalized. It is available only to so-called normal adults, as a possible avocation. Creative enrichment, like artistic identity, in the end becomes something for someone else: a panacea or an alternative lifestyle, therapy or a symbolic act.

Probably other cultures did not have full-fledged individuals either. But few, I think, have made such a cult of individuality and yet have so little understood it. We prize what we don't have. Our art in the nineteenth century—particularly realist portraits and novels that were created in the midst of a most oppressive and dehumanizing industrial era—extolled the advantages of the individual. We need only compare Alain Robbe-Grillet's omnipresent but nonexistent heroes of the 1950s and 1960s with those three-dimensional, readily identifiable figures, conceived almost as caricatures, that populate the novels of Dickens and Balzac to understand the great need in the nineteenth century to conceive believable types, the need to resurrect in prose what, I suspect, never really existed in urban life. The French theoretician Jacques Lacan has shown us that psychologists have traditionally posited a bucolic type as the ideal for an emotionally healthy individual. We wish to be integrated personalities, the kind that might be developed in rural circumstances where people are known from childhood, known through their family, and known within a relatively cohesive group where differences are seen in highest relief. Such integrated and distinct individuals might exist, but they are not recognized in our transient society where people's personalities have come to resemble brand-name products. It is my belief that the individuality of the artist started to achieve cult status in the early nineteenth century in the Romantic era, particularly in France where artists helped to evolve an art-for-art's-sake attitude and tried to purge themselves of the crassness of the middle class and the overwhelming sameness of existence. Artists became dandies, self-proclaimed aristocrats by virtue of their refined sensibilities and extremely subtle tastes, which distinguished them from the common crowd. If they wore black, then their black frock coats sported a slightly different cut, wider or narrower lapels, whatever the style among the real cognoscenti might be. Even Gustave Courbet, the realist, the self-proclaimed socialist, felt the need to distinguish himself from other artists and the rest of humanity by his grandiloquent Assyrian-styled beard, his resounding proclamations about the nature of unidealized reality, and his revolutionary fervor that encompassed both politics and aesthetics. Though he might have dressed like a worker, Courbet never wanted to be mistaken for an ordinary laborer; he wanted instead to ennoble workers and make them into the new individualized aristocrats of a future proletariat.

In the nineteenth century no one wished to dispense with individuality as an inconvenient category and recognize that it was often an inappropriate security blanket to which people retreated when they felt that they were coming close to the brink of mass production and mass humanity.

Individuality, I would venture to say, was as artificial a category as the idealized view of fourteenth-century Europe that excited such Gothic-revivalist architects and designers as A. W. Pugin and William Morris. These men thought they found in the fourteenth century a type of Christianity, simplicity, and egalitarian reliance on the virtues of the individual, a utopian dream for the future and also an escape from the deadlocked capitalist struggle that they believed was robbing their contemporaries of essential freedoms and humanity. Individuality, then, is a historic term, a category for dispelling some of the ills of industrialization that threatened people in the nineteenth century. Because art symbolizes the state of society, its aspirations as well as its needs, it became in the last century a significant way to manifest the cult of the individual. It could present portraits of individuals as did Courbet who pictured them with bulbous noses and rolled-up sleeves or the Impressionists who infuriated contemporaries because they made the prosperous middle class an undistinguished type, part of the mass of everyday heroes of modern life. But art could more fully incorporate the cult of individuality by manifesting it in the person of the artist. At the end of the nineteenth century many artists celebrated or suffered their individuality as a central aspect of their art: Paul Gauguin self-consciously assumed it in his updated versions of the Romantic hero in South Sea Islands dress, and Vincent van Gogh was a manifestation and victim of it. So great was the need for this type of individual that when some of Vincent's letters to his brother Theo were published, shortly after the latter's death, people clamored to see the paintings, to recognize this severely alienated but true individual, and to collect work by him. The fetishing of Vincent van Gogh's paintings as direct indicators of his personality is highly ironic, for it points to the fact that individuality in the modern era has been achieved only at a great expense: alienation from the mainstream and solitude, which is not peaceful reflection but is a self-imposed, essential, and nonescapable recourse. When people regard Vincent van Gogh as somehow present in his art, I think of the late middle ages when people clamored for the hair, fingernails, and bones of saints because these relics would somehow remind them of significant religious ideals or else would somehow intercede on their behalf and assure them of God's holy favor. Individuality in the nineteenth century and even still in the twentieth is a form of residual spirituality, which frames the self with the type of reverence that once was thought appropriate to the cult of the saints. Knowingly or not, artists have attempted to fulfill society's dreams of a believable individuality.

If individuals in the eighteenth- and nineteenth-century sense are inconceivable in today's terms, and if we have misjudged our art and attempted to find it a means of relieving pressure in our automated, ready-made, and standardized culture, then we need to look back, as this exhibition and catalog are trying to do, and reassess artistic innovation from a different perspective. We might find, for example, that some of the most accomplished art in the nineteenth and twentieth centuries recognized the significance of mass production and posited a new and

healthy form of participative art modeled on medieval guilds. We can look at William Morris's writings, the workshops of the Shakers, Die Brücke artists who helped to revive the medieval medium of woodcuts, the Wiener Werkstätte, and Bauhaus and understand that creation was shared. Even Picasso's and Braque's work on Cubism can be considered an outgrowth of this tradition, as is Der Blaue Reiter, De Stijl, and, surprisingly, Dada and Surrealism. The last two are loosely structured organizations of artists who focus on a common goal and are consequently modeled on the workshop or guild approach even though both consist of artists who are pursuing romantically oriented subjects. Coming after the Surrealists, the Abstract Expressionists constituted a romantic revival. Not really an organized group, the Abstract Expressionists were joined only by a common allegiance to individually intuited knowledge. They established a new standard for individuality and a concept of it as a divinely inspired gift but an incredibly difficult burden that frequently resulted in periods of extreme depression, bouts with alcoholism, and suicide. In Abstract Expressionism the individual became a channel through which the uneasy, almost insane temper of the times was distilled: Motherwell associated the loss of his own youthful idealism with the cessation of the Spanish Republic and consequently named a series of paintings *Elegies to the Spanish Republic*, and Jackson Pollock's respite from alcoholism parallels the euphoria felt throughout the world after World War II and resulted in the frenzied ebulliency of the drip paintings.

If one were to think of artists who epitomized the cult of the individual in the early sixties, without doubt the strongest contenders would be Pablo Picasso and Jackson Pollock. For many people, Picasso's individuality was a product of his showmanship, fame, and longevity. Anyone who had been friends with Gertrude Stein in the early years of the century, who loved African sculpture when most thought it exotic junk, who helped to form the international School of Paris, and who had that many wives and companions had to be an individual, didn't he? Of course. But the Pablo Picasso in *Life* magazine had little to do with the Picasso who was lifelong friends with Spanish and French poets, who was a Communist, and who constantly parodied and sustained the grand tradition.

More consistent with the current idea of individuality in the United States of the 1960s was Jackson Pollock. Because he culminated in art the tradition of the Existential hero, the disaffected, super-macho type popularized in fiction by Dashiell Hammett and in film by Humphrey Bogart, Marlon Brando, and Paul Newman, he makes an excellent starting point for discussing new attitudes toward the role of the artist that developed in the 1960s and 1970s. To the French, I'm sure, Pollock manifested characteristics of the Camus and Sartre heroes that they admired so much. Slow to act, taciturn, melancholy, and then suddenly explosive, Jackson Pollock, the man possessed of demons that he exorcised in paint and of an almost painful need to experience both life and art to its fullest, clearly demonstrated the Cold War desire for resolution of conflict and for the sheer will to act in the face of complete absurdity. Similar to the characters played by Bogart and

Brando, Pollock was a loner. He lived on the fringe of society, choosing to alienate himself by grandly and yet somewhat sullenly and resolutely showing his disdain for wealth and convention by doing such things as appearing drunk and naked at a party.

Although Jackson Pollock's individuality was authentic, it still belonged to a type. Probably not self-conscious—even though he certainly at times assumed poses—Pollock's character was predictable; it belonged to the Romantic tradition and continued a model of alienated hero first developed by Lord Byron, a hero who was separate, sullen, and rustic in behavior. Frequently he came from the East and was consequently dark, with disheveled hair, black intense eyes, a surly unruliness or brooding intensity that fascinated women who wished to subdue him. This Byronic hero received popular treatment in Heathcliff, Emily Brontë's hero of *Wuthering Heights*, who is of questionable background, perhaps even of gypsy stock, and who embodies, throughout the novel, the natural wildness of the English moors. Although Pollock came from the West rather than the East and was a product of good, solid Anglo-Saxon and Scotch-Irish stock, he manifested many Byronic characteristics. At times wild, he seemed to manifest the still untamed traces of the American West, and his drip paintings, which now seem nervously rococo in their lavish, playful traceries and delicate colors, looked at the time sublime maelstroms in paint. In the sixties we still accepted the cult of individuality and its direct, untrammeled manifestations in spontaneously applied brushstrokes that quickened with feeling, paused with hesitation, and sometimes became possessed with the bacchanalian revels

of Jackson Pollock. He was the last believable Romantic hero and, to my way of thinking at least, the last convincing individual in art.

After Pollock, artists continued to participate in the Romantic myth of the self at the expense of trivializing it and appearing mundane. When Helen Frankenthaler attempted to emulate Pollock by posing on her hands and knees pouring and sponging paint, she looked more like an ad for Spic-n-Span than an artist. And Jules Olitski in Barbara Rose's film on the sixties resembles hired help when he steadfastly pushes a squeegee loaded with paint and gel across a wide expanse of canvas.

The most interesting artists coming after Pollock recognized the myth of the individuality of the artist as simply another convention to be dealt with, and they gave it the *coup de grace* by presenting it ironically as the subject matter of their art. Jasper Johns excelled in debunking the Romantic cult of the self that Pollock epitomized. In *Painting with Two Balls* (1960), Johns pokes fun at macho posturing in paint; in *Painted Bronze*, also done in 1960 (fig. 32), he presents the two Ballantine beer cans that would be requisite for a real two-fisted guzzler; and in *Thermometer* (1959), he includes a long thermometer for registering the heat of inspiration that is supposedly incorporated in a work of art.

While Johns made fun of individuality and the inability of art to fully register it—after all, painting is only convention—other artists began to look to new attitudes toward the self that are in line with their times and to form new images of the artist as both collaborator and corporate thinker.

Because it is highly conscious, the attitude toward the self

that Andy Warhol assumed in his art is tragic. And also in the Hegelian sense Warhol's approach is tragic: he knows that right will not win out, that he is doomed to being less than the Abstract Expressionist man, that in a very real sense he is a nonperson. This nonperson is developed over time: Warhol has an affair with his television and is wedded to his tape recorder. He is the new media-dominated nonindividual who accepts the conventional role models that mass advertising and mass productions offer him. He becomes as vapid and two-dimensional as the Hollywood-generated images of Troy Donahue, Marilyn Monroe, and Elvis Presley that populate his silkscreened paintings. Assuming the role of a product on the order of Coca-Cola, he is standardized, packaged, and readily identifiable. Warhol dramatized this new nonperson/product by sending a double on the university lecture circuit. When accused of defrauding the public, he cryptically and prophetically said that the double could be a more believable Andy Warhol than he.

Warhol's nonself dovetails with his corporate or collaborative work. Instead of making art in a studio, Warhol produces it in the factory. He has a host of assistants who carry out his ideas assembly-line fashion. His great dream is to make as many paintings as Picasso, only he wants to create them in a couple of years rather than in a lifetime. Warhol depends on the so-called mistakes his assistants make with a squeegee, causing Marilyn's face to be blotted out in sections and thus giving the work a mechanical, mass-produced look and making Norma Jean a nonperson and a victim of the inexorable processes of mass production, mass advertising, and mass consumption.

With his Factory, Warhol initiated a new form of collaborative art that did not seek so much to evade the ramifications of mass production as to accept the premise of industrialization that includes an equation of humanity with machine and a loss of the concept of self as a creative, fully integrated personality. Warhol takes these dehumanizing aspects of modern society and uses them. He seeks not to change modern society so much as to symbolize its questionable values, to be truthful about them, and to avoid comforting people with a false sense of self. Warhol's collaborative art is in dramatic opposition to the Romantic work subscribed to by the Abstract Expressionists. It is yin to their yang: a negative whose full definition can only be elaborated once its positive is named and clearly understood. Although Warhol's collaborative art stands in opposition to Abstract Expressionism, it defines a type to which artists in the sixties and seventies responded, an art that is tough minded, resistant to simple interpretation, consistently ambiguous, and thought provoking. Warhol's collaborative productions seem to be an offhand denial of individuality, and yet they elicit strong feelings about the role of the individual in modern society, the personality of the artist that becomes a product for the art business.

Warhol's collaboration made an entire range of participative creation possible. Although the Minimalists were his contemporaries and were already involved with shapes that could be industrially fabricated, they did not seize hold of the importance of collaboration until after Warhol had initiated his silkscreened productions. The Minimalists were trying to find a *sine qua non* for form.

They wished to find simple, perfect, replicable shapes and were not at first concerned with elaborating on the nature of the artist's collaboration with industrial fabricators. Even when they admitted the importance of their collaborators, they regarded them as extensions of their materials, as concerns of the media and not as participants in a dialogue.

Only Robert Morris, who viewed his sculpture as possible elements in dance productions with Yvonne Rainer, clearly understood that a reductive, almost anonymous, geometric-shaped sculpture suggested a new role for art and for artists, who were less geniuses in closed back rooms than rediscoverers of basic elements. In *Column* of 1961, Morris initiates a new type of collaboration that depends on viewer response. Because *Column* is so reductive—it is made of wood, painted a light gray, which seemed to Morris a noncolor, measures six feet high, and appears to be definitely a static object—it causes viewers to reconsider the role of sculpture and the meaning of art. Sculpture, in Morris's terms, is less an ordained experience than a catalyst for one, less a presence than a conduit for allowing viewers to come to know themselves through art. As Annette Michelson and others have pointed out, Morris's art offers observers an opportunity for phenomenological investigation, for questioning artistic function, examining their assumptions about art, and coming to terms with the fictive arena of space surrounding a work of art and the real but vicarious space enveloping it.[4] *Column* becomes art through its context: in a city street it would be an object, in an art gallery a reductive piece of sculpture, and in a distant jungle an alluring and unfamiliar presence. *Column* is a

proposition about art, and its status is continually in question; in order to be art, it has to be accepted as part of a social contract that depends on collaboration with viewers.

In *Enantiomorphic Chambers* (fig. 33) Robert Smithson continues Morris's concept while making fun of it. If art consists of perception—if, in other words, it is a dynamic exchange between work of art and viewer, then Smithson turns perception into its opposite, nonperception, and plays on visual blindness. His form of collaboration depends on viewers looking at *Enantiomorphic Chambers* and regarding the obliquely placed mirrors that reflect the state of mirrored reflexiveness, of viewed blindness, so to speak, as art. Used to seeing art as a fictive realm to be looked into, viewers must examine this work as a functional equation for art in which perception equals the comprehension that art is a narcissistic proposition of self-reflection.

Both these works by Morris and Smithson and, to a great extent, most Minimalist art depend on an active, investigative viewer. If one wishes to look passively at Minimalist objects, to be delighted with ingratiating formal qualities, one will be disappointed. However, if a viewer wishes to understand how sculpture is similar to and yet different from ordinary objects, then Minimalism is a perfect vehicle. This art works against the dominant formalist mode of seeing as aesthetic pleasure and presents viewers with challenges. When one considers that, beginning in the fifties and continuing into the sixties, television was enjoying its heyday and was turning a generation of people into passive bystanders, it's interesting to consider the

compensatory role played by Minimalist objects that caused viewers to react, to consider why an industrially fabricated form could be art and not just an inert piece of high technology. Even though this viewer-activated art has continued to be important in the past two decades, it has not assumed as significant a role as in the early sixties when Minimalist art appeared to be so completely static and mute—a thing in a gallery.

As with any other attitude, this viewer-response type work has its decadent counterparts, the most memorable being Edward Kienholz's *Still Live* (fig. 34), a piece made in Berlin in 1974, and a play on the genre "still life," which in French is sometimes called *nature morte*. To characterize the time bomb that Berlin has become and to dramatize, perhaps, Heidegger's acceptance of death as a necessity to appreciating life, Kienholz together with Nancy Reddin wrote the following statement that accompanies *Still Live*:

> I have long been interested in making an environment that could be dangerous to the viewer. This year's A.D.A. exhibit, with invitation extended by the committee has provided such an opportunity. The piece is called STILL LIVE and consists of a barricaded space 10 meters by 10 meters, that is guarded at all times against accidental entry. Inside is a steel wall background with a comfortable group of furniture (armchair, table, lamps, magazines, etc.) placed before it. Six meters in front of the chair is a black box mechanism containing a live cartridge and a random timer triggered to fire once within approximately the next 100 years. Detonation may be this instant, tomorrow, next week, 14 years, etc. No one, including
> myself has any idea when the explosion will take place, but if the blue warning light is flashing you can be assured that the timer is running. The environment is completely safe for the casual observer. Danger can only come if one is sitting in the chair or crossing the line of fire at the moment of detonation. The odds are astronomical against injury, but the possibility does exist. Viewers may enter the work only after signing a document stating that they fully understand the risk they are taking. No one under 21 years of age will be permitted entry under *any* circumstances and proof of age will be required at the gate.
>
> I have been asked with some justification why I would build such a piece. My purpose is certainly not death. Quite the contrary, I would hope that this work may be able to invoke new and positive responses to the wonders of life.[5]

I had an occasion to see this environment when it was reconstructed for the Braunstein Gallery, San Francisco, in 1982, and I was fascinated by the reactions of people who sat in the chair facing the black box loaded with a live cartridge. Even if they appeared at first to be taking the situation lightly, within a few seconds they would undergo a perceivable change. One woman who sat down casually in the chair looked through a magazine and intended to read an article. Her movements, at first smooth, became jerky and quick, and even though she did not glance at the black box, her tenseness and half-hearted laugh at the taunts of a friend outside the barricade gave away her fears. Another viewer, a young man, attempted to challenge the black box

by staring at it. In the beginning he seemed cavalier, but within seconds he changed, I think, because he realized that he was not staring at just a black box with a firing mechanism but was looking at himself and considering the possibility of his end. Even though I was embarrassed at seeing another human being stripped of psychological defenses, I did question him after he left the barricaded area. At that point he had regained some composure and tried to shrug off the whole experience. But he did look deeply moved and preoccupied. To exist as art, *Still Live* needs an art environment and contemplative viewers who are willing to see the symbolic ramifications of the work and not just dwell on its sensationalist qualities. Viewers who put themselves literally in the center of the work, as I was afraid to do, actively collaborate with the piece. They become actors who assume an assigned role, only they play it for real.

In recent years couples have become important collaborators. Edward Kienholz has attempted to collaborate with his wife, Nancy Reddin, but has achieved little success. Although he has included his wife's name as co-creator, he has not yet allowed her to have great impact on his style. The art is clearly created in the Edward Kienholz mode, with some input from Mrs. Kienholz. Nancy Reddin Kienholz recognizes this problem, and in a panel at the American Sculpture conference in Oakland, California, in 1982, she said that there was little difference in the role she played in the art before she was recognized as collaborator and after, except that she now had to participate in panels and defend the art publicly. While the artist/viewer collaboration is a successful aspect of his art, Kienholz's inclusion of his wife is not yet resolved. His collaboration results more in a workshop situation than in a freely expressive and intensive creative relationship in which both artists are willing to take risks and go beyond the already formulated, macho-ego-dominated work for which Edward Kienholz has become recognized.

Among the more prominent couple-collaborators are the Bechers, Christos, Harrisons, Oldenburgs, and Poiriers. Some are acknowledged collaborators, others are forced, and still others seem to be innovative and integrative, depending on the complete cooperation of both members. Although the Oldenburgs' collaboration is acknowledged, it is probably forced because the style belongs to the husband, and the wife, Coosje van Bruggen, is serving more or less as an in-house curator who helps to select sites and define projects. The collaboration seems to be productive and worthwhile but it, like the Kienholz team, is still the product of the male and represents an occasion of allowing "the little lady" an opinion. Both acknowledge a need for pooling resources and for getting beyond the confines of an isolated and packaged ego, but the collaboration does not accept the ramifications of its premises. The art is more a workshop production than a collaboration, the wife more an assistant or sounding board than an innovator. In fairness to Oldenburg, I should point out that he has always been prone to officially recognize contributions made by assistants. His first wife, Pat, perhaps one of his most important assistants, sewed the canvas *Giant Hamburger*, helped with some *Good Humor Bars*, and in general made the large stuffed sculptures of the 1960s possible. But, the ideas were all Oldenburg's,

Figure 35
Anne and Patrick Poirier in their studio, Paris, 1980.

even though Pat may have made a suggestion here, a tuck and a seam there.

Differing from the Oldenburgs, the Christos (see fig. 24) have never formally acknowledged their collaboration as co-creation. The ideas are Christo's; the financial organization Jeanne-Claude's. Because of the nature of his work, which is formal, political, and economic, Christo, I think, should give his wife more credit. Although Christo does not include his wife as a full collaborator, he has, unfortunately, in an effort to be democratic, tried to make the engineers and technicians implementing his projects part of his aesthetic team. When he states in his film *Valley Curtain* that the work doesn't belong to him but is the creation of all his helpers, I believe that he is misjudging the situation and is attempting to make the assistants the modern-day equivalent to John Ruskin's medieval stonemasons, those rustic types who were each supposedly given his own capitol to design and carve. Just as Romanesque and Gothic cathedrals were highly engineered creations that kept the contributions of individuals firmly in check, so Christo's monumental projects are subsumed under his own whims and under the very able fiscal management of his wife.

While the tentative collaborations of the Oldenburgs, Kienholzes, and Christos seem remarkable because of the attempt to make the living partnership of marriage a workable, creative situation, the collaboration of Hilla and Bernd Becher (see cat. 85–88) seems less intriguing as a relationship and much more a matter-of-fact proposition. Their collaboration, a Minimalist-inspired activity with definite post-industrialist overtones and a healthy dose of archivist zeal, has taken on the character of a research team. They are recording a passing era of industrialization, and they are honoring a host of anonymous architects by making sure they remain practitioners of a common style, adherents of the type of building that governs each ensemble. This quality of anonymity, of cataloging types rather than emphasizing individual production, is a *modus operandi* for the work and for themselves: the subject matter reinforces the matter-of-fact, low-key interest in work and the submerging of artistic ego into a pattern that accords more with systems theory and permutations than with the idiosyncracies of two individuals who are attempting to forge a new concept of a collaborative self. Their shared identity is an *a priori* not an *a posteriori*, an established fact, not an essential outcome. And so for the general public the Bechers seem to be only names for the traveling team of documentary photographers or conceptualists who are careful to approach their subject directly and to emphasize similarity of vantage point so that one sees one cooling tank in almost exactly the same manner as one sees the others that have been lined up in the assembled set. With the Bechers, sex is never a question; the anonymity of their production, the mundaneness of their conception, and the documentary nature of their activity all work against exposing the individuality or sex of the artist.

Although Anne and Patrick Poirier (fig. 35; see also cat. 107) appear to be at the very opposite antipode from the German Bechers, being romantic instead of realistic, interested in fantasy rather than fact, and working with elaborate reconstructions of the mythic battle between the gods and other giants, a subject that has haunted them for

years, the Poiriers are, in many respects, similar to the Bechers. Anne and Patrick Poirier have formed a corporate or workshop style; they have reduced their palette to the oppositions of black and white, and they have even accentuated this reductive look in their daily lives by choosing to wear only black and white clothing. For all the romantic overtones of their art, it is carefully researched and dependent on a working knowledge of ancient Greek civilization. Their art, similar to that of the Bechers, is concerned with aftermath, with a time of nostalgia when monuments are turning to ruin. Although the Bechers are most closely attuned to conceptualists in terms of the straightforward look of the information they cultivate, they betray a certain undercurrent of romanticism when they feature desolate buildings falling into disrepair. Similarly, the Poiriers seize on the archaeologists' mode and recast the famous Giulio Romano *Fall of the Giants* at Palazzo del Tè into a more factual setting. The fantasy is there, but it is held in check, tempered by research of ancient types, and sustained with a subtle humor that recognizes the entire production as preposterous and playful, as somehow ludicrous in the late twentieth century and yet meaningful because it takes humor and myth seriously. The Bechers are similar to children playing the role of serious researchers, while the Poiriers are adults who wish to cultivate again the magic of childhood.

I believe that collaboration in the 1960s was largely modeled on corporate types. When it was successful, it depended on artists working in committees and coming to a consensus about specific problems. When functioning on the corporate model, artists were more think tanks than individualized egos; their aim was to change and mold society, to envision new possibilities, and then to attempt to implement them. These artists were less concerned with discovering themselves than with learning about the world. This collaborative type was epitomized, I think, in the innovative but miscalculated Experiments in Art and Technology, or E.A.T., as it was known, which was co-founded in 1966 by Robert Rauschenberg and Billy Klüver, a scientist working with Bell Laboratories. In their newsletter of June 1967, this group's intentions were concisely enumerated:

> E.A.T. is founded on the strong belief that an industrially sponsored, effective working relationship between artists and engineers will lead to new possibilities which will benefit society as a whole.

The idea was wonderful, and many artists and scientists throughout the United States responded to it enthusiastically. The main problem, as I see it, was that connections between art and science were either forced or trivialized, and neither group really knew enough about the other's agenda to be able to bridge differences and forge a new type of work that was neither art nor science but something in between. An outgrowth of the ebullience of E.A.T. was the carefully engineered and painstakingly organized exhibition *Art and Technology*, which was masterminded by Maurice Tuchman.[6] The idea of pairing artists with corporations was a splendid one, but the optimism of the approach, which was spearheaded during the sixties when prosperity and a belief in art as progress and pageant was at its height, was out of kilter with this

nation's very real anxieties that became apparent in 1968 and affected the country through the early seventies when inflation, ecological upsets, and dwindling energy sources caused people to start doubting the possibility of a bright new world through technology.

In the sixties artists were more concerned with style than with individuality. If they were individuals, then they were famous as personalities (that is, nonindividuals or brand-name products like Andy Warhol). And their individuality was equated with a distinctive style. In art history classes style was presented as the cornerstone of the discipline: students learned to make accurate and intelligent stylistic analyses, using such preferred terms as "balance," "juxtaposition," "recession," "fictive illusion," "mass," "value," "contrast," and "intensity of hue." And *Artforum*, the major new art periodical of the sixties, contained essays by Michael Fried and Kenworth Moffett that abounded in such stylistic terms as "inviolable surface," "deductive structure," "presence," and "actuality," with discussions that emphasized the minutiae of composition, color, and support. The sixties, then, culminated a period obsessed with style, with formalism as it is now called, and the pre-eminent formalist was and still continues to be Clement Greenberg.

Personally, I think Greenberg, in the past few years, has been taken too much to task for the excesses of his approach and not lauded enough for his accomplishments. I believe his entire influence on the art world could be approached more positively if we recognized him as an artistic collaborator and considered criticism, even prescriptive criticism, to be essential at times to the production of art and not ancillary to it. If we consider art a form of communication and not just a static object, then we need to recognize that its communication will of necessity be two-sided. Artists need to know what they have communicated: they need feedback from critics who function as ideal viewers, as informed and perceptive individuals who complete art's communication by responding to it in prose. So important is the critic's role to the creation of art that I would like to venture the idea that great art cannot be created unless the artist has an enlightened critic in the form of writer, patron, or close friend who will try to articulate in words—that is, make conscious—the experience of viewing art and deciphering its content.

Although I have earlier taken Greenberg to task in the article "Against a Newer Laocoon" that I co-authored with Barbara Cavaliere,[7] I would now assess his contribution differently. Greenberg, for example, may not have been the first to recognize the significance of Jackson Pollock's art but he did champion Pollock, and, in the process, helped him to achieve a confidence in himself that enabled him to experiment in new directions. And although Greenberg may have hindered more than he helped William Baziotes whom he counseled to let his paintings cook, he did seek out Baziotes's work as significant, and he did attempt to understand its special quality that is attained by glazing. Some artists have told me that Greenberg fulfilled a most important function because he would help them select works for an important show. Even though he counseled, for example, Kenneth Noland to exhibit the more colorful *Targets* first and the monochromatic ones later, thus fooling

history and giving a false, reductive, linear type of development to this series of works, he did imbue Noland and Morris Louis with essentializing their ideas and finding a way to work with the inherent means of the medium. And even though Greenberg frequently oversteps the normal bounds for a critic by giving artistic advice, helping in fact to create the work as when he makes suggestions to Anthony Caro about a formal problem or counsels Helen Frankenthaler on ways to crop her stained canvases, he does dramatize the critic's role as an arbiter of taste, disseminator of ideas about sensibility, and popular forum for art. Critics do not simply tell artists what to think; on occasion they participate in the creation of art by enabling artists to comprehend the uniqueness in their own work, to deal with its significance, understand the system of values it presupposes, and comprehend the way that their art functions in society. If artists take their creations on faith, if they intuit ideas and then develop them, if feeling is their guide, then they desperately need a response, and that response in our society has been assigned to the critic, who has in actuality two ideal audiences: artists and viewers.

The impact critics have had on the art world is significant but difficult to calculate. Even though Harold Rosenberg may have misjudged Action painting, he did help to make the ethics of risk a legitimate concern for a generation of artists attuned to existentialism. And Leo Steinberg's reading of Jasper Johns helped to make the tendency to literalize, to find material equivalents for art's function, a *raison d'être* for art in the fifties and sixties. Lawrence Alloway's connection with the British Pop art movement and his conspicuous presence at the Guggenheim Museum in the sixties have to be considered in any serious appraisal of Pop art in the United States. Lucy Lippard's Marxist attitude and her concern with feminism have helped artists outside the mainstream to define their goals and reassess their prospective audiences. Donald Kuspit's interest in the Frankfurt school and his desire to understand the political basis of art and the ways that powerful constituencies have affected it have in turn had an impact on artists who are concerned with articulating systems of value and mirroring power centers in the art world. And Robert Pincus-Witten's diaristic approach and phenomenal ability to coin new jargon such as "Post-Minimalism" can be considered a creative restructuring of the art world and a repositing of its stance vis-à-vis the sixties, formalism, and the impersonality of the art world. With each of these critics one can build a case for the creative function of criticism. Whether a critic initiates a style or is only important in modifying it is a moot point. And whether critics help to initiate a new era or are merely products of their own times is also open to question. But I should point out that these same arguments about the role of the individual and the impact of determinism have been debated for over a century.

We are living in an age of criticism. Many of the most important new orientations toward the world have been formulated by critics. In particular Structuralism and Post-Structuralism (better know as Deconstruction), the theories of Jacques Derrida, have been of great importance. As one would expect, much contemporary art participates in Structuralist and Deconstructionist ideas. One of the most obvious Structuralists is Vito Acconci who in his early

works reduced myths to series of formal operations on his body. Playing on the idea of the Greek deity Apollo who represents the sun, wisdom, and new beginnings and has been traditionally symbolized by the omphalos or navel, Acconci pulled hair from around his navel for the film *Openings* (1970) and thus created a modern, mundane image of new beginnings, of opening oneself literally to one's first connection with life, the umbilical cord. And the Deconstructionist attitude that attempts to undermine conventional fiction or ellipses in literature is an important working proposition for John Baldessari's *Blasted Allegories* (fig. 36), a series of images from popular media that are coupled with misaligned captions, causing one to puzzle over the works and regard art as a radiant surface and not a transparent, easily decipherable set of signs.

One could argue convincingly that critical collaboration is nothing more than simple influence, and I would agree that there are definite influences that suggest mutual support and not simple derivation of one idea from another. Maybe, with the Structuralist and Deconstructionist examples cited above, we are dealing with influences. But I would like to propose that collaboration is, in essence, nothing more or less than influence positively perceived as part of an ongoing cultural dialogue. Almost a decade ago when I taught my first course at Yale University, I announced to the students that art history is a negative discipline because it takes the positive idea of creation and turns it into sources and influences. Instead of dwelling on the new and innovative, we are always trying to take the conservative approach and see precedents for a particular motif. We write art history without exclamation points because we are

afraid to dwell on originality and understand how it can be as enormous as a Kierkegaardian leap or as slow and minute but still as inexorable as glacial drift. I believe that our negative emphases, coupled with their opposite, a Romantic belief in genius that has imbued art since the Renaissance, have put artists in an impossible situation. We have encumbered them with an obligation to prove us wrong and to show through their art that the isolated ego is the mainstay of creativity. All this negativity and compensatory posturing has led to an impossible situation for artists who frequently believe, as Robert Motherwell has so poignantly suggested, that they must create themselves and their art anew, that they must forge a completely independent and revelatory style. And Mark Rothko, following Charles Baudelaire, would have added that a legitimate style should be as much a surprise to its creator as to its audience.

How much easier and satisfactory is the collaboration idea! A concept of creating that does not separate but instead integrates, that does not make ego the subject but instead is attuned to some function outside the individual, isolated self. Collaboration, as it has been structured since the 1970s, is to my way of thinking largely responsible to the tenets of the feminist movement, to the desire to find a new model for successful human behavior that does not depend on aggression and booty but instead is concerned with more human and fulfilling needs that can be grouped under the terms "nurturance" and "community."

In the early seventies the feminist sensibility caused the big, brash canvases of the late sixties to undergo radical changes. One needs only to consider the differences

Figure 37
Frank Stella (American, b. 1936), *Darabjerd III*, 1967, synthetic polymer on canvas. Hirshhorn Museum and Sculpture Garden, Washington, D.C.

Figure 38
Miriam Schapiro (American, b. Canada 1923), *Black Bolero*, 1980, acrylic and fabric on canvas. Courtesy Barbara Gladstone Gallery, New York.

between Frank Stella's Protractor series (fig. 37) and Miriam Schapiro's fan-shaped canvases (fig. 38) to realize that the immediacy of the former works, which were instantly recognizable, almost preformulated gestalts, were replaced by works similar in shape but vastly different in appeal, works that invite viewers to come close and study the surface of cloth, sequins, paint, and remnants of patchwork and embroidery created by anonymous women in the past. Although Schapiro seems to appeal to Stella's immediacy and design, his large distancing permutations on basic shapes, his art that functions best in the lobbies of anonymous late-modern steel and glass buildings, she humanizes her art by incorporating in it the work of other women. One might argue that she is no different from Picasso who used newspaper, rope, wallpaper, and oilcloth in his collages. But I think her collages are less radical juxtapositions of industrially fabricated materials and much more concerned with the accretion of women's traditional handicrafts, their very personal creations for their families and friends. In a series of prints entitled *Anonymous Was a Woman* (1977), Schapiro memorializes this tradition by using such pieces of handiwork as crochet as the object matter of her prints. In my opinion Schapiro is involved in a most important form of collaboration when she recognizes this largely unhonored domestic tradition and uses it as the subject and sometimes the media of her art.

In contrast to Schapiro, Judy Chicago is less a collaborator than an enterprising businessperson. When she farms out china-painting and embroidery, she may attempt to dignify the participation of the women in the South and Midwest by mentioning their names and towns of origin, but she is not really allowing them to collaborate fully in the work. The designs are definitely Chicago's; the women are still taking in sewing; and the entire process reminds me of Stella's Italian family outside New York City who worked on his designs for the Protractors. To have a woman stitch a design is no different from having Lippincott industrially fabricate it. Whether the workers have ideas about French knots or welds matters little; their participation is limited to that of technician, and the art is still very much the prerogative of the artist.

Even though the feminist movement did not turn all women artists into collaborators, it did affect some, and it did represent a new definition of self that is interactive rather than inclusive, open rather than closed, a self that would be less an isolated ego than a participant in a community-directed function. Many women's collaborations exist, and several of the most important Suzanne Lacey has organized around specific causes or events. In 1977 she put together a task force in California to dramatize the issue of rape. The piece, titled *Three Weeks in May*, consisted of a rape crisis center where information on the numbers and locations of rapes was recorded. In addition, performances were staged in the Los Angeles area to emphasize the problems of rape and the significance of these violations. The work was political, social, symbolic, and media oriented. More recently, in 1982, in San Francisco, Lacey worked with a committee of local artists and volunteers to bring together as many different constituencies of women as possible and have them meet for one evening in a department store where they could discuss their problems, their roles, their satisfactions, and their disappointments.

Assembled that August evening were senior citizens, administrators, housewives, members of ethnic groups, and prostitutes. The work was a celebration of women's working lives, and viewers were invited to walk through the store and examine the groups and listen to their conversations. In this kind of collaborative performance, the work becomes the spontaneous interaction of separate individuals. No longer is the artist portraying her own ego or dwelling on some fantasy; she is now building on traditional women's roles of community organizer, shopper, and hostess.

The feminist movement has been an impetus to the collaboration of Helen Mayer and Newton Harrison, a wife/husband team, who for over a decade have been creating ecological art. Taking the feminist goals of cooperation, integration, community, and nurturance, and the ecological concept of listening to the needs of the environment, they have evolved a mythic/poetic/scientific art. In their recent narrative *The Mangrove and the Pine* (cat. 106), they have studied the effects of the alien Australian pine on the ecology of the Barrier Islands off the west coast of Florida. Brought to the United States to protect orange groves from winds and cold, the Australian pine has become a weed. Although they resemble the beautiful long-needled pines of Cézanne's beloved Aix-en-Provence, these trees have become ecological disasters in Florida where they edge out the mangroves that created the Barrier Islands and thereby disrupt the coastline of these protective islands. Implicit in the Harrisons' presentation of the battle being waged between the pines and the mangroves is the idea that other aliens such as human beings have interrupted the ecological balance of this area and have attempted to make these islands, which are naturally always in flux, into permanent areas where lots can be sold and condominiums and suburbs established. The Harrisons ask for a new understanding of the need to collaborate with nature, and they help to manifest this need directly in their art by collaborating with each other. In this manner the subject matter reinforces the means by which the art is created, and both become part of its plea for integration, for listening to the needs of the landscape, and particularly for viewing the environment from a perspective different from our usual anthropomorphic one.

In the late seventies more and more artists became disenchanted with the old, established romantic conception of art that was conceived as a manifestation of one individual's sensibility, a sentient being, and a precious object that would be an accoutrement to the rich. Although the middle and lower classes might have their mass media art in the form of television, particularly, I think, in the form of commercials that provide a repeated litany for human behavior, artists have recently recognized that the avant-garde has been trivialized to the point of fashion and titillation and has little to do with the broad populace. When a fashionable magazine on the order of *Town and Country* or *Vanity Fair* can term itself "avant-garde," one knows that the concept of "avant-garde" meaning progress and innovation is a clichéd idea. I think artists in the seventies also recognized that in our materialist society art becomes just another group of objects and that experiences are oftentimes more captivating and moving than things.

Two New York groups that have found challenging alternatives for disseminating art information are Fashion

Moda and Colab. Both groups have moved away from the traditional sales-oriented gallery system to establish a new form of interactive art. So attuned are we to the gallery system that we fail to realize how recent the appearance of commercial galleries really is. Although art was sometimes sold in paint shops, and in the seventeenth century the Dutch certainly found a means for selling art to great numbers of people, commercial galleries as a prime means of exhibiting and selling art are a mid- to late-nineteenth-century development that parallels, in France, the Impressionists' decision to circumvent conservative, official salons. Commercial galleries became great successes in the late nineteenth century, as can be seen in the eventual financial success of the Impressionists who took their ideas to the marketplace and let it be the final arbiter of taste. Now, after a century of commercial galleries, artists are finding the marketplace a limited patron because it dictates creating and selling luxurious goods that will appeal to ensconced powers rather than allowing for art simply to provide new and radical schemes for symbolizing modern life. (As I write this, I am leery of using the terms "new" and "radical" because they have been so co-opted by tradition. We now have to invent new terms for new art, because "new" means orthodox and conservative. Just as Post-Modern is a reaction to formalist Modernism and not to innovative art, so the death of the avant-garde is a rebellion against now-established vanguard truisms.)

Stefan Eins, the main organizer of Fashion Moda, has chosen to take art out of a bourgeois marketplace and relocate it in the lower-income South Bronx where it is shown in a storefront museum. Crossbreeding young SoHo vanguardists with locals in the South Bronx who talk about what art means to them, Eins has managed to make us aware of vanguard art's previously limited group of supporters and its possibilities for an enlarged audience. By bringing together local artists, citizens, downtown artists, and critics, he has managed to circumvent some of art's insularity. The paradigm that he is evolving is a collaboration between artists and audience whereby one can learn from the other, and the resultant art will represent a genuine and necessary mode of catalyzing communication and reacting to it. The ongoing collaboration between sculptors John Ahearn and Rigoberto Torres is exemplary: urban sophisticate and South Bronx folk artist have joined forces to document blacks and Hispanics living in Torres's neighborhood.

Colab, short for collaboration, consists of approximately thirty-five artists (some of whom also exhibit at Fashion Moda) who have grouped together to form large shows. Their most notable piece, the Forty-second Street exhibition, took place in a deserted massage parlor that they turned into an impromptu museum. Much of the power of the work derived from its seedy ambiance, which lent authenticity to diverse kinds of work harking back to the fifties' California art of Bruce Conner and Edward Kienholz. Attempting to be *enfants terribles*, albeit with a decorative touch, Colab artists included images of rats running up a staircase, environments using refuse found in the building, and a small museum bookshop cum gallery that sold multiples, artists' books, and catalogs. Although much of

the work looked *déjà vu*, seeing it in such a context as a Forty-second Street massage parlor transformed it into a remarkable site-specific project. The piece, then, was a collaboration between various artists who played down their individual personalities, and it was also a collaboration between artists and a particular site, which played an enormous role in legitimizing the work and transforming it from a merely titillating experience to a much more challenging confrontation with a specific unsavory place. Almost always attempting to avoid being linked with fashion, modern art has attempted a number of strategies to declare its significance and authenticity. And it seems to me ironic that the Colab group has managed to be both fashionable and authentic by choosing a site that becomes a major factor in the work. As Rosemary Mayer, an artist sometimes associated with Colab, once told me, "The pre-eminent material of the eighties may well be satin, which combines high-fashion elegance with low-brow burlesque sleaze." Colab's Forty-second Street show exudes the sensibility of fashionable sleaze and has helped to usher in the eighties.

Most examples of collaboration that I have discussed have to do with cooperative ventures between consenting parties. Probably one of the most notable ventures in collaboration, the famous addition Julian Schnabel made to David Salle's *Jump*, 1980 (fig. 39), has to do with denigration or criticism. According to the most popular version of the story, Schnabel and Salle exchanged works, and Schnabel decided to make an addition to Salle's piece, to complete it, so to speak. Given the painting by Salle in

exchange for one of his own, Schnabel reversed the order of the two panels constituting *Jump* and superimposed a large portrait of Salle. Not so much an act of destruction as a collaboration, Schnabel's addition is actually consistent with Salle's style. In his art Salle formulates a number of conventions that are discretely placed so that they will remain conventions: color fields resembling Ellsworth Kelly, grids looking like early Judd objects, illustrations reminiscent of the Ashcan painters, cartoons of Bugs Bunny, signs on the order of late Kandinsky compositions, and images of women who seem to be traditional artists' models or humiliating sexual stereotypes. By keeping these individual styles separate and yet allowing them some interplay with the other elements, Salle sets up a painting equivalent to Jacques Derrida's Deconstruction; he breaks apart fictive illusions and shows us that the reality of the work of art is a group of consistent and believable conventions. All Schnabel did was to enter into a dialogue with the conventions already established by Salle and add one of his own. And by entering this dialogue, Schnabel deconstructed Salle by breaking down the finely poised composition of interconnections and finely balanced oppositions and showing that a contrapuntal composition scheme that played figure against field and flat image with three-dimensional construct was at work. Even though Salle deconstructs Modernism, he still appears to believe in it; and he is careful to parody its conventions while continuing to create a decorative and relatively flat type of painting that is at home with formalist art. Because Schnabel often transforms modern art's traditional flat and matte

Figure 39
David Salle and Julian Schnabel, *Jump*, 1980, acrylic on canvas.
Courtesy Mary Boone Gallery, New York.

background into shimmering velvet, which connotes lushness, fashion, and decoration, he breaks down this convention. And in his collaboration with Salle, while he does not use velvet, he does employ his decorative and almost parodic Abstract Expressionist paint strokes, a convention for feeling rather than feeling itself, to offset Salle's cool finesse.

In the past two decades, collaboration has not been art's mainstay, but it has provided artists with an alternative way of looking and reacting to the world. Sociologists remind us that our society is dynamic, not static, and is concerned with acquiring experiences rather than objects: we are still materialistic, only we wish to purchase those items such as vacations, lessons, computers, dinners, and video games that will allow us opportunities to see, learn, and grow. If this is true, and I certainly think it is, then collaborative art enables both artist and viewer a more involved and dynamic experience than earlier art. With collaborative art, we can no longer assume that we are having an aesthetic and private meditation on the distilled sensibility of another person. When we look at a collaborative work of art, we are examining a dialogue or conversation between artists. And we do not dumbly gaze, awestruck with aesthetic pleasure; we must participate by thinking about the interaction that takes place and actually start interacting with the art ourselves. In many works, this new dynamic mode of seeing and perceiving art can be demonstrated. I remember several years ago that Shelly Silvers, a Cornell student, was developing a concept of art as a social contract. Around campus she placed a number of deliberately dumb dating

game posters with attached postcards enumerating places to be filled out or colored in and an address of a local post office box. Although the games seemed at first to be a new psychological test for assessing and later matching personalities, they were so inane that they had to be considered gratuitous. Placed in an everyday public space—bulletin boards in university buildings and local coffeehouses—the work was art only if one chose to consider it art.

Similarly the political events of the Art Squad, a Philadelphia collaborative, can be taken as either art or politics or both depending on viewer reaction. The Art Squad has taken film footage of nuclear explosions and of Hiroshima and Nagasaki victims and shown them on walls of Philadelphia buildings, interrupting outside diners and forcing casual bystanders to think about the significance of these images. By avoiding traditional art spaces that tend to serve as bracketing devices, as decontextualized spaces for aesthetic pleasure, and not as a means of confrontation, the Art Squad attempts to shock people into accepting the horrible reality of nuclear war. On the anniversary of Three Mile Island, Art Squad members dressed as nuclear radiation testers and demonstrated at Center City shopping areas. Janet Kaplan, an Art Squad member, has summarized the focus of the group as "an artist's resource bank that offers skills to other political groups in need of visually powerful graphics or events for demonstrations, flyers, etc.; and an action/resource group that develops performances, exhibitions in non-traditional locations and other events, to reach the widest possible audience."[8]

Figure 40
Helen Mayer Harrison (American, b. 1929) and Newton Harrison
(American, b. 1932), *The Fifth Lagoon, Second Version: The Voice
of the Lagoonmaker*, 1978, mixed media on canvas. Courtesy
Ronald Feldman Fine Arts, New York.

Figure 41
Helen Mayer Harrison and Newton Harrison, *The Fifth Lagoon,
Second Version: The Voice of the Witness*, 1978, mixed media on
canvas. Courtesy Ronald Feldman Fine Arts, New York.

Likewise, in Helen and Newton Harrison's *Lagoon Cycle* (begun approximately a decade ago and continuing to the present), the viewers are given a specific role. They are readers of information and speculators about two characters, the Lagoonmaker and the Witness, who discourse throughout the cycle on the meaning of change and ways of approaching nature and correcting environmental problems (figs. 40, 41). Both of these quasi-mythic figures argue, joke, exchange roles, and describe the increasing importance of the metaphor of the estuarial lagoon, the tentative habitat, symbolizing modern life, where fresh and salt water mix and the majority of aquatic animals meet and reproduce.

I met with Pierre Alechinsky in his studio outside Paris in the fall of 1982, and we discussed the term "collaboration" and tried to find another word that could be used in its place. Long involved in interactive works with other artists (see fig. 42 and cat. 67, 68), with poets, and even with history in the form of nineteenth-century letters acquired at Paris flea markets, Alechinsky kept repeating to me that "collaboration" is an inappropriate term because, in Europe at least, it has the connotation of conspiring with the enemy: "Collaborators were those who helped the Germans!" At one point in the discussion, Alechinsky went over to the corner of his studio, pulled out a recent catalog of work, and signed his name first with his one hand, then with the other. Then he gave the catalog to me, saying, "This is what we need—a word that will express clearly and succinctly what it means when one hand knows what the other hand is doing."

Figure 42
Karel Appel (left) and Pierre Alechinsky working on their
collaborative series *Encres à deux pinceaux*, Alechinsky's studio,
Bougival, France, 1976.

I respect Alechinsky's statement and am sympathetic with it as far as it goes. But I frankly think, as I have tried to show in this essay, that collaboration is oftentimes so open-ended and pervasive that it is not consciously recognized. Sometimes critics collaborate with artists, artists with other artists, artists with viewers, and all of us with history. Collaboration can be a conspiracy, and it can be open. It is important because it allows all of us to break down barriers, to cease being locked into a monolithic and largely materialistic definition of the self, and to recognize art as dynamic rather than static, part of a discourse and not an absolute, connected with history and people and not simply a decontextualized masterpiece. Of course, artists conceive and make art, but all of us collaborate in creating its cultural role. We can remove art from its context and aestheticize it as significant form, and that too is a possible way of dealing with it in a difficult, changing world that needs definite anchors even if they are only manifested sensibilities. But we can also recognize that art plays an important function of symbolizing reality at a particular time; to function it requires numbers of people pooling their common interests to think about it and assess it. In this manner art becomes collaborative, and it also becomes culture.

NOTES

1. Hayden White, *Metahistory: The Historical Imagination in Nineteenth-Century Europe* (Baltimore: Johns Hopkins, 1974).

2. In particular, I am thinking of Walter Benjamin and Robert Venturi. But there are a number, including the early art historians Alois Riegl and Heinrich Wölfflin, who were concerned more with ways of assessing historical change and understanding period styles than they were with individual genius.

3. Grace Seiberling, *The Amateurs: Sources of Innovation in British Photography 1850–1860*, exh. cat. (Rochester: George Eastman House, forthcoming).

4. Annette Michelson, "Robert Morris: An Aesthetics of Transgression," in *Robert Morris*, exh. cat. (Washington, D.C.: Corcoran Gallery of Art, 1969), pp. 7–89.

5. Edward Kienholz and Nancy Reddin, "Artist's Statement," Braunstein Gallery, San Francisco, August 1982. The piece was first exhibited in West Berlin in 1974. After two days it was confiscated; through the help of the American Embassy, the artists were able to recover their work. The work has been exhibited at the Louisiana Museum in Denmark.

6. Maurice Tuchman, *A Report on the Art and Technology Program of the Los Angeles County Museum of Art, 1967–1971*, exh. cat. (Los Angeles: Los Angeles County Museum of Art, 1971).

7. Barbara Cavaliere and Robert C. Hobbs, "Against a Newer Laocoon," *Arts Magazine* 51, no. 8 (April 1977): 110–17.

8. Undated (1983) letter to the author.

Catalog of the Exhibition

Brief biographies of the artists, focusing on their collaborative activities, are at the back of this volume, beginning on page 193.

An asterisk (*) indicates a work of art exhibited only at the Hirshhorn Museum and Sculpture Garden.

Dimensions are given in centimeters (and inches), height preceding width preceding depth. For works on paper, dimensions indicate sheet size.

*1
Sonia Delaunay and Blaise Cendrars
La Prose du Transsibérien et de la petite Jehanne de France, 1913
Gouache and ink on printed scroll
207 × 35.3 (81½ × 13⅞)
Museum of Modern Art, New York, purchase

2
Robert Philippi and Egon Schiele
Oriental Man Standing and Portrait of a Man, 1914
Drypoint
15.9 × 22.5 (6¼ × 8⅞)
Private collection, courtesy Galerie St. Etienne, New York

Dada

*3
Marcel Duchamp with Walter Arensberg
With Hidden Noise, 1916
Assisted ready-made; ball of twine between two brass plates, joined
by four long screws, containing a small unknown object added by
Arensberg
13 × 13 × 11.4 (5¹/₈ × 5¹/₈ × 4¹/₂)
Philadelphia Museum of Art, Louise and Walter Arensberg Collection

4
Jean Arp and Sophie Taeuber-Arp
Duo-Collage, 1918
Paper on cardboard
82 × 60 (32¼ × 23½)
Staatliche Museen Preussischer Kulturbesitz, Nationalgalerie, Berlin,
Federal Republic of Germany

5
Jean Arp and Sophie Taeuber-Arp
Dada Object, c. 1918–19
Gilt-edged wooden box containing silk and wool forms
15.2 × 12.7 × 12.1 (6 × 5 × 4¾)
Private collection

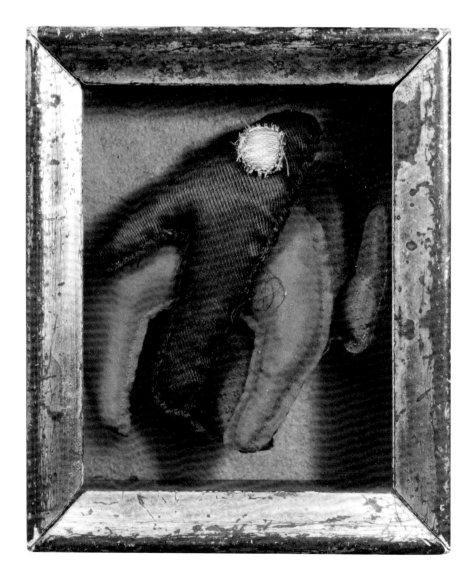

6
Raoul Hausmann with Johannes Baader
Der Dada 1, 1919
Periodical
29 × 22 (11½ × 8⅝)
Merrill C. Berman, Scarsdale, New York

7
George Grosz and John Heartfield
Der Dada 2, 1919
Periodical
29 × 23 (11½ × 9⅛)
Merrill C. Berman, Scarsdale, New York

8
George Grosz, Raoul Hausmann, and John Heartfield
Der Dada 3, 1920
Periodical
23 × 15.5 (9⅛ × 6⅛)
Merrill C. Berman, Scarsdale, New York

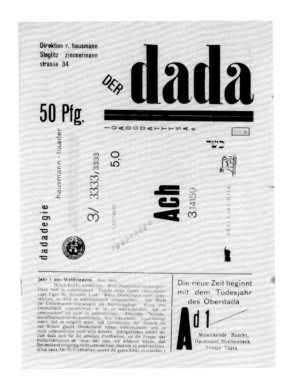

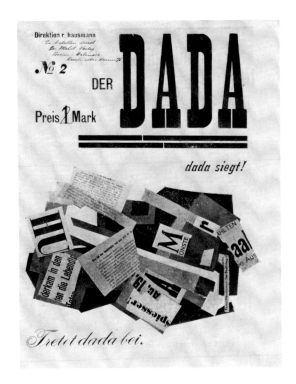

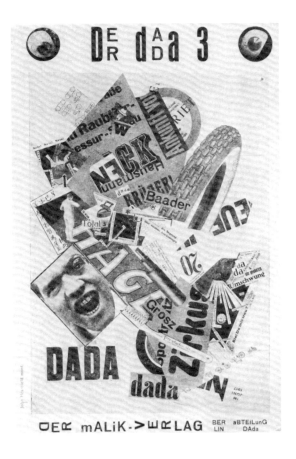

9

George Grosz and John Heartfield
Erste International Dada-Messe [*First International Dada Fair*], 1920
Exhibition brochure
31.1 × 38.7 (12¼ × 15¼)
Merrill C. Berman, Scarsdale, New York

"Working in Berlin in 1916, John Heartfield (formerly Helmut Herzfelde) and George Grosz began collaborating together with photomontage—an art form they claimed to have invented. They combined cut-up photographs, printed matter, and drawings in order to create new, startling, and frequently shocking contexts and statements. Both artists had previously explored the realm of political and social satire, and now returned to it as the direction for their new media. Unlike its predecessor—Cubist collage—subject was paramount: great metropolises, war, social injustices, and later on, Nazis.

"Heartfield and Grosz became directly involved in the Dada movement when it arrived in Berlin in 1918. They also worked together within the cooperative activity of the Malik-Verlag publishing house, where they collaborated on the publication *Neue Jugend*. After their collaboration ended, John Heartfield continued working in photomontage and developed it into a major art form."

—C.J.M.

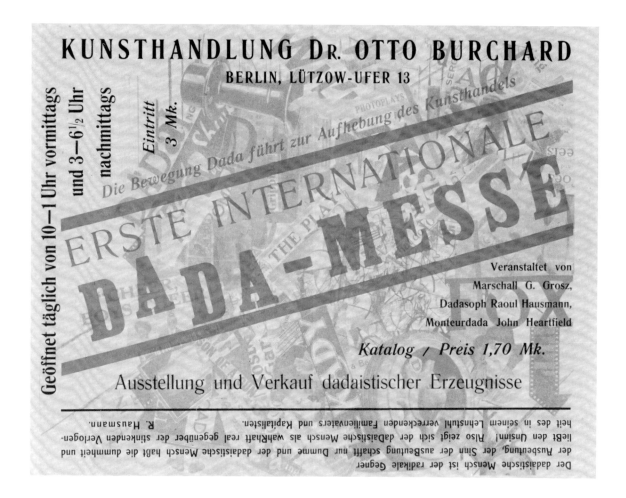

*10
Jean Arp, Johannes Baader, Hugo Ball, Giorgio de Chirico, Jefim
Golyscheff, George Grosz, Raoul Hausmann, John Heartfield,
Hannah Höch, Franz Jung, Gerhard Preiss, Otto van Rees, Christian
Schad, Kurt Schwitters, Walter Serner, and Sophie Taeuber-Arp
Dadaco, 1919–20
Thirteen prints for a proposed Dada handbook
Varying in size from 59 × 43.5 (23¼ × 17⅛) to 59 × 46 (23¼ ×
18⅛)
Berlinische Galerie, Berlin, Federal Republic of Germany

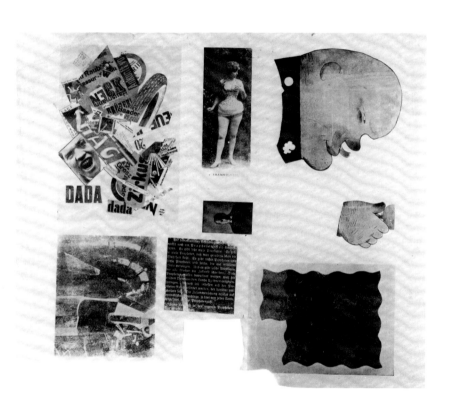

*11

Raoul Hausmann and Hannah Höch

Dada Cordial, c. 1920

Photomontage and collage on paper

45 × 58 (17³/4 × 22⁷/8)

Berlinische Galerie, Berlin, Federal Republic of Germany

12

Max Ernst with Jean Arp

Physiomythological Flood-Picture [*Switzerland: Birthplace of Dada*],
1920

Collage on paper mounted on paperboard

11.2 × 10 (4¹/2 × 4)

Kunstmuseum with Sprengel Collection, Hanover, Federal Republic
of Germany

13

Louise Strauss Ernst and Max Ernst

Augustine Thomas and Otto Flake or *Otto Flake Synthesizes the Art
of the Corset with a Taste of the Refinement of the Material and of the
Metaphysical Meat, While Arp Prefers the Meat of the Flowers of Evil*,
1920

Collage on paper

23.1 × 13.4 (9 × 5¹/4)

Kunstmuseum with Sprengel Collection, Hanover, Federal Republic
of Germany

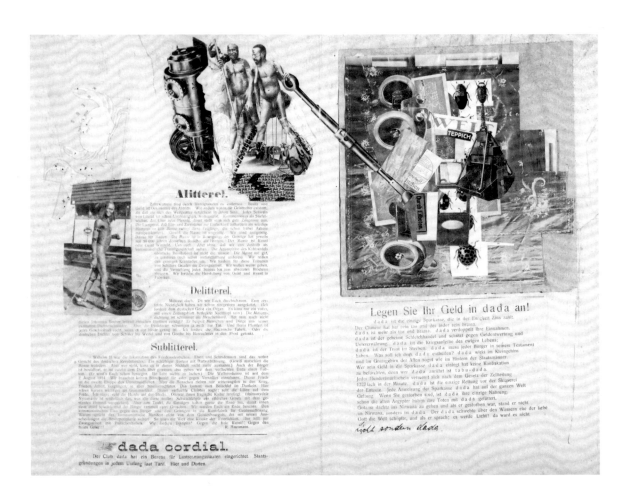

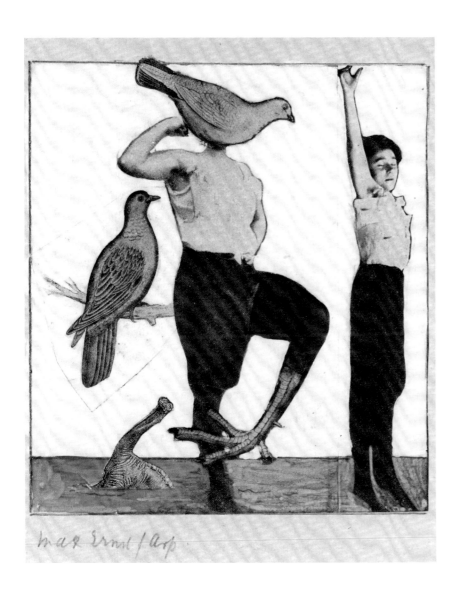

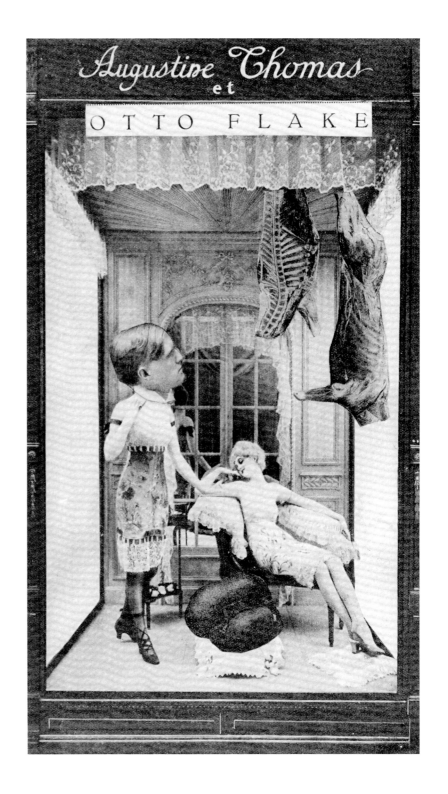

14
Theo van Doesburg and Kurt Schwitters
Small Dada Soirée, 1923
Color lithograph
30 × 30 (11⁷⁄₈ × 11⁷⁄₈)
Leslie and Alice Schreyer, Washington, D.C.

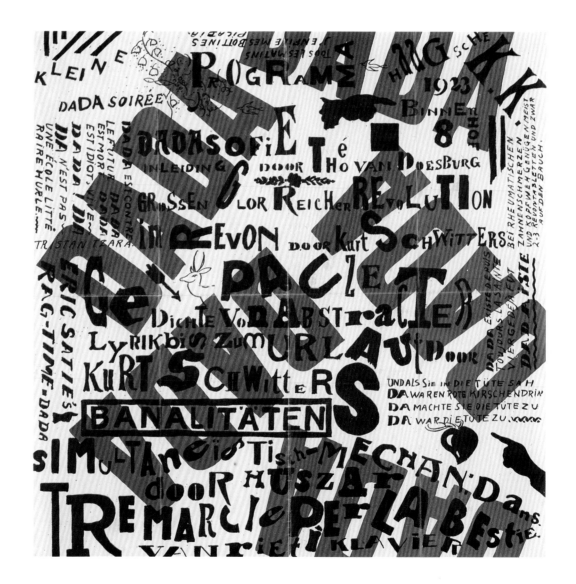

15
Georgii Stenberg, probably with Vladimir Stenberg
KPS-11, 1919–20, reconstructed 1975
Painted wood, iron, and glass
236.5 × 84.9 × 46.7 (93 1/8 × 33 1/2 × 18 3/8)
Los Angeles County Museum of Art, gift of Jean Chauvelin

16
Kasimir Malevich and Mikhail Matiushin
Color Study, c. 1922–23
Collage of pasted papers on paper
26 × 31.8 (10 1/4 × 12 1/2)
Private collection

17
Kasimir Malevich and Mikhail Matiushin
Color Study, c. 1922–23
Collage of pasted papers on paper
27 × 31.8 (10⅝ × 12½)
Private collection

18
Georgii Stenberg and Vladimir Stenberg
Who, What, When at the Chamber Theater [*Kto, shto, Kogda V
Kamernom Teatre*], 1924
Brochure (theater program)
34.7 × 26.2 (13⅝ × 10⅜)
Alma H. Law, Scarsdale, New York

"What was the nature of the Stenberg brothers' collaboration?
This is always a vexing question when dealing with any form of
artistic collaboration, but it is particularly difficult when only one
half of the collaborative team is available to testify about it.

"In interviews with this author, as well as with other persons,
Vladimir Stenberg has always maintained that he and his brother
had worked so closely together since their earliest years that it
was impossible to separate out who did what on any given project:

It was because we grew up together. . . . It began with my
getting sick the first year of school and staying back the second.
George entered the same school. And we worked together,
studied together, worked for our father together, and so on from
our earliest years. And therefore we developed very much the
same view of everything.

"At another time Vladimir stated:

When my brother and I were working together, we even made a
test. What color should we paint the background? We would do
it like this: he would write a note and I would write one. I had no
idea what he had written, and he didn't know what I had written.
We would write these notes and then look, and they would
coincide! You think maybe one was giving in to the other? No.

"According to Vladimir, when it came to designing posters,
which after their first one were always signed '2-Stenberg-2,' he
and his brother would begin by discussing various ideas. After
they had decided on a version, they would then prepare the paper,
and using an epediascope, project on it the image they had
chosen, tracing only the basic contours.

Then we'd begin to work and one of us, say me, would propose,
'Let's put it on a yellow background,' and George would agree,
'Yes, let's have yellow.' It was as though George was obeying

19
Georgii Stenberg and Vladimir Stenberg
The Three Musketeers, 1927
Film poster
95 × 62 (37³/₈ × 24³/₈)
Merrill C. Berman, Scarsdale, New York

me. And then he would say, 'Let's do it on a black background.'
I would say, 'Let's do it on black.' As if I were taking orders.
Then we would try such a version. And when we were talking
about, say, what color to make the face, what color to do the
background or something else, each of us would jot down
notes. There was always a complete coincidence.

"Evidence from other sources, however, suggests that their
working relationship was not always as smooth as Vladimir
recalls. Mikhail Dlugach, for example, another member of the
pioneering group of film poster artists brought together in 1924 to
work for Sovkino, and who for a period of time lived with the
brothers, has characterized their relationship as at times 'very
stormy' (in conversation, February 6, 1982).

"In writing about the two artists, their colleague, and sometimes
collaborator, Yakov Rukhlevsky has shed additional light on their
collaboration. He characterized the personalities of the two artists
as follows:

Georgii Stenberg was a talented artist who had a subtle sense of
color; he was a fine draftsman with a very well-balanced, quiet
and to a certain degree, slow-reacting personality. He always
resolved his creative problems thoughtfully and patiently. His
works evoked admiration for their sublety of design, culture of
color, and distinctness of form.

 Vladimir Stenberg, who was no less talented, was a complete
contrast to his younger brother in personality. He was first of all,
hot tempered. In solving any task, Vladimir would quickly be
ignited by one or another creative idea, and there was no
shortage of those with him.

"In discussing their working relationship, Rukhlevsky went on to
state:

If some difference of opinion arose, there would be a heated
argument between the brothers. These artistic arguments,

20
Georgii Stenberg and Vladimir Stenberg
Buster Keaton, 1929
Film poster
95 × 62 (37³/₈ × 24³/₈)
Merrill C. Berman, Scarsdale, New York

sometimes long and very stormy, which arose fairly often, as a rule ended quickly in friendly collaboration. It was as though, according to the law in physics of the attraction of opposites, those two artists, so unlike in temperament and personality, would fuse in a single creative contact, successfully complementing each other, to create works of art which couldn't be passed by with indifference. [Iakov Rukhlevsky, 'The Soviet Film Poster's First Steps' (Pervye shagi Sovetskogo kinoplakata), *The Soviet Film Poster* (Sovetskii kinoplatkat. Sbornik statei), ed. V. A. Tikhanova (Moscow: Sovetskii Khudozhnik, 1961).]

"Perhaps more telling are the remarks made by Vladimir's wife, Nadezhda, who had ample opportunity to observe the two brothers together from 1928 until Georgii's death. Only eighteen at the time she met Vladimir, she went often to the brothers' workshop on Buamin Street to watch them work. When Vladimir and Nadezhda were married in 1929, Vladimir moved in with Nadezhda and her mother, and Georgii and his wife moved into the workshop. After that, until 1932 when they were given a new workshop, the two brothers worked at the apartment where Vladimir and Nadezhda were living. Nadezhda recalls that the two brothers were always working against a deadline and so they would work as quickly as possible:

As a rule, they would agree. Though sometimes there were stormy arguments. Vladimir was hot-tempered and quick to fly off the handle. Georgii would paste down the paper on the board they used for preparing the poster (pasting it only around the edge so that it could later be cut off) and then in a ceremony that became a kind of tradition, I would put on some lipstick and 'for luck' put my lip print on the edge of the paper. After the paper was pasted down and the general outline of the figure was sketched, they would sit with the flat board, working

*21

Georgii Stenberg and Vladimir Stenberg
Fragment of an Empire, 1929
Film poster
94.2 × 62.3 (37⅛ × 24½)
Merrill C. Berman, Scarsdale, New York

together, each doing whatever part was closest to them. [In conversation with the author, January-February 1982.]

"There was apparently no clear division of labor between the brothers, except that according to Nadezhda, 'Vladimir always did the lettering. He was an engineer by training, and he could do it freehand. Just as in their work in the theater, Georgii loved doing the costume sketches whereas Vladimir liked doing the maquettes. Vladimir also did the plans for the drawings of the various projects they did, such as, for example, the one for the Dneperstroi Hydroelectric Plant. But the painting on these they always did together.'

"What the available evidence suggests, then, is that in their collaboration each brought to their work particular talents: Georgii, principally an artist's eye for color and form, and Vladimir, an engineer's talent for layout and design.

"The fact that Vladimir virtually ceased making posters after Georgii's death in 1932 has also raised questions about their collaboration, especially since those few posters by Vladimir that have come to light (which he signed simply 'Stenberg'), cannot match, either in artistic or innovative terms, the posters the brothers designed together."

—Excerpted from Alma H. Law, *The Stenberg Brothers Film Posters* (New York: Ex Libris, forthcoming).

*22
Joan Miró, Max Morise, Man Ray, and Yves Tanguy
Exquisite Corpse: Nude, 1926–27
Pen and ink, pencil, and colored crayon on paper
36.2 × 22.9 (14¼ × 9)
Museum of Modern Art, New York, purchase

23
Joan Miró, Max Morise, Man Ray, and Yves Tanguy
Exquisite Corpse, 1928
Pen and ink and crayon on paper
34 × 21.6 (13³⁄₈ × 8¹⁄₂)
Mr. and Mrs. E. A. Bergman, Chicago

*24
André Breton, Max Morise, Pierre Naville, Benjamin Péret, Jacques
Prévert, Jeannette Tanguy, and Yves Tanguy
Exquisite Corpse: Figure, 1928?
Collage on paper
28.7 × 22.9 (11³⁄₈ × 9)
Museum of Modern Art, New York, van Gogh Purchase Fund

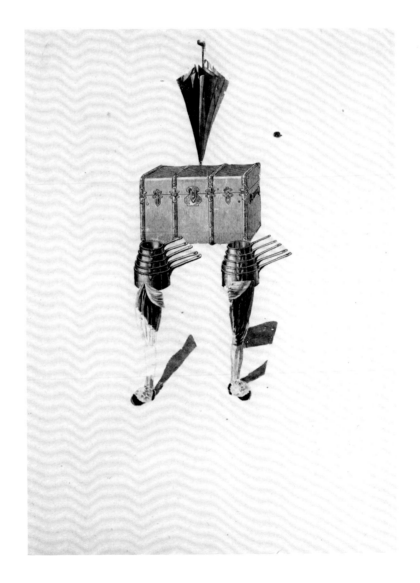

25
André Breton, Frédéric Mégret, and Suzanne Muzard
Exquisite Corpse, c. 1930
Colored chalk on black paper
31.8 × 23.8 (12½ × 9⅜)
Private collection

26
Victor Brauner, Jacques Hérold, and Yves Tanguy
Exquisite Corpse, c. 1932
Pencil and collage on paper
25.1 × 19 (9⁷/₈ × 7¹/₂)
Indiana University Art Museum, Bloomington

27
Pablo Picasso and Salvador Dali
Surrealist Figures, c. 1933
Mixed media on etching
36 × 42.5 (14¹/₄ × 16³/₄)
Musée Picasso, Paris

28
Victor Brauner, André Breton, Jacques Hérold, and Yves Tanguy
Exquisite Corpse, 1934–35
Pencil on paper
26 × 17 (10¹/₄ × 6³/₄)
Jacques Hérold, Paris

29

Oscar Dominguez, Estéban Francès, and Remedios Varo
Exquisite Corpse, 1935
Collage on paper
27.3 × 20 (10³/₄ × 7⁷/₈)
Edouard Roditi, Paris

"Remedios Varo was born on December 14, 1913, in the town of Anglés in the region of Gerona in the Spanish province of Catalonia. Her parents were both Spanish, her heritage combining the southern temperament of her father who was from Córdoba in Andalusia with the northern tradition of her mother, a Basque from Vizcaya. The youngest of three children and their only girl, Varo spent her early years traveling as the work of her father, a hydraulic engineer, took them throughout Spain and north Africa.

"Once finally settled in Madrid, Varo was sent first to convent school and, after exhibiting early artistic talent, to Spain's most prestigious art school, the Academia de San Fernando in Madrid. Toward the end of her traditional academic training, which lasted from 1929 to 1933, she married a fellow student, Gerardo Lizárraga. Upon finishing their studies, the couple spent a year in Paris (1934) where they had their first contact with the Surrealist group. Returning to Spain, they settled in Barcelona in 1935, the year in which Varo participated with Oscar Dominguez, Marcel Jean, and Estéban Francès, who was her lover at the time, in the

30
Remedios Varo, Oscar Dominguez, and Marcel Jean
Exquisite Corpse, 1935
Collage on paper
26.9 × 17 (10½ × 6¾)
Marcel Jean, Paris

game of *cadavre exquis*. As Marcel Jean remembers this time:

I met Remedios and Estéban Francès when I visited Oscar Dominguez, their friend and mine, while he was in Barcelona in July 1935. Remedios' husband, Gerardo Lizarraga, and herself, were commercial artists (advertising) [Varo worked for J. Walter Thompson, the publicity agent at this time]. . . . We spent some time together making 'cadavre exquis' among which is the one at the MOMA.

"In this letter to Varo's biographer, Janet Kaplan, from August 7, 1981, Jean refers to the *cadavre exquis* by Remedios with Dominguez, Francès, and Jean in the MOMA collection that was reproduced in the Museum's exhibition and catalogue by William Rubin, *Dada, Surrealism, and Their Heritage of 1968* in which he lists her as Remedios Lissarraga [sic]. Other examples of this group's collaboration include the two pieces in the exhibition *Artistic Collaboration* also dating from July 1935 [cat. 29, 30]."

—Statement by Janet Kaplan, July 1983.

31
Marcel Jean, Estéban Francès, and Oscar Dominguez
Exquisite Corpse, 1935
Collage on paper
29 × 22.2 (11³/₈ × 8³/₄)
Marcel Jean, Paris

32
Marcel Jean, Oscar Dominguez, and Estéban Francès
Exquisite Corpse, 1935
Collage on paper
21 × 15.7 (8¹/₄ × 6¹/₄)
Marcel Jean, Paris

33
Estéban Francès, Oscar Dominguez, and Marcel Jean
Exquisite Corpse, 1935
Collage on paper
26.8 × 17 (10¹/₂ × 6³/₄)
Marcel Jean, Paris

Sur le char, d'un côté des personnages vivants
femmes et enfants symbolisant La Terre, de
l'autre des mineurs symbolisant Germinal
L'encadrement dentelé tricolore autour du
portrait (en transparent) est en contreplaqué
et colorié des 2 côtés — La panoplie de livres
est en contreplaqué également — à la base du
char
Les cocardes et banderoles à la base du
char sont en étoffe
Le portrait de Zola doit être très schématique
comme une gravure sur bois largement traitée

34
Marcel Gromaire and Jacques Lipchitz
Chariot Design for a Popular Front Parade, 1936
Watercolor and pen and ink on paper
32 × 24 (12⅝ × 9½)
André Fougeron, Montrouge, France

35
Joseph Cornell after Leonor Fini
Sketch for "The Lost Needle," c. 1937
Pen and ink and photographs on paper
32.7 × 28.6 (12⅞ × 11¼)
Mr. and Mrs. E. A. Bergman, Chicago

36
Louis Marcoussis and Joan Miró
Portrait of Miró, 1938
Etching
49.5 × 35.6 (19½ × 14⅞)
Hood Museum of Art, Dartmouth College, Hanover, New
Hampshire

37
Estéban Francès, Matta, and Gordon Onslow-Ford
Exquisite Corpse, 1939
Colored crayon on black paper
29.8 × 15.9 (11¾ × 6¼)
Conroy Maddox, London

"A little background information on the *cadavre exquis* [37]: At the beginning of the war Gordon Onslow-Ford came over to this country from France where he had been painting in the company of Estéban Francès and Matta. It was at this time, 1940, that Onslow-Ford gave me the work on which the three had collaborated. Before Onslow-Ford left for the States he helped, with E. L. T. Mesens and Roland Penrose, to organise the exhibition *Surrealism Today* at the Zwemmer Gallery, London. . . .

"The names of the three artists involved have been written down the left-hand side of the work by Onslow-Ford in the order in which the work was made."

—Letter from Conroy Maddox to Anna Brooke (Librarian, Hirshhorn Museum and Sculpture Garden), July 20, 1983.

38
Victor Brauner and Jacques Hérold
Exquisite Corpse, 1941
Chinese ink on paper
14 × 12 (5½ × 4¾)
Jacques Hérold, Paris

*39
André Breton and Frederick Kiesler
Ode to Charles Fourier, 1945
Final maquette by Kiesler: 42 panels, recto and verso; tempera,
India ink, and pencil on paper
9.5 × 428 (3¾ × 168½)
Private collection, courtesy Ex Libris, New York

*40
Marcel Duchamp and Enrico Donati
Please Touch, 1947
Plaster
21.9 × 18.2 (8⅝ × 7⅛)
Enrico Donati, New York

"Historically, this is how it happened. Marcel Duchamp had been requested by André Breton to make the cover for the Paris Maeght exhibition *Thirty Years of Surrealism*, and came to see me. He wanted to reproduce a breast on the cover. He presented me with a plaster model [40] and gave me the problem of how to make 1,000 reproductions.

"I went to work on the subject, and I found that if we took a foam rubber 'falsie' we could flatten it out and paste it on cardboard. So I went ahead molding over 1,000 pieces. However, the breast looked too naked when pasted on the cover of the book, so I cut out a piece of black velvet and made it appear as if it was protruding from a dress. Marcel Duchamp and I colored, one by one, the 1,000 and more nipples in my studio. Then I added 'Prière de Toucher.'

"I realized that when the packing and corrugated boxes to be sent to Paris were done, the rubber breasts, being pushed down to put as many as possible in a box, reacted like a spring the moment you opened the flap and the breasts flew up to the ceiling. Under the circumstances, I wrote to André Breton to have at Customs photographers and reporters since I was sure the boxes would be opened because of the inscription I had put on each of them, 'Alive Breasts.' Naturally, the scene was astounding and exciting to all the French newspapers. I have pictures of Breton surrounded by photographers and reporters along with 'flying breasts.' "

—Letter from Enrico Donati to Cynthia Jaffee McCabe, July 18, 1983.

*41
Marcel Duchamp and Enrico Donati
Please Touch, 1947
Book cover for *Le Surréalisme en 1947*; foam rubber and velvet on
paperboard
23.5 × 20.3 (9¼ × 8)
Enrico Donati, New York

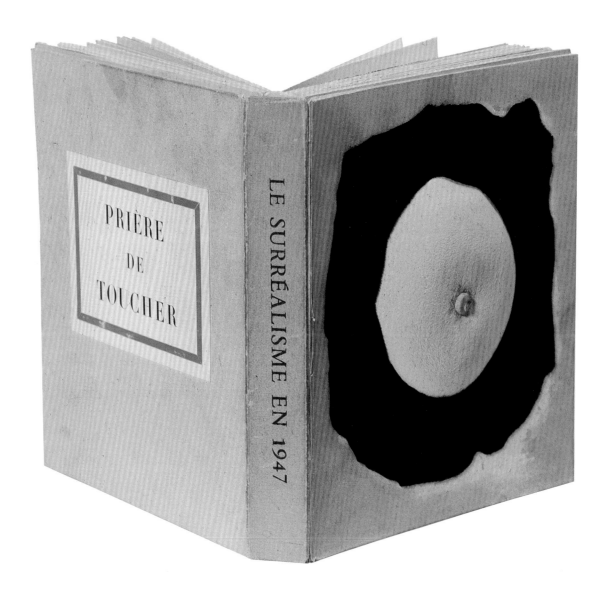

*42
Max Ernst, William N. Copley, and Dorothea Tanning
Toy Theater, late 1940s
Mixed media construction with three paper collage-rolls
19 × 28 × 7.5 (7½ × 11 × 3)
William N. Copley, New York

"I met Max Ernst and his wife at the time of my Beverly Hills Gallery and soon got in the habit of crossing the California desert to visit them in the breath-taking environment of their Sedona, Arizona, home.

"At the time Sedona was a combination post office/general store and we had to provide our own entertainment. The *Toy Theater* [42] was the entertainment of one of those evenings."

—Letter from William Copley to Cynthia Jaffee McCabe, July 1983.

"The *Toy Theater* [42] was made as an affectionate joke while Bill Copley was staying with us one time in Sedona, Arizona, where Max and I lived for six years. I remember that we had an awfully good time doing it."

—Letter from Dorothea Tanning to Cynthia Jaffee McCabe, June 25, 1983.

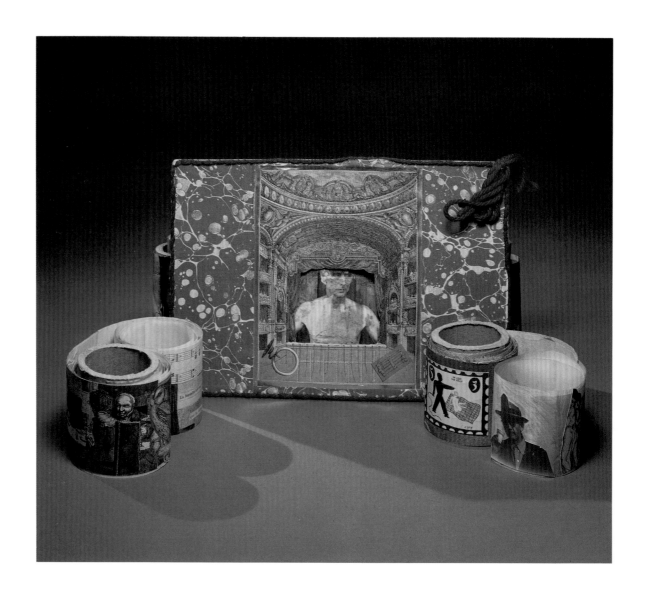

43
Jean Arp and Camille Bryen
Temps troué, 1951
Book with original woodcuts
20 × 15.2 (8 × 6)
Museum of Modern Art Library, New York

OURAGAN D'ARDOISE

Ouragan d'ardoise trancheuse d'œufs
l'hivernal cercueil thoracique entraîne
les monceaux de navigations et d'escaliers vivants
à se perdre
dans ses chaussures admirablement sucrées
où se détrempent tresses blondes et filialement armoriées
l'éventail de sommeil — jeune fille
qui se jaunit et se froisse
La tisane lunatique des déshabillés
les regrettables pressions de promenades rouillées
Un accordéon de phare indispose la mer
et désoriente les vêtements en peau de coquillage
Les lamés des souvenirs lilas rejoignent
les gras de boutons
les chairs à moustaches
les cosmétiques rondes militaires
les animaux savants dévastant l'orchestre des peintures
 Mais
dans une cage de modiste les segments désœuvrés
prennent peaux et grillent
La géographie du feu cerne les sensuels continents
endormis de beurre frais
qui brûle les intérieurs d'os les magazines de seins
les craies de couleurs de gorges
que j'oblitère d'inouies découpures
 impressions de guimpes et retour grillé des romances
 de mes doigts de sorbets une tapisserie de lèvres
 s'épuise [roses
Des barques sortent des bergeries naufrages de poitrines
Des arceaux d'inquiétudes pleurés
cartes postales des suicides en cours
des poussières photographiques
Le bouquet mal lavé de rubans pâles
pavé des yeux de l'hiver qui s'étoile à mes pieds
raidit les jambes des tables
tire les bas des correspondances

16

*44
Victor Brauner and Matta
Intervision: The Invited Guest, 1955
Oil on canvas
145 × 195.5 (57 × 77)
Matta, Paris

45
Victor Brauner and Matta
Intervision, 1955
Charcoal and pastel on paper mounted on linen
74 × 103 (29$\frac{1}{8}$ × 40$\frac{5}{8}$)
Max Clarac-Serou, Paris

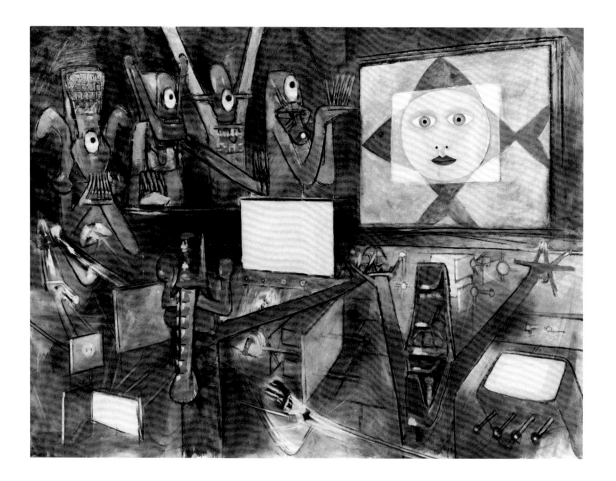

46
Elizabeth Voorh Cornell Benton with Joseph Cornell
Untitled, 1955–60
Pen and ink, pencil, and crayon on magazine-derived illustrations,
Spanish text, and newspaper on fiberboard panel in wooden frame
38.4 × 30.8 (15⅛ × 12⅛)
National Museum of American Art, Washington, D.C., gift of Mr.
and Mrs. John A. Benton

47

Elizabeth Voorh Cornell Benton with Joseph Cornell
Untitled, c. 1960
Mixed media on paper mounted on panel
34 × 23.8 (13³/₈ × 9³/₈)
Robert H. Bergman, Chicago

"I am now going to put down a long deferred statement about the 'companion collages' [46] which now are with you at the National Collection [now National Museum of American Art]. As you know, Joe used to send me quantities of 'source material' to do my collages. One time he sent two sheets of colored pictures of glass paper weights, which are called 'multi-flora' I believe. He said that maybe I could use one or more of them in a collage. I chose one, and with pictures from the 'National Geographic' I made a collage. I sent it to him, as I did all of the ones I made and he mounted it on the masonite and framed it. Some time later, when we were in Flushing, he put some collages in the car and when we got home, I found mine and the one he had done amongst them. *Unbeknown to one another*, we had used the *same* paper weight from the two sheets (he had duplicates). As you know, he framed them in the same type of frame. At one time, and the only time such a thing happened, I dropped mine and some years later, Elliot Gordon (then with the Queens Museum) repaired it for me. Trying to date these collages is difficult but I *think* it was in the '50s. If I could find the issue of the 'Geographic' I used, it would pinpoint it but I just can't face any such research."

—Letter from Elizabeth Cornell Benton to Lynda Roscoe Hartigan, October 14, 1977, on file in the curatorial records of the Department of Twentieth-Century Painting and Sculpture, National Museum of American Art.

Arp and Taeuber-Arp

48
Jean Arp and Sophie Taeuber-Arp
Marital Sculpture, 1937
Lathe-turned and sawed wood
39.1 × 29.5 × 27.5 (15$^3/_8$ × 11$^5/_8$ × 10$^7/_8$)
Stiftung Jean Arp und Sophie Taeuber-Arp, Rolandseck, Federal
Republic of Germany

"We don't want to copy nature. We don't want to reproduce, we
want to produce. We want to produce like a plant that produces a
fruit, and not reproduce. We want to produce directly and not by
way of any intermediary.

"Since this art doesn't have the slightest trace of abstraction,
we name it: concrete art.

"Works of concrete art should not be signed by the artists.
These paintings, sculptures—these objects—should remain
anonymous in the huge studio of nature, like clouds, mountains,
seas, animals, men. Yes! Men should go back to nature! Artists
should work in communities as they did in the Middle Ages. In
1915, O. van Rees, C. van Rees, Freundlich, S. Taueber, and
myself made an attempt of that sort.

"That year I wrote: 'These works are constructed with lines,
surfaces, forms, and colors that try to go beyond the human and
attain the infinite and the eternal. They reject our egotism. . . . The
hands of our brothers, instead of being interchangeable with our
own hands, have become enemy hands. Instead of anonymity, we
have renown and masterpieces; wisdom is dead. . . .
Reproduction is imitation, play acting, tightrope walking.'

"The Renaissance bumptiously exalted human reason. Modern
times with their science and technology have turned man into a
megalomaniac. The atrocious chaos of our era is the consequence
of that overrating of reason."

—Jean Arp, "Concrete Art" (1942), in *Arp on Arp: Poems, Essays,
Memories* (New York: Viking, 1972), pp. 139–40.

49
Jean Arp and Sophie Taeuber-Arp
Signpost [*Jalon*], 1938
Carved wood
60 × 25 × 36 (23⅝ × 9⅞ × 14¼)
Fondation Arp, Clamart, France

"The exhibit that took place in the Tanner Gallery in Zurich in November 1915 turned out to be the most important event of my life. It was there that I first met Sophie Taeuber. . . .

"In the works that she showed me shortly after we met, Sophie Taeuber had also used wool, silk, cloth, and paper. There still exist still lifes and portraits going back to her very early artistic activity. But by then she had already destroyed most of her works because she was looking for new solutions in art. Her spiritual purity, her love for her craft led to a maximum simplification of the forms she created in her very first abstract compositions. . . .

"Sophie Taeuber and I decided to completely renounce the use of oil colors in our compositions. We wanted to avoid any reminiscence of canvas painting, which we regarded as characteristic of a pretentious and conceited world. In 1916 Sophie Taeuber and I began to collaborate on large compositions in cloth and in paper.

"With Sophie Taeuber's help, I embroidered a series of vertical and horizontal configurations. From 1916 to 1919 I experimented in many different ways, and the same problems still preoccupy me today. . . .

"Around that time Sophie Taeuber and I were collaborating on collages, some of which, dating from 1918, still exist. As early as 1916 Sophie Taeuber had been doing colored-pencil drawings which anticipated collages. After long and impassioned discussions, the rules for the construction of our mural painting took shape. Horizontal and vertical configurations and the use of new materials had become for me the alpha and omega of plastic art. . . .

"The years during which we worked exclusively with the new materials, turning out embroideries and configurations in paper or cloth, affected us like a purification, like spiritual exercises, so that we finally rediscovered painting in its original purity. . . .

"Until 1920 we were unaware of the importance of our

50
Jean Arp and Sophie Taeuber-Arp
Le Siège de l'air: Poèmes de Jean Arp 1915-1945, 1946 (drawings made 1939)
Printed book
21.3 × 15 (8³/₈ × 5⁷/₈)
Library of Congress, Washington, D.C.

experiments. When the first international publications came to our attention after the war, we were quite surprised to see that identical attempts had been made throughout the rest of the world. Mondrian's and van Doesburg's works especially, with their great influence on Dutch and international contemporary painting, elicited our admiration. At the same time we were amused by the fact that everyone who had drawn a square felt compelled to emit a shriek of euphoria. Nevertheless, we decided to patent our squares. Our static investigations actually were the product of intentions essentially different from those of most 'constructivists.' We foresaw paintings of meditations, mandalas, signposts. Our signposts of light were meant to point out the roads to space, depth, infinity."

—Jean Arp, "Signposts" (1950), in *Arp on Arp: Poems, Essays, Memories* (New York: Viking, 1972), pp. 270–73.

51
Jean Arp and Sophie Taeuber-Arp
Duo-Painting, 1939
After drawing in *Le Siège de l'air*, p. 29
Oil on canvas
60 × 42 (23⅝ × 16½)
Stiftung Jean Arp und Sophie Taeuber-Arp, Rolandseck, Federal
Republic of Germany

"These lithographs [52] are collaborations. Sonia Delaunay, Sophie Taeuber, Alberto Magnelli, and I did them, sometimes two of us together, sometimes three or four of us. They are duos, trios, quartets. Four instruments create a harmonious consonance. Four people blend, submerge, submit, to attain a plastic unity. The lines of one hand furrow the color spaces constructed by a fellow hand. Shapes join together and live naturally as do organs in a body. An alloy is cast into a bell and rings out.

"1941. We found ourselves in Grasse. The constellations bringing those four artists together were especially favorable to the realization of joint work, for the tragic hours during which these lithographs were conceived compelled modesty, the sacrifice of all vanity, the effacement of any overly individual expression."

—Jean Arp (1949), *Arp on Arp: Poems, Essays, Memories* (New York: Viking, 1972), p. 257.

52
Jean Arp, Sonia Delaunay, Alberto Magnelli, and Sophie Taeuber-Arp
Four from Grasse: Jean Arp, Sonia Delaunay, Alberto Magnelli, Sophie Taeuber-Arp, 1950
Portfolio of ten colored lithographs after collaborative drawings, 1941–42
Each 27 × 21 (10⅝ × 8¼)
Ex Libris, New York

53
Alberto Magnelli
Untitled, 1941–42
Chinese ink on paper; drawing for *Four from Grasse* portfolio,
plate 4
21 × 27 (8¼ × 10⅝)
Fondation Arp, Clamart, France

54
Alberto Magnelli and Sophie Taeuber-Arp
Untitled, 1941–42
Chinese ink on paper; drawing for *Four from Grasse* portfolio,
plate 4
21 × 27 (8¼ × 10⅝)
Fondation Arp, Clamart, France

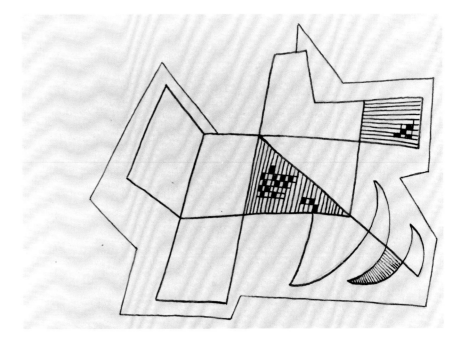

55
Jean Arp, Alberto Magnelli, and Sophie Taeuber-Arp
Untitled, 1941–42
Tempera on paper; drawing for *Four from Grasse* portfolio, plate 4
27 × 21 (10⅝ × 8¼)
Fondation Arp, Clamart, France

56
Sonia Delaunay, Alberto Magnelli, and Sophie Taeuber-Arp
Untitled, 1942
Tempera on paper
27 × 21 (10⅝ × 8¼)
Fondation Arp, Clamart, France

57
Jean Arp after Jean Arp and Sophie Taeuber-Arp
Geometric Duo-Drawing, 1947
Collage and pen and India ink on paper
30.4 × 23.2 (12 × 9)
Kupferstichkabinett, Kunstmuseum, Basel, Switzerland

58
Jean Arp after Sophie Taeuber-Arp
Last Construction, 1960
After Sophie Taeuber-Arp's drawings, 1942
Nine bronze plaques mounted on stainless steel
Varying in size from 40 × 43.5 (15³/₄ × 17) to 52 × 52 (20³/₈ ×
20³/₈)
New Orleans Museum of Art, gift of Mrs. Edgar B. Stern

59
Arshile Gorky and Hans Burkhardt
Circus, 1936
Oil on canvas
63.5 × 99 (25 × 39)
Sandy and Adrea Bettelman, Beverly Hills, California

60
Arshile Gorky, De Hirsh Margules, and Isamu Noguchi
Hitler Invades Poland, 1939
Crayon and sealing wax on paper
44.5 × 58.1 ($17^{1}/_{2}$ × $22^{7}/_{8}$)
Private collection

139

61
William Baziotes, Gerome Kamrowski, and Jackson Pollock
Untitled, 1940–41
Oil and enamel on canvas
48.9 × 64.8 (19 1/4 × 25 1/2)
Mary Jane Kamrowski, Ann Arbor, Michigan

62
Christian Dotremont and Asger Jorn
Dentelles de foudre, 1948
Oil on canvas
29 × 22.5 (11½ × 8⅞)
Guy Dotremont, Limelette, Belgium

63
Christian Dotremont and Asger Jorn
La Chevelure des choses, 1948
Oil on cardboard mounted on canvas
17.5 × 21.5 (6⁷/8 × 8¹/2)
Collection Alechinsky, Bougival, France

64
Asger Jorn, Carl-Henning Pedersen, and Egill Jacobsen
Cobra 1, 1949
Cover design; lithograph and watercolor
31 × 24.5 (12¼ × 9⅝)
Collection Alechinsky, Bougival, France

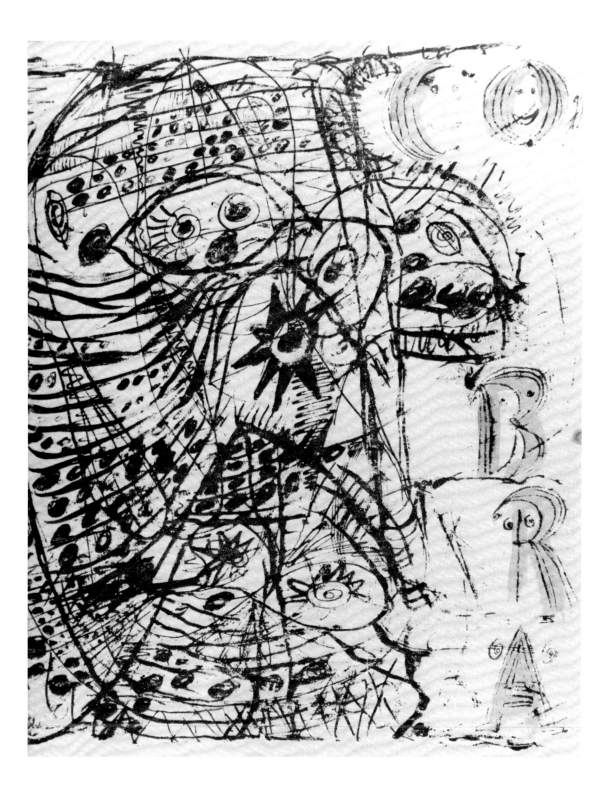

LA DANSE TORD LES MEMBRES DE L'ESPACE ET DU TEMPS ET LES DÉTEND COMME UN RAPACE POUR LES EMBRASSER

DANS LA BOUCHE DU BLANC LES DENTS LA LANGUE ET LA GORGE DU PAYS INTERNE L'AGRESSIVITÉ DU VIRAGE ET LA SOUPLESSE DE LA DURETÉ

SUR LE DÉSERT BLANC L'ARBRE DES FORMES S'ÉTEND, ET EN MÊME TEMPS SE NOUE DANS LA SÈVE NOIRE DE L'ÉTÉ DU DEDANS

65
Jean-Michel Atlan and Christian Dotremont
Les Transformes, 1950
Six sheets; gouache on paper
Each 25 × 35 (9⅞ × 13⅞)
Guy Dotremont, Limelette, Belgium

66
Asger Jorn and Pierre Alechinsky, later Walasse Ting
Jorn gravé, 1970–74
Acrylic on paper mounted on canvas
64 × 94 (25³/₁₆ × 37)
Collection Alechinsky, Bougival, France

67
Pierre Alechinsky and Karel Appel
Lazy Monday [*Un Lundi de paresse*], 1976
Brush and ink on paper mounted on canvas
153 × 153 (60¼ × 60¼)
Karel Appel, Monaco

68

Pierre Alechinsky and Karel Appel

For the Umpteenth Time [*Pour la Tantième Fois*], 1976

Brush and ink on paper mounted on canvas

153 × 153 (60¼ × 60¼)

Collection Alechinsky, Bougival, France

69
Pierre Alechinsky and Christian Dotremont
Abrupte Fable, 1976
Brush and ink and acrylic on paper mounted on canvas; five
panels
284 × 475 (111³/₄ × 187) overall
Collection Alechinsky, Bougival, France

Abrupte Fable

abrupte fable
d'être d'herbe de verbe de sable de flots
à serpentements d'orage
tendre de fruit
à cheminements presque terrestres
à traces de presque pas
à presque rien d'avant
à développements
en roue d'oiseau-lyre
à brusquement voler
de nuances ensemble
à la nuit d'un nuage
doré jusqu'au soleil
à dépliures de cri
à bruissements de jour
à regards de chant

—Christian Dotremont, 1976.

70
Pierre Alechinsky and Karel Appel
Suite à deux, 1978
Portfolio of seventeen etchings
Varying in size from 29.9 × 21.4 (11³/₄ × 8¹/₂) to 30.8 × 21.4
(12¹/₈ × 8¹/₂)
Hirshhorn Museum and Sculpture Garden, Washington, D.C., gift
of Pierre Alechinsky, 1982

71
Equipo 57: Augustin Ibbarola with Juan Cuenca, Angel Duarte,
José Duarte, and Juan Serrano
PA-18, 1959
Oil on canvas
144.8 × 114.3 (57 × 45)
Solomon R. Guggenheim Musem, New York, gift of Mr. and Mrs.
Herbert C. Bernard

72
Lucio Fontana and Jef Verheyen
Dream of Mobius, 1962
Oil on canvas
115 × 145 (45¼ × 57⅛)
Private collection

"The former collaboration between Lucio Fontana and me has now to be considered as the accomplishment of an utopia. That is why we took the Mobius-Ring as theme [72]. The union of two such different personalities was only possible because we both believed in real continuity and we lived in a very strong father-son brotherhood.

"The force that is created out of such an attachment is the only constant I believe in."

—Letter from Jef Verheyen to Cynthia Jaffee McCabe, September 6, 1983.

73
Gruppo N: Alberto Biasi, Toni Costa, Edoardo Landi, and Manfredo
Massironi
Kinetic Structure, 1964
Plastic disks and electric motor
120 × 120 × 25 (47 1/4 × 47 1/4 × 9 7/8)
Alberto Biasi, Padua, Italy

"*Kinetic Structure* [73] is a decorative panel of wheel-like discs
executed in 1964 by Gruppo N. Dimensions, excluding the frame:
approximately 120 × 120 × 25 cm. It is composed of nineteen
plastic discs painted in enamel and moved by electric motor.

"Located on the back of the work are several stamps of the
group (36 Ns composed in a square) and the wording '*Gruppo
enne 1964 a. biasi, t. costa, e. landi, m. massironi*' and other
indications of the assembly and functions of the work.

"The work was shown at the Venice Biennale in 1964. The
project was commissioned by the Society of Marelli for a
demonstration of color television revival at the Milan Fair. The
fundamental characteristic is represented by the continuous
movement of color that, due to variations in position, not
permanently set in the same spot for more than a number of
seconds, simulates color television."

—Letter from Alberto Biasi to Cynthia Jaffee McCabe, September
9, 1983 (translation by Deborah Knott Geoffray).

74
Adolf Luther and Günther Uecker
Collaboration Object, 1967
Plexiglas, lenses, and nails
51.3 × 51.3 × 13.9 (20¼ × 20¼ × 5½)
Stadtisches Kunstmuseum, Bonn, Federal Republic of Germany

"The object [74] connects materials (nails and optic glass) that were developed out of grappling with the problem of fragmentation of concrete light. I was mainly concerned about the verification of a 'transoptic reality' made visible through light that would be substantially and also artistically appreciated.

"This collaboration is intellectually already obvious but became also formally possible because both concepts—light and matter (or light and movement)—stayed within objective criteria."

—Letter from Adolf Luther to Cynthia Jaffee McCabe, July 7, 1983 (translation by Regina Hablutzel).

75
Bernard Baschet and François Baschet
Lotus, 1976
Stainless steel and glass rods on labradorite base
223.5 × 106.7 × 71.1 (88 × 42 × 28)
Staempfli Gallery, New York

"If this sculpture [75] were a violin, the metal leaf would be the sound box or the amplifier. The glass rods would be the bow, the water would be the rosin and the horizontal threaded rods would be the strings. They are tuned according to their lengths and to the place of the additional vertical bars. The shorter the threaded rod, the higher the pitch.

"All the higher part is made of stainless steel. The shape of the leaf is a circle written in a square. We took off two opposite corners of the square leaving the two others. The resulting shape is a sort of oval with two points. This oval is folded on itself at one-third of an extremity.

"We made only two 'glass-horns' with this shape: this lotus, and a smaller one in 1976. This smaller one was donated by President Mitterand to the Queen of Denmark last year."

—Letter from Bernard and François Baschet to Cynthia Jaffee McCabe, July 7, 1983.

76
Robert Rauschenberg and Susan Weil
Female Figure, c. 1949–50
Monoprint on blueprint paper
105 × 36 (41¼ × 14)
Saarland-Museum, Saarbrucken, Federal Republic of Germany

77
Robert Rauschenberg and Susan Weil
Light Borne in Darkness, c. 1951
Monoprint on blueprint paper
15.9 × 24.8 (6¼ × 9¾)
Milwaukee Art Museum, gift of Mr. and Mrs. Irving D. Saltzstein

78
Frank O'Hara and Larry Rivers
Stones, 1957–60
Portfolio of fourteen lithographs
Each 48.2 × 59.1 (19 × 23¼)
Hirshhorn Museum and Sculpture Garden, Washington, D.C., gift
of Mr. and Mrs. Samuel Efron, 1981

"Tatyana Grossman's choice of Frank O'Hara as Rivers's collaborator [78] was the result of a series of fortunate coincidences. She recalls:

> I went to see . . . Barney Rosset of the Grove Press to ask if he could perhaps suggest a poet for such a book [i.e., of lithograph stones], and he suggested Frank O'Hara. Well, I read some of O'Hara's poems, but I didn't really understand them very well, they were so abstract. But then a few days later . . . I drove out to Larry Rivers' studio in Southampton. . . . I talked to Larry about this idea of a book that would be a real fusion of poetry and art, a real collaboration, not just drawings to illustrate poems, and Larry listened, and then he called out 'Hey, Frank!' And down the stairs came a young man in blue jeans. It was Frank O'Hara.

"Rivers was delighted that 'This Siberian lady didn't just find some painter and some poet who would work together. She asked two men who really knew each other's work and life backwards.' Despite their 'super-serious, monstrously developed egos,' Rivers and O'Hara saw what had to be done: 'Frank O'Hara wasn't going to write a poem that I would set a groovy little image to. Nor were we going to assume the world was waiting for his poetry and my drawing which is what the past "collaborations" now seem to have been.'

"Working on the lithograph stone proved to be a new challenge for O'Hara and Rivers, who saw themselves as carrying on the tradition of 'Picasso, Matisse, Miró, Apollinaire, Eluard, and Aragon.'. . .

"Here Rivers stresses the *improvisational* character of the collaboration, its status as an event or happening rather than as a predetermined, planned 'work of art.' This is not to say, however, that anything goes; the account makes quite clear that, at each step of the way, the two artists depended upon one another's response."

—Marjorie Perloff, *Frank O'Hara: Poet among Painters* (New York: Braziller, 1977), pp. 100–101.

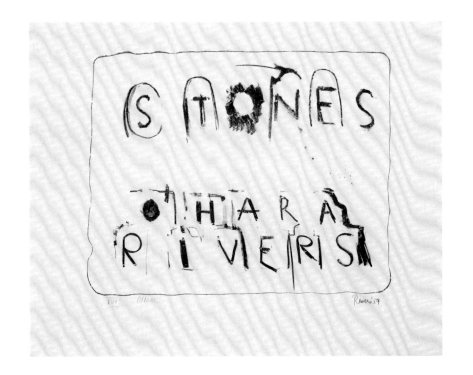

79
Niki de Saint Phalle, Daniel Spoerri, and Jean Tinguely
Assemblage, 1961
Assemblage
45 × 49.5 (17³/4 × 19¹/2)
Galerie Bruno Bischofberger, Zurich, Switzerland

80
Robert Filliou and Daniel Spoerri
To Weigh Their Words Proper and Obscene [*Peser ses Mots Propre et Sale*], 1964
Assemblage
26 × 49 × 25.5 (10¼ × 19⅜ × 10)
André L'Huillier, Geneva, Switzerland

81
Arman and Bernar Venet
Accumulation Informative, 1969
Assemblage
202 × 126 × 9 (79¹/2 × 49¹/2 × 3¹/2)
Galerie Bruno Bischofberger, Zurich, Switzerland

"Except for the team works which are based on constant collaboration, like Gilbert and George, the Poiriers, etc., works by two or more artists are created for a particular occasion, such as the formation of a group, a trend, or a commmon statement, and are generally produced by young artists or artists in their youth.

"For my part in the new realist group, I worked on several occasions with my other friends in the group: Shooting a rifle at colors embedded in plaster to make them explode in a Niki de Saint Phalle composition; participating in Daniel Spoerri's process for trapping reality; finding ready-made compressions for César; pouring plastic over Martial Raysse's sculptures. But my participation in these cases was limited and anonymous. When I made assemblages of artist's studio garbage, the participation of the other artists was also more passive than active. Another example is the multiple I did with what was left over from Andy Warhol's flower silkscreens—in which Andy let me use his material.

"The two pieces in which I had a real part and in which the finished products were in consideration from beginning to end were 'The Scroll' made with Yves Klein, Claude Pascal and Restany, and the *New York Times* piece that I made with Bernar Venet [81]. In those two works the ideas of sharing a conceptualized project and its realization were always present and each artist's creative input was equal to that of the others involved.

"I don't presently have any project of collaboration except for my part in the important Jean Tinguely sculpture called 'The Head,' which already includes works by many different artists."

—Letter from Arman to Cynthia Jaffee McCabe, June 13, 1983.

82
Pierre Alechinsky and Arman
Indivisible Prints [*Epreuves en indivis*], 1969
Thirty etchings encased in polyester
15 × 15 × 15 (6 × 6 × 6)
Collection Alechinsky, Bougival, France

"Before this piece [81] was realized in 1969, I had often used the *New York Times* as working material. That was during the period when I was involved with conceptual art, and I was extracting from it some reports on the 'New York Stock Exchange' and the 'Weather Reports' to make, among other things, those photographic blow-ups that I was exhibiting.

"One day, while I was talking with Arman, we came up with the conclusion that the Sunday *New York Times* would be an ideal subject for him to make an accumulation. Not only was there the beauty of the object in its mass, in its physicality, but also, the *New York Times* was already in itself an impressive mass of information, a multiplied accumulation of knowledge, opinions, news, studies, observations, advertisements, etc.

"Obviously, the idea had a logic. My participation was to introduce the content, the functional meaning of those linguistic symbols; Arman made the gesture, the accumulation as a symbolic monument to the power of knowledge."

—Letter from Bernar Venet to Cynthia Jaffee McCabe, September 1983.

83
Friedensreich Hundertwasser and René Brô
The Miraculous Draft of the Fishes, 1950
Mixed media on fiberboard
275 × 500 (108¼ × 196¾)
Baumgartner Galleries, Washington, D.C.

Figure 43
Friedensreich Hundertwasser, left, and René Brô in front of a detail
of their mural painted in Saint-Mandé-sur-Seine near Paris in the
old hunting pavilion of Emperor Napoleon III, 1950.

He Is Brô

René Brô is my master and friend
through him, in 1949, I got in contact with modern art
which was quite different from
the almost photographic imitation of nature
I had been happy with till then.
But Brô is more than just that.
He is one of the very few unique humans
who have the possiblity
to see behind the curtain of our existence
and who have the powerful means
to depict and to paint what they see.
As all independent visionaries, he cannot be classified
He is Brô.

His paintings are a program
impossible to explain in words.
Men from another star live in
transparent hills full of fruit trees.
Are they us or are they them,
are they before or are they after,
are they mirrors or are they shadows?
Nobody knows.
Does he know?
You fall into the hills drifting
into them if you are lucky
lucky indeed.

The laws are different
yet you are at home.
Brô is guiding you home.
Take off your hautenity
and you will find Brô.
Look into yourself
and you will find Brô.

—Friedensreich Hundertwasser, 1981.

"Coming back from Italy, the eyes still full of the Toscanian walls,
frescos, monumentality, gold, blue, red, green, yellow, raw siena
. . . all the colours on the white of the lime. In Paris, these pressed
fibre boards were the royal walls of absent palaces. Imagination
and dream could spread out on these limited spaces which,
however, for us, at this time, were but a small part of an immense
world.

"In this work of collaboration [83], I was responsible for the
composition and painting faces; Frederic for the extraordinary
oneiric atmosphere and colours. This work was made in such a
great climate of spiritual union that it was like a work made by one
artist who existed only for the time to paint two murals, this one
and the one which is on Long Island today.

"Then life did not allow this artist to stay alive: Frederic became
Hundertwasser and I went on being Brô."

—Statement by René Brô, September 1983.

*84
R. B. Kitaj and Eduardo Paolozzi
Work in Progress, 1962
Mixed media on wood
82 × 86.4 (32¹/₄ × 34)
Private collection

85
Hilla Becher and Bernd Becher
Winding Towers, Series F: Belgium, France, and Germany,
1966–83
Fifteen photographs
Each 50.8 × 40.6 (20 × 16)
Sonnabend Gallery, New York

166

86
Hilla Becher and Bernd Becher
Winding Towers, Series G: Belgium, England, and France, 1966–83
Twelve photographs
Each 50.8 × 40.6 (20 × 16)
Sonnabend Gallery, New York

87
Hilla Becher and Bernd Becher
Winding Towers, Series N: England and South Wales, 1966–83
Nine photographs
Each 50.8 × 40.6 (20 × 16)
Sonnabend Gallery, New York

88
Hilla Becher and Bernd Becher
Winding Towers, Series S: Pennsylvania, USA, 1982–83
Fifteen photographs
Each 50.8 × 40.6 (20 × 16)
Sonnabend Gallery, New York

89
Antoni Tàpies and Josep Royo
Pants and Woven Wire, 1973
Wire, wood, and cloth
200 × 132 (78³/₄ × 52)
Hirshhorn Museum and Sculpture Garden, Washington, D.C.,
Martha Jackson Memorial Collection: gift of Mr. and Mrs. David K.
Anderson, 1980

90
Anthony Caro and Kenneth Noland
Books [*Stainless Piece I*], 1974–78
Painted stainless steel
26.8 × 68.5 × 34.5 (10½ × 27 × 13⅝)
Anthony Caro, London, and Kenneth Noland, South Salem, New York

"It was natural for me to work with Kenneth Noland. We have been close friends for many years and it is to Noland that I owe a great deal in terms of art making, working process, invention and criticism. From 1963 onwards I made most of my work in America, close by, and later at Noland's Shaftsbury farm.

"Colour in sculpture was one of many topics in art we discussed. It is seldom handled well by sculptors. Enhancing yet not overwhelming the forms calls for a delicacy of colour choice and understanding of how colour works with form, which sculptors seldom possess.

"My first stainless steel sculptures were made with pieces from David Smith's estate. The raw steel and stainless steel that was at Smith's studio at Bolton Landing had been bought by Kenneth Noland, and brought to Shaftsbury. I worked on the stainless pieces in Noland's garage. When they were made some of them called for colour. Noland brushed some colour onto one, while I watched. His choice was impeccable. *Books* [90] was one of the first of this small group. *Passage* [91] was left at his house and he worked on it by himself, at a later date. The plainer treatment called for tonal accentuation; and Noland worked on this group in subsequent sessions.

"Since, in my view Noland is unquestionably one of the great artists of this century, I feel very happy about his involvement in these pieces, and the closeness of our aesthetic attitude made our collaboration easy and I believe fruitful."

—Statement by Anthony Caro, September 1983.

91
Anthony Caro and Kenneth Noland
Passage [*Stainless Piece F-F*], 1975–83
Painted stainless steel
25.7 × 137.2 × 53.8 (10¹/₈ × 54 × 21¹/₄)
Anthony Caro, London, and Kenneth Noland, South Salem, New
York

92
Richard Hamilton and Dieter Roth (Ch. Rotham)
D. R. with Suitcase, R. H. Supporting, 1976
Enamel, oil pastel, synthetic oil primer, tape, and pencil on
silkscreened paper
102 × 73 (40¼ × 28¾)
Lanfranco Bombelli Tiravanti, Cadaqués, Spain

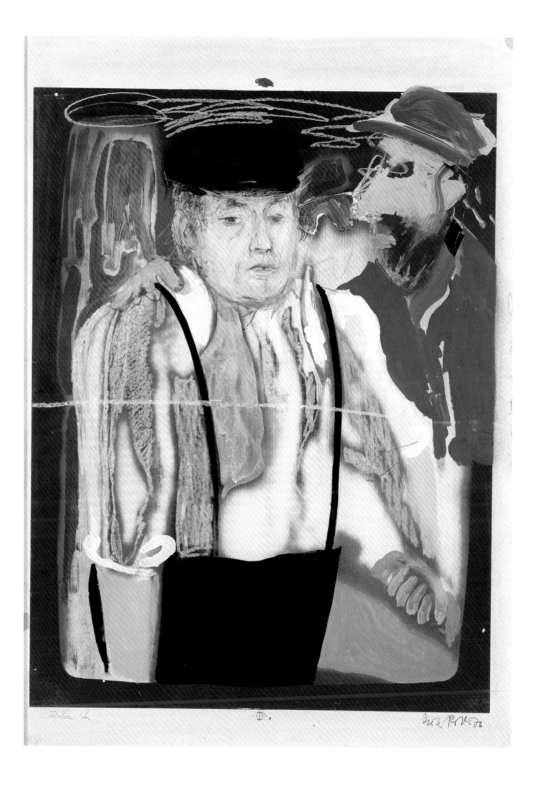

93
Richard Hamilton and Dieter Roth (Ch. Rotham)
Certificate: Polaroid of R. H. as Portrait of D. R. with Suitcase, D. R.
as Portrait of R. H. Supporting, 1976
Six Polaroid color photographs mounted on paper
30 × 42 (11³/₄ × 16¹/₂)
Lanfranco Bombelli Tiravanti, Cadaqués, Spain

94
Richard Hamilton and Dieter Roth (Ch. Rotham)
Banner with a Strange Device: 'Recived Degnarts,' 1976
Enamel and synthetic oil primer on handmade paper
46.5 × 58 (18³/₈ × 22⁷/₈)
Galeria Cadaqués, Cadaqués, Spain

95
Richard Hamilton and Dieter Roth (Ch. Rotham)
Certificate: Seascape Supported, 1976
Collaged postcard
30 × 42 (11⁷/₈ × 16¹/₂)
Galeria Cadaqués, Cadaqués, Spain

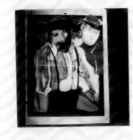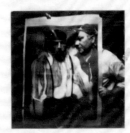

96
Vitaly Komar, Alesander Melamid, and Douglas Davis
Questions: New York Moscow, Tel Aviv New York, 1976–78
Six photographs
Each 77.5 × 102.8 (30½ × 40½)
Hirshhorn Museum and Sculpture Garden, Washington, D.C., gift
of the artists, 1978; and Douglas Davis, New York

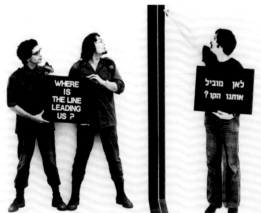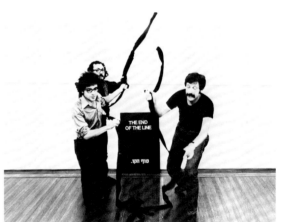

"It was in Moscow in fall of 1974. I remember that the sky was leaden gray, that it was snowing, and that the weather made me think of a movie I had seen long ago, about Russia in the last century. Inside the house, there were two men, one very short and spry and animated, the other tall and stolid, and for some reason I said to myself: *here are the Brothers Karamazov*. Immediately I saw a long red canvas banner on the wall, lettered in white. It resembled all the billboards I had seen in Moscow, down to the exclamation point at the end of the row of words, with one exception: beneath the row the artists had attached their own names. Katya, the wife of Alesander Melamid (the short one), translated it for me: 'Forward for the Victory of Communism!' she said, with a very straight face.

"It was completely unlike any art I had so far seen in the city—whether the official realist style or the unofficial surrealist, semi-abstract style. We talked about many other things, of course, with great animation, often arguing, often agreeing. Within a few minutes, for example, we decided that we would make a joint work out of the space and time that separated us.

"The next step was one year later. A close friend of Melamid and Komar—a microbiologist—obtained a visa to live in Israel. He came to New York and telephoned, reminding me of our long-delayed promise to collaborate. Later, we met. As we talked, I thought of the line. I remember drawing it on a page, me on one side, Melamid and Komar on the other. I thought of two photographs, taken at the same time and spliced together. The microbiologist stood right up and telephoned Moscow. Miraculously, they were there, within thirty minutes. He explained the idea in Russian and they immediately understood. They suggested that we ask alternating questions about the line and that the languages be reversed—I should ask in Russian, they in English. We also discussed dates for the simultaneous performance-photographs, and agreed that there should be no answers. All of this took approximately five minutes. Their last

words were: 'We will call this the first work of art detente.'

"The first image dates from midnight, January 1, 1976. It is 8:00 a.m. in Moscow the next morning, on the left-handed side of the line. But it is the same moment and indeed the same place on the plane of the image. At its irreducible base, the work is a performance. But I would like to stress that the performance and the image that you see are one. They are locked together on film. But there is no difference between performance and record. Both are equally important. Both are instantaneous. You are there when you see it, in both cities. In the most fundamental sense, the work only exists when it is coupled together.

"The next image is dated May 1, their choice. It is noon in New York, 8:00 p.m. in Moscow, where it is also the festive occasion of May Day. The question is theirs.

"July 4, 1976, the third image, was a Bicentennial performance. My half took place at Artpark, a facility in upper New York State that sponsors a summer-long festival of theater, music, dance, and environmental art. My wall was in a metaphorical sense moved from the city of New York outdoors. Here you see the moment of the photograph—2:00 p.m. in the United States, 10:00 p.m. there. This is July 4. The night before, on July 3, we agreed by telephone to exchange statements the next day about the meaning of the line and of the occasion. But the telephone operator in Moscow would not allow us to speak to each other: she claimed over and over that Melamid and Komar weren't answering their phone. Of course, it never rang, as the artists now attest. They waited with their friends all day and night for a ring that did not come.

"The date of the fourth photograph—and the question—was decided by Melamid and Komar. It is November 7, 1976, 8:00 p.m. in New York, 4:00 a.m. in Moscow. In this image, we reach into each other's space for the first time—certain, then, that we were composing the last photograph, that the ultimate defiance of the line was to reach gently around it, no more. When we received their 'half' from Moscow, we were at first puzzled by the heavy

coats and hats, until a friend said, 'They're getting ready to go.'

"He was right. In the winter of 1978, after the four *Questions: Moscow New York* had been finally exhibited in public throughout the world, I received a phone call from an art gallery in Tel Aviv. My friends were there, I learned, and they wanted a fifth picture. When I finally spoke to Melamid, now in working command of English, we instantly agreed upon the question, the date (April 21, the anniversary of Israeli independence), and the use of Hebrew in place of Russian. But I insisted that a sixth picture was now inevitable, when they made their way to New York. '*That* will be the end of the line,' I said.

"And so it did end, on September 29, 1978. At last we were together in the same space. At last one picture could do the work of two. I remember I could hardly stand up—it was barely one week before an urgent operation on my inner ear to correct imbalance. But we did, finally, shatter the line, the thing that had separated us for so long.

"Or did we? A good and wise colleague maintains: 'Art destroyed the line.' In one sense, yes. Now we live together in the same city. We can talk about anything whenever we wish. If I think back upon what has happened since that gray day in 1974, the result is indeed miraculous. I am told that the line is known even in Russia, since it has been documented by *Domus*, an Italian magazine that circulates in every art library in the Soviet Union.

"But in another sense, the line is still there. Perhaps it should be. If political and temporal lines are arbitrary, others are not. The lines between sexes, languages, and certain kinds of spaces, between life and death, are inevitable. I don't object to the existence of lines. I simply object to one of them. Or should I say two?"

—"Behind the Line: Memories of a Collaboration," statement by Douglas Davis, May 1983.

176

97
Equipo Crónica: Rafael Solbes and Manuel Valdès
El, 1977
Acrylic on canvas
150 × 200 (59 × 78³⁄₄)
Galerie Maeght, Barcelona, Spain

98
Douglas Davis, Joseph Beuys, and Nam June Paik
The Last Nine Minutes, 1977
Video of live satellite television performance at Documenta 6
Douglas Davis, New York

99
Diego Cortez and Lucio Pozzi
Cisitalia, 1979
Collage, pencils, and acrylic on paper; two panels mounted on board
116.2 × 72.4 (45³/₄ × 28¹/₂)
Diego Cortez, New York, and Lucio Pozzi, New York

"Diego and I got together one afternoon to play with paint, glue, paper and photographs. We set up stuff we both had brought for the occasion around the floor and started adding things onto sheets of white board. We didn't discuss much what we were doing until we would just spontaneously agree that no further work was needed on this sheet or that.

"Collaborating in art is like a ping-pong of ideas in which the subtlest mixture of agreement and challenge weaves itself into the participants' concentration. For Diego and me, I think, it was a normal thing to do in a period when concern for context and inclusion of all kinds of data in their work were habitual for certain New York artists."

—Letter from Lucio Pozzi to Cynthia Jaffee McCabe, August 29, 1983.

100
General Idea: A A Bronson, Felix Partz, and Jorge Zontal
Black Poodle Fragments, 1981
Enamel on wood and drywall panel; five sections
220.9 × 190.5 (87 × 75) overall
Carmen Lamanna Gallery, Toronto, Canada

101
Salomé and Luciano Castelli
Kadewe, 1981
Acrylic on canvas; four panels
340.4 × 482.6 (134 × 190)
Annina Nosei Gallery, New York

"This is a very special painting for me. The idea for *Kadewe* [101], which I did together with Luciano Castelli, was conceived in Berlin's largest department store, Kadewe, which had just been rebuilt. It is one of the craziest department stores you have ever seen, especially the meat market section. Here you can see raw sides of beef, calf and pork hanging on hooks behind large glass windows. Luciano and I were both shocked and inspired by this gruesome display. So we planned to make this large painting to hang in the market across from those windows.

"The painting is composed of human bodies hanging, just as we saw the animal carcasses. The symbolism is clear. These creatures that we kill and eat symbolized to us what men are capable of doing to each other. Also, that we are all equal, we are all meat, all made of flesh and blood.

"*Kadewe* was never hung in that market, the place it was intended to hang in. Life is strange. But indeed this piece can only survive in a public place. It was conceived and executed only for the public. It is a protest against torture, against man's inhumanity to man. It is a message to humanity, and that is a public affair, and the public has the only right to own it."

—Letter from Salomé to Cynthia Jaffee McCabe, July 5, 1983.

181

102

Anna Kubach-Wilmsen and Wolfgang Kubach-Wilmsen
Blue Life Book, 1982
Brazilian granite
149.9 × 100.3 × 50.2 (59 × 39½ × 19¾)
Staempfli Gallery, New York

"Artists' collaborations cannot be planned. They suddenly happen like the birth of unexpected twins.

"When we finished the Akademie der Bildenden Kunst in Munich in 1965 as a sculptor and a painter, we bought an old church in Bad Kreuznach, moved into it, and started independent lives as a sculptor and a painter. In the next five years we had no contact with other artists, and for seven years we did not exhibit our works. Finally, nine years after we left Munich, the first critic came to our studio.

"But we had one another and over the years four children. We lived like hermits. All our academic 'provisions' got lost in loneliness. And we had to find another way of being artists.

"The first communal interest we had as a sculptor and a painter was to test the new material polyester, its volume and color. We were able to make big pieces together and we were so enthusiastic, putting gold leaf all over the forms. After five years, we stopped working with polyester. We hated it and had to destroy all our work. Its form and colors seemed to us superficial, without relationship to man.

"In the meantime, we received a commission from a little village to make an altar out of stone. As we both had never learned to work in stone, we could not treat it as a stonecutter or a mason does. We had never respected stone as material. Now we found out that in the stone there was always a detail, a relic of our world surface here and there, and although it was a stone detail or a stone relic of Russia, Greece, or South Africa, it was still alive. We started grinding stone, discovering that its innerside is full of color, time drawings, world tremblings, and healing scars. We experienced its history as well as its organism. We did not any longer think of being a sculptor or a painter. We only wished to discover stone as our third partner. Finally we fell in love with it.

"When we search for stones in the quarries at the riversides of Europe, we are searching alone. At the end of a day we show one another the stones that we would like to have. Each stone has its own content, and when we both discover it in one piece, we start to work.

"When our artist friend Karl Prantl from Vienna came to visit us in Bad Kreuznach in 1970, he was astonished by our teamwork. He could not understand it. In discussion with him, we became aware of the happening ourselves."

—From an interview of Anna and Wolfgang Kubach-Wilmsen by Cynthia Jaffee McCabe, September 13, 1982.

Figure 44
Gilbert, left, and George during interview by Robert C. Hobbs and
Cynthia Jaffee McCabe, Sonnabend Gallery, New York, 1983.

103
Gilbert and George
Modern Faith: Wine God, 1982
Photograph; twenty panels
241.3 × 250.8 (95 × 98¾)
Suzanne and Howard Feldman, New York

104
Gilbert and George
Modern Faith: Colored Enemies, 1982
Photograph; sixteen panels
241.3 × 200.7 (95 × 79)
Pamela and James Heller, New York
[Not illustrated]

*105
Gilbert and George
Modern Faith: Winter Heads, 1982
Photograph; twenty panels
241.3 × 250.8 (95 × 98¾)
Paine Webber, New York
[Not illustrated]

185

106
Helen Mayer Harrison and Newton Harrison
Barrier Islands Drama: The Mangrove and the Pine, 1982
Nine photo murals with oil and graphite mounted on canvas
Varying in size from 45.7 × 61 (18 × 24) to 243.8 × 365.8
(96 × 144)
Helen Mayer Harrison and Newton Harrison, Del Mar, California

"*The Mangrove and the Pine* [106] is a section of a larger work called *Barrier Islands Drama*, a mural that is about one hundred feet long and eight feet tall in many parts and was commissioned by the Ringling Museum in Sarasota, Florida, for the exhibition *Common Ground: Five Artists in the Florida Landscape*. Among the things that interested us about the Florida landscape—i.e., phosphate mining, difficulty with the water table, a bit of corruption here and there in government and some cancer among workers and animals presumably from the phosphate mining— most visually interesting to us was the pressure we observed at the boundaries of earth and water. That pressure had led to the diminuation of habitat for the mangrove. Now one variety or another of mangrove grows worldwide in tropical coastal marshes and shorelines, generating earth, holding land from the encroaching waters, and acting as a nursery for a multitude of creatures. The Australian pine was introduced to the Florida coastline early in the century to decorate the landscape. In its new environment the pine is an exotic, grows like a weed, and has no enemies. It colonizes behind the mangrove, spreads until it gains the ocean edge and displaces the mangrove, when, shallow rooted, it topples in the wind, loosing ground thereby. To walk among the graceful pines almost to the water's edge is aesthetically pleasing. To walk among the native mangroves almost to the water's edge is not. Thus, one can never tell when an aesthetic decision will proliferate and ruin the landscape."

—Statement by Helen and Newton Harrison, August 1983.

107
Anne Poirier and Patrick Poirier
Mimas, 1983
Bronze in wooden trough with water
393.7 × 487.7 × 518.2 (155 × 192 × 204)
Sonnabend Gallery, New York

"Architecture and Mythology are the two principal themes of our work since its beginning. They recur alternately, echo themselves, and complete each other. Archaeology, Architecture, and Mythology are privileged metaphors that try to establish in space or put on stage the phenomena of the unconscious. That is why the remotest mythologies, the sites that are most ancient and farthest away still interest man today: because, intuitively, he knows that somewhere there is an affinity between those distant and forgotten myths, those lost worlds and a little-known part of himself. He knows that those figures are archetypes that still concern him, that they represent that which makes the human psyche timeless and permanent. The myth that has guided the conception of this sculpture is the Battle between the Gods and the Giants, a myth of violence and destruction.

"What are the often confusing and contradictory texts saying? The giants were begotten by Gaia, the Earth, impregnated by the blood flowing from Ouranos's genitals, cut up by the Titan Cronos, Gaia's rebellious son. When Zeus rebelled against his father, Cronos, and imprisoned the Titans in Tartarus [Hell], Gaia forced her other monstrous sons, the giants, to declare war to the Olympian gods. The giants were armed with rocks, pickaxes, and flaming oak trunks. The gods were lead by Zeus armed with his thunderbolts, pre-eminently godlike weapons, forged by the Cyclops; Heracles fought at the side of the gods armed with his arrows poisoned in Hydra's blood. The giant Porphyrion tried to rape Hera, but Zeus threw his thunderbolt at him and Heracles finished him off with an arrow. Another giant, Ephialthes, was killed by an arrow in each eye, one discharged by Heracles, the other by Apollo. Athena hurled the island of Sicily at another giant, Encelande, and he lies underneath, forever imprisoned, and sometimes his breath of fire escapes through Mount Etna. Hephaistos engulfed Mimas in a melting mass under the volcano Vesuvius. Athena killed Pallas, skinned him, and covered her breastplate with the skin of the monster. Artemis used her bow and arrows, and Hecate used infernal torches. One sees the magnitude and the significance of the battle. For the matter is about a battle between the elementary and brutal forces attributed to the giant sons of the Earth and the superior forces attributed to the Olympians. In fact, it is perhaps a battle between the conscious and the unconscious, rational and irrational forces, shadow and light, pulsations of life and pulsations of death.

"From this battle, which was inhuman in scale, we have retained only some signs: from the giant there survives only an enormous fragment, as it springs from a colossal statuary. Fallen from the sky and thrust into the ground with all their violence, the huge weapons of the gods remain invisible. As for the mythical land where the battle raged, it is reduced to a state of ruin."

—Statement by Anne and Patrick Poirier, February 1984 (translated by Regina Hablutzel).

108
Brad Davis and Ned Smyth
The Garden, 1984
Reconstruction of mixed media room installation, 1977
762 × 762 (300 × 300)
Brad Davis, Carbondale, Colorado, and Ned Smyth, New York,
courtesy Holly Solomon Gallery, New York

"In the summer of 1976 we were discussing our work and both felt that we wanted to extend it beyond its present limits—the sculpture into color and imagery—the painting into a more environmental presentation. A collaboration was proposed to bring this about. Initially, we met, talked, and went home to develop drawings for the next meeting. Quickly we discovered that it was easier to draw and look at books together as a means of communication.

"The first ideas were simple, concrete frames for painted inserts. This work attracted the interest of our dealers, Holly and Horace Solomon, who encouraged us to develop the ideas further for a future exhibition. So, we set out exploring a more ambitious collaboration with few limitations and a year's work schedule ahead.

"Meeting once a week, often at the Jung Institute picture library, we drew and discussed our ideas and ambitions for the piece and soon arrived at a format of a sacred garden. With architectural sculptured elements defining a courtyard, one would look out to large murals surrounding at least three sides. Our biggest problem became imagery—what it should be and what it should look like.

We wanted a feeling of an archetypal resting place, a protected contemplative spot.

"We discussed early Christian and Indian religious imagery, drawn particularly to the images of water—cleansing, creative, soothing—and the palm—fecund and celebratory—that these traditions shared. The four rivers flowing from Christ's feet, the Ganges flowing from Shiva's head were presented in the font and the river. The Creator was represented in It's symbolic animal form—the deer/Christ, the peacock/Krishna, the swan/the Universal Soul. The setting was an earthly paradise dominated by stylized architectural and painted palms. It is presented in three classic views—the climbing, vertical mountain scene; the intimate, dense floral scene; and the spreading, low plain. We wanted the space protected from the outside—the barrier gate—and unified— the dark green background. And above all we wanted the experience accessible to everyone. While the symbolism may be obscure to many, its specific meaning is not essential to the direct experience of the pervasive mood and sanctuary of this place."

—Statement by Ned Smyth and Brad Davis, December 1983.

Biographies

Pierre Alechinsky

b. Brussels 1927

Education: Ecole Nationale Superieure d'Architecture et des Arts Décoratifs, La Cambre, Brussels, 1944; studied with S. W. Hayter, Atelier 17, Paris, 1952. First group exhibition: Galerie Lou Cosyn, with Raymond Cosse and Serge Cruez, Brussels, 1947. First solo exhibition: Galerie Lou Cosyn, 1947. Joined Cobra group, Paris, 1949; established Les Ateliers du Marais, community house and Cobra research center, Brussels, 1949. First Cobra exhibition: *First Exposition of International Experimental Art*, Stedelijk Museum, Amsterdam, 1949. Lives in Bougival, France.

Karel Appel

b. Amsterdam, The Netherlands 1921

Education: Royal Academy of Fine Arts, Amsterdam, 1940–43. First group exhibition: *Young Artists*, Stedelijk Museum, Amsterdam, 1946. First solo exhibition: Beerenhuis, Groningen, The Netherlands, 1946. Founder-member of Cobra group, Paris, 1948. First Cobra exhibition: *First Exposition of International Experimental Art*, Stedelijk Museum, 1949. Lives in New York City and Monaco.

Walter Conrad Arensberg

Pittsburgh, Pennyslvania 1878–1954 Los Angeles

Education: Harvard University, B.A., 1900. Active as a poet, patron, and participant in the New York avant-garde, 1915–20. Art collection donated to Philadelphia Museum of Art, 1950.

Arman (Armand Fernandez; Armand Pierre Arman)

b. Nice, France 1928

American. Education: Ecole Nationale d'Art Décoratif, Nice, 1946–49; Ecole du Louvre, Paris, 1949–51. First solo exhibition: Galerie Haut Pavé, Paris, 1956. With Yves Klein, César, Jean Tinguely, and others, founded Nouveaux Réalistes group, Milan, 1960. Moved to U.S., 1961; citizen, 1973. Lives in New York City.

Jean Arp (Hans Arp)

Strasbourg, German Alsace 1886–1966 Basel, Switzerland

French. Education: Kunstgewerbeschule, Strasbourg, 1902; studied with Georges Ritteng, Strasbourg, 1903; Kunstschule, Weimar, Germany, 1905–7; Académie Julian, Paris, 1908. First exhibition: *Der Moderne Bund*, Hôtel du Lac, Lucerne, Switzerland, 1911. Met Max Ernst, Cologne, 1914. Moved to Zurich, 1915; met Sophie Taeuber. Co-founded Dada movement, Zurich, 1916; participated in Dada activities at the Cabaret Voltaire. Collaborated with Max Ernst and Johannes Theodor Baargeld on Fatagaga collages, Cologne, 1919–20. First solo exhibition: Galerie Surréaliste, Paris. 1927. Fled with Taeuber-Arp from Meudon, near Paris, to Grasse, in Vichy France, 1940–41; collaborated with her, Sonia Delaunay, and Alberto Magnelli on *Four from Grasse* portfolio, published 1950.

Jean-Michel Atlan	Constantine, Algeria 1913–1960 Paris

French. Education: Sorbonne, Paris, 1930–33. Self-taught as a painter. First solo exhibition: Galerie de l'Arc-en-ciel, Paris, 1944. First group exhibition: Salon des Surindépendants, Paris, 1945. Joined Cobra group, Paris, 1950.

Johannes Baader	Stuttgart, Germany 1876–1955 Bavaria

Active in Berlin Dada movement, 1918–20; self-proclaimed "Oberdada." Associated with Raoul Hausmann; participated in *Erste International Dada-Messe*, Berlin, 1920.

Hugo Ball	Pirmasens, Germany 1886–1927 Sant'Abbondio, Switzerland

Education: Gymnasium, Zweibrucken, Germany, 1905–6; University of Munich, 1906–7, 1908–10; University of Heidelberg, 1907–8. Active in experimental theater, Berlin and Munich, 1910–12. Moved to Zurich, 1915; founded Cabaret Voltaire, headquarters for Zurich Dada, 1916. Withdrew from Dada group, 1917.

Bernard Baschet	b. Paris 1917

Studied engineering, Ecole Central, Paris, 1943. Research group, French Broadcasting, 1960–63. First team exhibition of sound sculpture with brother, François Baschet: Musée des Arts Décoratifs, Palais du Louvre, Paris, 1964. Lives in Michel-Saint-sur-Orge, France.

François Baschet	b. Paris 1920

Studied sculpture with Emmanuel Auricoste, Paris. First team exhibition of sound sculpture with Bernard Baschet: Musée des Arts Décoratifs, Palais du Louvre, Paris, 1964. Lives in Paris.

William Baziotes	Pittsburgh, Pennsylvania 1912–1963 New York City

Education: National Academy of Design, New York, 1933–36. First group exhibition: Municipal Art Gallery, New York, 1936. Included in *First Papers of Surrealism* exhibition, New York, 1942. First solo exhibition: Art of This Century, New York, 1944.

Bernd Becher (Bernhard Becher) b. Siegen, Germany 1931

Education: Staatliche Kunstakademie, Stuttgart, 1953–56. Began working with Hilla Wobeser, 1959; married, 1961. First team exhibition: Galerie Ruth Nohl, Siegen, 1963. First group exhibition: *Prospect 69*, Kunsthalle, Düsseldorf, 1969. Lives in Düsseldorf.

Hilla Becher (Hilla Wobeser) b. Berlin 1934

Education: Kunstakademie, Düsseldorf, Germany, 1958–61. Began working with Bernd Becher, 1959. First team exhibition: Galerie Ruth Nohl, Siegen, Germany, 1963. First group exhibition: *Prospect 69*, Kunsthalle, Düsseldorf, 1969. Lives in Düsseldorf and New York City.

Elizabeth Voorh Benton (Elizabeth Voorhis Cornell Benton) b. Nyack, New York 1905

Studied charcoal drawing with Edward Hopper, Nyack, summer, c. 1915. Made first collages, 1944. Included in *Joseph Cornell: An Exploration of Sources*, National Museum of American Art, Smithsonian Institution, Washington, D.C., 1982–83. Lives in Westhampton, New York.

Joseph Beuys b. Kleve, Germany 1921

Education: Gymnasium Kleve, 1940; Kunstakademie, Düsseldorf, 1942–52. First group exhibition: *Fluxus*, Kunstakademie, Düsseldorf, 1963. First solo exhibition: Kunstmuseum, Wupppertal, Germany, 1952. Lives in Düsseldorf.

Alberto Biasi b. Padua, Italy 1937

Education: Superior Institute of Architecture, Venice, 1958–60. With Manfredo Massironi, Pesce, and others, formed group N/A, 1959. Formed Gruppo N, 1960. Teaches technical graphics, Professional Institute of Publicity, Graphics, and Photographs, Padua. Lives in Padua.

Victor Brauner Piatra, Rumania 1903–1966 Paris

French. Education: Evangelistic School, Braila, Rumania, 1916–18; School of Fine Arts, Bucharest, Rumania, 1921. First group exhibition: Contemporanul, Bucharest, 1924. First solo exhibition: Galerie Mozart, Bucharest, 1924. Moved to Paris, 1930. Associated with Surrealist group, Paris and Marseilles, 1930s–40s.

André Breton	Tinchebray, France 1896–1966 Paris

Poet, essayist, novelist, theorist, editor, critic, and physician. Participated in Paris Dada movement, 1917–21. Founder and leader of Surrealist movement; published *Surrealist Manifesto*, 1924. Editor of *La Révolution Surréaliste*, 1925–30, and *Le Surréalisme au Service de la Révolution*, 1930–33. Escaped to U.S. from Vichy France via Emergency Rescue Committee, 1941. Organized *First Papers of Surrealism* exhibition, New York, 1942. Returned to France, 1945.

René Brô (René Brault)	b. Charenton, France 1930

First group exhibition: *L'Art et la vie*, Galerie Mai, Paris, 1948. Executed two frescoes with Friedensreich Hundertwasser, Saint-Mandé-sur-Seine, France, 1949. First solo exhibition: Centre Saint-Jacques, Paris, 1954. Lives in Paris and Normandy, France.

A A Bronson (Michael Tims)	b. Vancouver, British Columbia, Canada 1946

Education: School of Architecture, University of Manitoba, B.A., 1964–67. First General Idea team exhibition: *Concept '70*, Nightingale Gallery, Toronto, 1970. Lives in Toronto.

Camille Bryen	Nantes, France 1907–1977 Paris

Poet, painter, and illustrator. Settled in Paris, 1926. Exhibited series of "automatic drawings," inspired by the Surrealists, Paris, 1934. Solo exhibition: Galerie des Deux-Iles, Paris, 1949.

Hans Burkhardt	b. Basel, Switzerland 1904

American. Education: Cooper Union for the Advancement of Science and Art, New York, 1925–28; Grand Central Art School, New York, 1928–29. Studied with Arshile Gorky, New York, 1929–36. First solo exhibition: Stendhal Gallery, New York, 1939. Lives in Los Angeles.

Anthony Caro	b. London 1924

Education: studied engineering, Christ's College, Cambridge, England, 1942; sculpture, Polytechnic, London, 1946; Royal Academy of Arts, London, 1947–52. Worked as assistant to Henry Moore, Much Hadham, England, 1951–53. First group exhibition: *New Sculptors and Painter-Sculptors*, Institute of Contemporary Arts, London, 1955. First solo exhibition: Galleria del Naviglio, Milan, 1956. Lives in London.

Luciano Castelli	b. Lucerne, Switzerland 1951
	Swiss. First group exhibition: *Visualisierte Denkprozesse*, Kunstmuseum, Lucerne, 1971. First team exhibition: Galerie Toni Gerber, Bern, Switzerland, 1971. Lives in Berlin.
Blaise Cendrars (Frederic-Louis Sauser)	La Chaux-de-Fonds, Switzerland 1887–1961 Paris
	French poet. Lived in Russia, 1904–7, 1911. Education: University of Bern, Switzerland, 1909. Lived in U.S., 1910–11. Published *Les Pâques à New-York*, 1912, with a special cover designed by Sonia Delaunay for the limited edition of this poem.
Giorgio de Chirico	Volo, Greece 1888–1978 Rome
	Italian. Education: Polytechnic Institute, Athens, 1900–1906; Academy of Fine Arts, Munich, 1906–8. First group exhibition: Salon d'Automne, Paris, 1912. First solo exhibition: Casa d'Arte, Rome, 1919. Associated with the Surrealist group, Paris, 1925–30.
William N. Copley (William Nelson Copley)	b. New York City 1919
	Education: Yale University, B.A., 1942. Self-taught as a painter. First solo exhibition: Royer's Bookstore, Los Angeles, 1947. First group exhibition: *Americans in Paris*, Arthur Craven Gallery, Paris, 1953. Lives in New York City.
Joseph Cornell	Nyack, New York 1903–1972 Flushing, New York
	Education: Phillips Academy, Andover, Massachusetts, 1917–21. Self-taught as an artist. First group exhibition: *Surrealism: Paintings, Drawings, and Photographs*, Julien Levy Gallery, New York, 1932. First solo exhibition: Julien Levy Gallery, 1932. Collaborated on films with Stan Brakhage, 1939–55; Rudy Burkhardt, 1955–59; Larry Jordan, 1969.
Diego Cortez	b. Geneva, Illinois 1946
	Education: School of the Art Institute of Chicago, M.F.A., 1973. First group exhibition: Artist's Space, New York, 1975. First solo exhibition: Studio Trisorio, Naples, Italy, 1975. Lives in New York City.
Toni Costa (Giovanni Antonio Costa)	b. Padua, Italy 1935
	Member of Gruppo N; active principally 1960–64. Lives in Padua.

Juan Cuenca b. Puente Gentile, Spain 1934

Founding member of Equipo 57, Paris, 1957. Participated in team exhibition, Galerie Denise René, Paris, 1957. Returned to Spain with team, 1957. Lives in Madrid.

Salvador Dali b. Figueras, Spain 1904

Education: Royal Academy of Fine Arts of San Fernando, Madrid, 1921–25. First group exhibition: Galeries Dalmau, Barcelona, 1922. First solo exhibition: Galeries Dalmau, 1925. Associated with Surrealists, Paris, 1929–34. Collaborated with Luis Buñuel on film *L'Age d'Or*, 1930. Lives in Port Lligat, Spain.

Brad Davis b. New York City 1948

Education: University of Chicago, 1962; School of the Art Institute of Chicago, 1963; University of Minnesota, Minneapolis, B.A., 1966. First solo exhibition: 98 Greene Street Loft, New York, 1972. First group exhibition: *American Drawings*, Whitney Museum of American Art, New York, 1973. First team exhibition, with Ned Smyth: *The Garden*, Holly Solomon Gallery, New York, 1977. Lives in Carbondale, Colorado.

Douglas Davis b. Washington, D.C. 1933

Education: American University, Washington, D.C., B.A., 1956; Rutgers University, New Brunswick, New Jersey, M.A., 1958. Abandoned painting for video and performance art, 1969. First solo exhibition: Reese Paley Gallery, New York, 1970. First group exhibition: *Ten Video Performances*, Finch College Museum of Art, New York, 1971. Traveled to Moscow to produce collaborative television performance with Vitaly Komar and Alesander Melamid, 1974. Lives in New York City.

Sonia Delaunay (Sonia Stern; Sonia Terk) Gradiesk, Ukraine, Russia 1885–1979 Paris

French. Education: Studied drawing with Ludwig Schmidt-Reutte, Karlsruhe, Germany, 1903–5; Académie de la Palette, Paris, 1905. First solo exhibition: Galerie Notre Dame-des-Champs, Paris, 1908. First group exhibition: *Erster Deutscher Herbstsalon*, Galerie der Sturm, Berlin, 1913. Met Blaise Cendrars at Guillaume Apollinaire's studio, Paris, 1913. Collaborated with husband, Robert Delaunay, on murals for Air and Railroad pavilions, International Exposition, Paris, 1937. After Robert's death, 1941, joined Jean Arp and Sophie Taeuber-Arp in Grasse, France; collaborated with them and Alberto Magnelli on *Four from Grasse* portfolio, published 1950.

Theo van Doesburg (Christian Emil Marie Küpper; I. K. Bonset; Aldo Camini)	Utrecht, The Netherlands 1883–1931 Davos, Switzerland
	Dutch. Self-educated as an artist. First group exhibition: Haagsche Kunstkrina, The Hague, 1908. Founded *De Stijl* magazine, 1917. Taught at Bauhaus, Weimar, 1922. Organized International Congress of Constructivists and Dadaists, Weimar, 1922. Collaborated with Jean Arp and Sophie Taeuber-Arp on decorations for Café Aubette, Strasbourg, German Alsace, 1926–28.
Oscar Dominguez (Oscar Manuel Dominguez Palazon)	Laguna, Tenerife, Canary Islands 1906–1958 Paris
	Spanish. First group exhibtion: Circurlo de Bellas Artes, Tenerife, 1933. Moved to Paris, 1934; joined Surrealist group. First solo exhibition: Galerie Louis Carré, Paris, 1943.
Enrico Donati	b. Milan, Italy 1909
	American. Graduated University of Pavia, Italy, 1929. Immigrated to U.S., 1934. Studied: Art Students League of New York, 1940; New School for Social Research, New York, 1941. First solo exhibition: New School for Social Research, 1942. Lives in New York City.
Christian Dotremont	Tervuren, Belgium 1922–1979 Buizingen, Belgium
	Education: Académie de Louvain, Louvain, Belgium, 1937. Lived in Paris, 1941–42; became known as poet and writer. Active in Surrealist movement. Founder-member of Cobra group, Paris, 1948. First group exhibition: *Cobra*, Palais des Beaux-Arts, Brussels, 1949. First solo exhibition: Jysk Kunstgalleri, Copenhagen, 1968.
Angel Duarte	b. Cáceres, Spain 1929
	Self-taught as an artist. Founding member of Equipo 57, Paris, 1957. Participated in team exhibition, Galerie Denise René, Paris, 1957. Lives in Sion, Switzerland.
José Duarte	b. Cordova, Spain 1926
	Education: School of Fine Arts, Seville, Spain. Founding member of Equipo 57, Paris, 1957. Participated in team exhibition, Galerie Denise René, Paris, 1957. Returned to Spain with team, 1957. Lives in Cordova.

Marcel Duchamp (Henri-Robert-Marcel Duchamp)

Blainville, Normandy, France 1887–1968 Neuilly, France

American. Education: Académie Julian, Paris, 1904–5. First group exhibition: Salon des Indépendants, Paris, 1909. His *Nude Descending a Staircase*, the cause célèbre of the Armory Show, New York, 1913. First traveled to U.S., 1914. First solo exhibition: Arts Club of Chicago, 1937. Escaped to U.S. from Vichy France via Emergency Rescue Committee, 1942; citizen, 1955. Installed *First Papers of Surrealism* exhibition, Whitelaw Reid mansion, New York, 1942.

Louise Strauss Ernst (Luise Amalia Straus)

Cologne, Germany 1899–1944 Auschwitz

German art historian and writer. Education: Rheinischen Friedrich-Wilhelms University, Bonn, doctorate, 1917. Married to Max Ernst, 1917–26.

Max Ernst

Bruhl, Germany 1891–1976 Paris

French. Education: University of Bonn, Germany, 1909–12. First group exhibition: *Das Junge Rheinland*, Bonn and Cologne, 1912–13. First major solo exhibition: Galerie der Sturm, Berlin, 1916. Co-founded Cologne Dada group with Johannes Theodor Baargeld (Alfred Grunewald), 1919; collaborated there on Fatagaga collages with Baargeld and Jean Arp and on other works with first wife, Louise Strauss Ernst. Moved to Paris, 1921; associated with Dadaists and Surrealists. Interned as German alien, France, 1939, 1940. Escaped to U.S. from Vichy France via Emergency Rescue Committee, 1941. Returned permanently to France, 1953.

Robert Filliou

b. Sauve, Gard, France 1926

Education: University of California at Los Angeles, 1951–54. First group exhibition: *Festival of the Avant-Garde*, Paris, 1959. First solo exhibition: Galerie Koepcke, Copenhagen, 1961. Became associated with Fluxus artists, 1962. Lives in Flaysoc, Var, France.

Leonor Fini

b. Buenos Aires, Argentina 1908

French. Self-taught as an artist. First solo exhibitions: Milan and Paris, 1935; Julien Levy Gallery, New York, 1937. First major group exhibition: *Fantastic Art, Dada, Surrealism*, Museum of Modern Art, New York, 1936. Lives in Paris.

Lucio Fontana

Rosario, Argentina 1899–1968 Comabbio, Varese, Italy

Italian. Education: studied sculpture in father's studio, Milan, 1922–28; Accademia di Brera, Brera, Italy, 1928–30. First group exhibition: 17th Venice Biennale, 1930. First solo exhibition: Galleria del Milione, Milan, 1930. Joined Abstraction-Création group, Paris, 1934. Participated in first collective exhibition of abstract art in Italy, 1935.

Estéban Francès	Port Bou, Spain 1914–1976 Barcelona

Education: studied painting in Barcelona and with André Breton, Paris. Member of Logical Focus group, Barcelona, 1936. Invented Surrealist technique, "grottage," c. 1938. Moved to New York, 1944; designed cover of Surrealist magazine *View*, December. Ballet designs for George Balanchine included *Le Renard*, 1947 (Ballet Society), and *Don Quixote*, 1965 (New York City Ballet).

George (George Passmore)	b. Devon, England 1942

Education: Dartington Hall College of Arts, Devon; Oxford School of Art; St. Martin's School of Art, London. Met Gilbert at St. Martin's School of Art, 1967. First team exhibition: *Three Works, Three Works*, Frank's Sandwich Bar, London, 1968. First team "living sculpture" presentation: St. Martin's School of Art, 1969. Lives in London.

Gilbert (Gilbert Proesch)	b. Dolomites, Italy 1943

Education: Nolkenstein School of Art; Hallein School of Art; Munich Academy of Art; St. Martin's School of Art, London. Met George at St. Martin's School of Art, 1967. First team exhibition: *Three Works, Three Works*, Frank's Sandwich Bar, London, 1968. First team "living sculpture" presentation: St. Martin's School of Art, 1969. Lives in London.

Jefim Golyscheff	Kherson, Ukraine, Russia 1897–1970 Paris? São Paulo?

Painter and musician. Moved to Germany, 1909. Active in Berlin Dada movement; exhibited: first Berlin Dada exhibition, J. B. Neumann's Graphisches Kabinett, 1919. His *Anti-Symphonie* first performed at a Berlin Dada soirée, 1919. Fled to Barcelona, 1933. Active as a chemist, Paris, from 1952; then moved to Brazil.

Arshile Gorky (Vosdanig Manoog Adoian)	Khorkom, Eastern Armenia, Ottoman Empire 1904–1948 Sherman, Connecticut

American. Education: Technical High School, Providence, Rhode Island, 1920–21; Rhode Island School of Design, Providence, 1921–22; New School of Design, Boston, 1922–24; Grand Central Art School, New York, 1925. First group exhibition: *Forty-six Painters and Sculptors under Thirty-five Years of Age*, Museum of Modern Art, New York, 1930. First solo exhibition: Mellon Galleries, Philadelphia, 1934. Met André Breton and other Surrealists-in-exile, New York, 1944.

Marcel Gromaire	Noyelles-sur-Sambre, France 1892–1971 Paris

Education: Académie Colarossi, Académie Ranson, and Académie de la Palette, Paris, 1910. First group exhibition: Salon des Indépendants, Paris, 1911. First solo exhibition: Galerie Licorne, Paris, 1921.

George Grosz (George Gross) Berlin 1893–1959 Berlin

American. Education: Konigliche Kunstakademie, Dresden, Germany, 1909–11; Staatliche Kunstgewerbeschule, Berlin, 1911; Académie Colarossi, Paris, 1913. Joined Berlin Dada movement, 1918. First group exhibition: Galerie Neue Kunst, Munich, 1918. First solo exhibition: Galerie Hans Goltz, Munich, 1920. Collaborated with John Heartfield on photomontages, collages, and illustrations for *Die Pleite* and other periodicals, 1919–24. Co-organized *Erste International Dada-Messe*, Berlin, 1920. Labeled "Culture Bolshevik Number 1" by the Nazis. Immigrated to U.S., 1932; citizen, 1938.

Richard Hamilton b. London 1922

Education: St. Martin's School of Art, London, 1936; Royal Academy Schools, London, 1938–40, 1946; Slade School of Art, London, 1948–51. First solo exhibition: Gimpel Fils, London, 1950. First team exhibition: *Rotham*, with Dieter Roth, Galeria Cadaqués, Cadaqués, Spain, 1976. Lives in London.

Helen Mayer Harrison (Helen Mayer) b. New York City 1929

Education: Queens College, New York, B.A., 1948; New York University, M.A., 1952. First team exhibition with husband, Newton Harrison: *Vesuvius*, Seattle Art Museum, 1972. Lives in Del Mar, California.

Newton Harrison b. New York City 1932

Education: Yale University School of Art and Architecture, New Haven, Connecticut, B.F.A., 1964; M.F.A., 1965. First group exhibition: *Kinesthetics*, Howard Wise Gallery, New York, 1969. First solo exhibition: 10/4 Group Gallery, New York, 1961. First team exhibition with Helen Mayer Harrison: *Vesuvius*, Seattle Art Museum, 1972. Lives in Del Mar, California.

Raoul Hausmann Vienna 1886–1971 Limoges, France

Austrian. Education: studied with father, before 1900; Academy of Fine Arts, Berlin, 1900. Began contributing to *Die Aktion* and other periodicals, Berlin, 1916. Joined Berlin Dada group, 1917. First Dada exhibition: J. B. Neumann's Graphisches Kabinett, Berlin, 1919. Participated in *Erste International Dada-Messe*, Berlin, 1920. First solo exhibition, photomontages: Staatliche Museum, Berlin, 1931. Branded as a "degenerate artist" by the Nazis; quit Germany, 1933.

John Heartfield (Helmut Herzfelde) Berlin 1891–1968 Berlin

Education: School of Applied Arts, Munich, 1907–10; Arts and Crafts School, Berlin, 1912–14. Met George Grosz, 1915. Began working on *Neue Jugend* and other periodicals for brother Wieland Herzfelde's publishing house, Malik-Verlag, 1917. Co-organized *Erste International Dada-Messe*, Berlin, 1920. Traveled to USSR, 1930; first solo exhibition, Moscow. His work considered "degenerate art" by the Nazis. Fled to England from Germany, 1938; interned there, 1940. Returned to Germany, 1950.

Jacques Hérold b. Piatra, Rumania 1910

French. Education: School of Fine Arts, Bucharest, Rumania, 1925–26; Vladesco Academy, Bucharest, 1929. Member of the Surrealist group, Paris and Marseilles, 1930s–40s. First group exhibition: Salon des Surindépendants, Paris, 1936. First solo exhibition: Galerie Maeght, Paris, 1947. Lives in Paris.

Hannah Höch Gotha, Germany 1889–1978 Berlin

Education: Staatliche Kunstgewerbeschule, Berlin, 1912; Kunstakademie, Charlottenburg, Germany; Kunstgewerbemuseum, Berlin, 1916. Associated with Berlin Dada movement, 1917–20; worked closely with Raoul Hausmann on collages and photomontages. Participated in *Erste International Dada-Messe*, Berlin, 1920. First solo exhibition: The Hague, Rotterdam, and Amsterdam, 1929.

Friedensreich Hundertwasser (Friedrich Stowasser) b. Vienna 1928

Education: Akademie der Bildenden Künste, Vienna, briefly, 1948. Executed two frescoes with René Brô, Saint-Mandé-sur-Seine, France, 1949. First solo exhibition: Art Club, Vienna, 1952. First major group exhibition: 27th Venice Biennale, 1954. Lives in Vienna, Venice, and Bay of Islands, New Zealand.

Augustin Ibbarola b. Bilboa, Spain 1930

Education: studied with Vazquez Diaz. Founding member of Equipo 57, Paris, 1957. Participated in team exhibition, Galerie Denise René, Paris, 1957. Returned to Spain with team, 1957. Lives in Spain.

Egill Jacobsen b. Copenhagen, Denmark 1910

Education: Academy of Fine Arts, Copenhagen, 1932–33. First group exhibition: *Artists' Autumn Exhibition*, Copenhagen, 1932. Founder-member of Cobra group, Paris, 1948. First solo exhibition: Galerie le Gendre, Paris, 1961. Lives in Copenhagen.

Marcel Jean	b. La Charité-sur-Loire, France 1900

Surrealist writer and artist. Education: Ecole des Arts Décoratifs, Paris, 1919–21. First group exhibition: Salon d'Automne, Paris, 1930. First solo exhibition: Galerie Roux-Henschel, Paris, 1946. Lives in Paris.

Asger Jorn (Asger Jorgensen)	Vejrum, Denmark 1914–1973 Aarhus, Denmark

Studied painting with Martin Kaaland-Jorgensen, 1930; with Fernand Léger, Paris, 1936–37. First group exhibition: *Free Jutlandish Painters*, Silkeborg, Denmark, 1933. First solo exhibition: Pustervig Kunsthandel, Copenhagen, 1942. Founder-member of Cobra group, Paris, 1948. First team exhibition: *First International Exposition of Experimental Art*, with Cobra members, Stedelijk Museum, Amsterdam, 1949.

Franz Jung	Neisse, Germany 1888–1963 Stuttgart, Germany

Free-lance writer and social theorist. Active in Berlin Dada movement and in German politics. Contributed to periodical *Die Aktion*; co-edited *Club Dada*, Berlin, 1918. Traveled to U.S. intermittently after 1937.

Gerome Kamrowski	b. Warren, Minnesota 1914

Education: St. Paul School of Art, St. Paul, Minnesota; Art Students League of New York; Hans Hofmann School, New York. First group exhibition: Art Institute of Chicago, 1945. First solo exhibition: Mortimer Brandt, New York, 1946. Lives in Ann Arbor, Michigan.

Frederick Kiesler	Czernowitz, Austria-Hungary 1890–1965 New York City

American. Education: Akademie der Bildenden Künste, Vienna. Designed first *Endless House* as a space theater, 1923. Moved to New York to direct International Theater Exposition, Steinway Building, 1926. U.S. citizen, 1936. Designed *Exposition Internationale du Surréalisme*, directed by André Breton and Marcel Duchamp, Galerie Maeght, Paris, 1947. First solo sculpture exhibition, Museum of Modern Art, New York, 1951.

R. B. Kitaj (Ronald Brooks)	b. Cleveland, Ohio 1932

American. Education: Akademie der Bildenden Künste, Vienna, 1951–53; Ruskin School of Drawing and Fine Art, Oxford, England, 1957–59; Royal College of Art, London, 1960–62. First group exhibition: *Young Contemporaries 1958*, RBA Galleries, London, 1958. Collaborated briefly with Eduardo Paolozzi, 1962. First solo exhibition: Marlborough New London Gallery, London, 1963. Major solo exhibition: Hirshhorn Museum and Sculpture Garden, Washington, D.C., and tour, 1981–82. Lives in London.

Vitaly Komar	b. Moscow 1943
	Education: Stroganov Institute for Art and Design, Moscow, 1967. First team exhibition: *Joint Works on the Theory of Art*, with Alesander Melamid, Moscow Institute of Art and Design, 1965. Immigrated to U.S., 1978. Lives in New York City.
Anna Kubach-Wilmsen (Anna-Maria Wilmsen)	b. Appeldorn, Germany 1937
	Education: Kunstakademie, Munich, diploma in sculpture, 1965. First solo exhibition: Sculpture Gallery, Melbourne, Australia, 1961. Married Wolfgang Kubach, 1965. First team exhibition with Wolfgang Kubach: Goethe Institute, Rome, 1973. Lives in Bad Munster am Stein, Federal Republic of Germany.
Wolfgang Kubach-Wilmsen (Wolfgang Kubach)	b. Bad Munster am Stein, Germany 1936
	Education: Kunstakademie, Munich, 1959–65. First team exhibition with Anna Kubach-Wilmsen: Goethe Institute, Rome, 1973. Lives in Bad Munster am Stein.
Edoardo Landi	b. San Felice sul Panaro (Modena), Italy 1937
	Graphic and industrial designer. Education: Superior School of Industrial Design, Venice; University of Venice, architecture degree. Member of Gruppo N; active principally 1960–64. Lives in Padua.
Jacques Lipchitz (Chaim Jacob Lipchitz)	Druskieniki, Lithuania, Russia 1891–1973 Capri, Italy
	American. Education: Ecole des Beaux-Arts and Académie Julian, Paris, 1909–10. First group exhibitions: Salon d'Automne and Salon National des Beaux-Arts, Paris, 1912. First solo exhibition: Galerie de l'Effort Moderne, Paris, 1920. Escaped to U.S. from Vichy France via Emergency Rescue Committee, 1941; citizen, 1957.
Adolf Luther	b. Krefeld, Germany 1912
	Education: studied law and political science, 1934–41. Active as lawyer and judge until 1958. First exhibition: Kaiser Wilhelm Museum, Krefeld, 1960. Lives in Krefeld.

Alberto Magnelli	Florence, Italy 1888–1971 Meudon, France

Italian. Self-taught as an artist. First solo exhibition: Galerie Materassi, Florence, 1920. Moved to La Ferique, France, near Jean Arp, Sophie Taeuber-Arp, and Sonia Delaunay, 1939. Returned clandestinely to Paris, 1944.

Kasimir Severinovich Malevich	Environs of Kiev, Russia 1878–1935 Leningrad

Education: School of Fine Arts, Kiev, 1895; Moscow Institute of Painting, Sculpture, and Architecture, 1903. First group exhibition: Moscow Artists Society, Moscow, 1907. Designed costumes and decor for Futurist opera *Victory over the Sun*, 1913. Exhibited first Suprematist paintings at the exhibition *The Donkey's Tail, 0-10*, Moscow, 1915. Taught at Vitebsk School of Art, 1919–22; Inkhuk (Institute of Artistic Culture), Petrograd, 1922–29. Visited Warsaw and Berlin with first solo exhibition, 1927.

Man Ray (Emmanuel Radinski)	Philadelphia 1890–1976 Paris

American. Education: National Academy of Design, New York, 1908; Ferrer Center, New York, 1911–13. First solo exhibition: Daniel Gallery, New York, 1915. First group exhibition: *Forum Exhibition of Modern American Painters*, Anderson Galleries, New York, 1916. Founding member of Society of Independent Artists, New York, 1917. Affiliated with Dadaists and Surrealists, Paris, 1920s and early 1930s.

Louis Marcoussis (Ludwig Casimir Ladislas Markous)	Warsaw, Russian Poland 1883–1941 Cusset, France

French. Education: Academy of Art, Cracow, 1901; Académie Julian, Paris, 1903. First group exhibition: Salon d'Automne, Paris, 1907. First solo exhibition: Galerie der Sturm, Berlin, 1920.

De Hirsh Margules	Jasse, Rumania 1899–1965 New York City

American. Came to U.S. as an infant. Studied art privately, New York and Paris. First solo exhibition: Feigl Gallery, New York, 1945. Worked as reporter for New York City News Association; was a noted Greenwich Village character.

Manfredo Massironi	b. Padua, Italy 1937

Education: University of Venice, architecture degree. Member of Gruppo N; active principally 1960–64. Teaches visual communication, University of Rome. Lives in Padua.

Mikhail Vasilievich Matiushin

Nizhnii Novgrod, Russia 1861–1934 Leningrad

Education: Moscow Conservatory of Music, 1878–81; School of the Society of the Encouragement of the Arts, 1898–mid 1900s. First group exhibition: *Impressionists*, St. Petersburg, 1909. First team project: *Troe (The Three)*, an illustrated book, with Kasimir Malevich and Alexei Kruchenykh, 1913. Wrote musical score for *Victory over the Sun*, collaborative Futurist opera, 1913.

Matta (Roberto Sebastian Antonio Matta Echaurren)

b. Santiago, Chile, 1911

Education: College of the Sacred Heart, Santiago; Catholic University, Santiago, 1929–31. Joined the Surrealist group, Paris, 1936. First group exhibition: *International Surrealist Exhibition*, Galerie des Beaux-Arts, Paris, 1938. Moved to U.S., 1939. First solo exhibition, Julien Levy Gallery, New York, 1940. Included in: *Artists in Exile*, Pierre Matisse Gallery, New York, 1941; *First Papers of Surrealism*, New York, 1942. Returned to Europe, 1948. Lives in Paris.

Frédéric Mégret

Paris 1912–1975 Paris

French poet. Participated in Surrealist activities, Paris, late 1920s.

Alesander Melamid

b. Moscow 1945

Education: Stroganov Institute for Art and Design, Moscow, 1967. First team exhibition: *Joint Works on the Theory of Art*, with Vitaly Komar, Moscow Institute of Art and Design, 1965. Immigrated to Israel, 1977; to U.S., 1978. Lives in Jersey City, New Jersey.

Joan Miró

Montroig, near Barcelona 1893–1983 Palma de Majorca

Education: Longa School of Fine Arts, Barcelona, 1907; Gali's School of Art, Barcelona, 1912–15. First group exhibition: Municipal Exhibition of Courbet Group, Barcelona, 1919. First solo exhibition: Galerie Dalmau, Barcelona, 1918. Associated with Dada and Surrealist groups, Paris, 1920–32.

Max Morise

Versailles 1900–1973 Paris

French writer. Founding member of Surrealist movement. Contributed to periodicals *Littérature*, 1922–23, and *La Révolution Surréaliste*, 1924–29. Co-signed collective manifesto of the Bureau of Surrealist Researches, Paris, 1925.

Suzanne Muzard

Blainville, France 1889–?

Associated with André Breton and the Surrealist group, Paris, c. 1926–30.

Pierre Naville 1903–1952

French Surrealist. Co-edited first issue of *La Révolution Surréaliste* with Benjamin Péret, 1924. Co-signed collective manifesto of the Bureau of Surrealist Researches, Paris, 1925, and *Un Cadavre*, broadside attacking André Breton's Second Manifesto of Surrealism, 1930.

Isamu Noguchi b. Los Angeles 1904

Education: Columbia University, New York, 1922–24; Leonardo da Vinci Art School, New York, 1924; Académie de la Grande Chaumière and Académie Collarosi, Paris, 1924. First solo exhibitions: Leonardo da Vinci Art School, 1924; Eugene Schoen Gallery, New York, 1929. First group exhibition: Albright-Knox Art Gallery, Buffalo, New York, 1931. Designed ballet sets for *Frontier*, 1935, the first of many collaborations with choreographer Martha Graham. Lives in New York City.

Kenneth Noland b. Asheville, North Carolina 1924

Education: Black Mountain College, near Asheville, 1946–48. First solo exhibition: Galerie Creuze, Paris, 1949. First group exhibition: Annual Spring Purchase Exhibition, Watkins Art Gallery, American University, Washington, D.C., 1951. Major solo exhibition: Solomon R. Guggenheim Museum, New York, and Hirshhorn Museum and Sculpture Garden, Washington, D.C., 1977. Lives in South Salem, New York.

Frank O'Hara Baltimore, Maryland 1926–1966 Mastic Beach, New York

Poet and art critic. Education: Harvard University, B.A., 1950; University of Michigan, Ann Arbor, M.A., 1951. Joined staff of Museum of Modern Art, New York, 1951; editorial associate, *Artnews*, 1953–55. Artist-collaborators included Larry Rivers, Michael Goldberg, Norman Bluhm, Joe Brainard, and Jasper Johns.

Gordon Onslow-Ford b. Wendover, England 1912

American. Education: Dragon School, Oxford, England, 1922–25; Royal Navy College, Dartmouth, 1925–27. Participated in Surrealist exhibitions, Paris, London, and New York, 1938–43. Moved to U.S., 1940; citizen, 1952. First solo exhibition: Karl Nierendorf Gallery, New York, 1946. Lives in Inverness, California.

Nam June Paik b. Seoul, Korea 1932

American. Education: University of Tokyo, B.A., 1956; University of Munich, 1956–57; Conservatory of Music, Freiburg, 1957–58; University of Cologne, 1958. First group exhibition: *Simultan*, Galerie Lauhus, Cologne, 1961. First solo exhibition: Galerie 22, Düsseldorf, 1959. Lives in New York City.

Eduardo Paolozzi b. Leith, Edinburgh, Scotland 1924

British. Education: Slade School of Art, Oxford, England, 1945–47. First solo exhibition: Mayor Gallery, London, 1947. First group exhibition: Hannover Gallery, London, 1950. Collaborated briefly with R. B. Kitaj, 1962. Lives in London and Essex.

Felix Partz (Ronald Gabe) b. Winnipeg, Manitoba, Canada 1945

Education: School of Art, University of Manitoba, B.A., 1967. First General Idea team exhibition: *Concept '70*, Nightingale Gallery, Toronto, 1970. Lives in Toronto.

Carl-Henning Pedersen b. Copenhagen 1913

Self-taught as an artist; began painting in 1933. First group exhibition: *Artists' Autumn Exhibition*, Copenhagen, 1936. Founder-member of Cobra group, Paris, 1948. First solo exhibition: Copenhagen, 1949. Lives in Copenhagen and Molesmes, France.

Benjamin Péret Reze, Loire-Atlantique, France 1899–1959 Paris

Poet and writer. Participated in Paris Surrealist movement; co-edited the first issue of *La Révolution Surréaliste* with Pierre Naville, 1924. With then-wife Remedios Varo, escaped from Vichy France to Mexico via Emergency Rescue Committee, 1941. Returned to France, 1947.

Robert Philippi Graz, Austria 1877–1959 Vienna

Viennese painter and graphic artist, best known for his woodcuts.

Pablo Picasso (Pablo Ruíz Picasso)	Málaga, Andalusia, Spain 1881–1973 Mougins, France

Education: School of Fine Arts, Barcelona, 1895–97; Royal Academy of Fine Arts of San Fernando, Madrid, 1897. First group exhibition: Exposición Nacional de Bellas Artes de Madrid, 1897. First solo exhibition: Els Quatre Gats, Barcelona, 1900. First trip to Paris, 1900; settled there, 1904. Designed decor for *Parade*, Sergei Diaghilev's Ballets Russes de Monte Carlo, 1917. Included in *Exposition: La Peinture Surréaliste*, Galerie Pierre, Paris, 1925. First welded metal sculpture in collaboration with Julio Gonzalez, 1928.

Anne Poirier (Anne Houllavigue)	b. Marseilles, France 1942

Education: Ecole des Arts Décoratifs, Paris, 1962–67. Studied in Rome as Prix de Rome recipient, 1968–71. First team participation with husband, Patrick: International Exhibition, Osaka, Japan, 1970. First team exhibition: Arco d'Alibert, Rome, 1970. Lives in Paris.

Patrick Poirier	b. Nantes, France 1942

Education: Ecole des Arts Décoratifs, Paris, 1962–67. Studied in Rome as Prix de Rome recipient, 1968–71. First team participation with wife, Anne: International Exhibition, Osaka, Japan, 1970. First team exhibition: Arco d'Alibert, Rome, 1970. Lives in Paris.

Jackson Pollock (Paul Jackson Pollock)	Cody, Wyoming 1912–1956 Easthampton, New York

Education: Manual Arts High School, Los Angeles, intermittently, 1928–29; Art Students League of New York, 1930–33. First group exhibition: *Eighth Exhibition of Watercolors, Pastels, and Drawings by American and French Artists*, Brooklyn Museum, 1925. First solo exhibition: Art of This Century, New York, 1943. Moved to Springs, Easthampton, New York, 1945.

Lucio Pozzi	b. Milan, Italy 1935

American. Education: studied with sculptor Michael Noble, Milan, 1955–59; studied architecture, Rome, 1958–59. First solo exhibition: Topazia Alliata Gallery, Rome, 1961. First major group exhibition: Galerie Suzanne Bollag, Zurich, 1962. Immigrated to U.S., 1962; citizen, 1972. Lives in New York City.

Gerhard Preiss	Stettin, Germany 1883–?

Musician. Member of Berlin Dada group. One of the signatories of "Dada Manifesto," 1920.

Jacques Prévert | Paris 1900–1977 Paris

French poet and screen writer. Member of Paris Surrealist movement, 1925–29. Collaborated with Marcel Carné on eight major films, 1937–50, among them *Les Enfants du Paradis*. His poems set to music include *Les Feuilles Mortes (Autumn Leaves)*.

Robert Rauschenberg | b. Port Arthur, Texas 1925

Education: Kansas City Art Institute, 1946–47; Académie Julian, Paris, 1947; Black Mountain College, near Asheville, North Carolina, 1948–49; Art Students League of New York, 1949–52. First team exhibition: *Blueprint*, with then-wife Susan Weil, Museum of Modern Art, New York, 1951. First group exhibition: *Artists Annual*, Ninth Street Gallery, New York, 1951. First solo exhibition: Betty Parsons Gallery, New York, 1951. Lives in New York City and Captiva Island, Florida.

Otto van Rees | Freiburg, Germany 1884–1957 Utrecht, The Netherlands

Dutch. Active in Zurich Dada movement. Collaborated with Jean Arp on two murals for the Corray School, Zurich, 1916. Participated in first Dada exhibition, Zurich, 1917. One of the signatories of the "Dada Manifesto," Berlin, 1920.

Larry Rivers (Yitzroch Loiza Grossberg) | b. Bronx, New York 1923

Education: New York University, New York, B.A., 1951. First solo exhibition: Jane Street Gallery, New York, 1949. First group exhibition: *Talent 1950*, Kootz Gallery, New York, 1950. Exhibited collaborative lithographs, *Stones*, Tibor de Nagy Gallery, New York, 1959. Lives in New York City and Southampton, New York.

Dieter Roth (Karl-Dietrich Roth; Dieter Rot) | b. Hanover, Germany 1930

Swiss. Education: studied graphic design, Studio Friedrich Wuthrich, Bern, Switzerland, 1947–51. First group exhibition: *Berner Kunstler*, Galerie Schindler, Bern, 1953. First solo exhibition: Mokka Kaffi, Reykjavik, Iceland, 1958. First team exhibition: *Rotham*, with Richard Hamilton, Galeria Cadaqués, Cadaqués, Spain, 1976. Lives in Reykjavik and Stuttgart, Germany.

Josep Royo | b. Barcelona 1945

Education: Drawing School of Sant Cugat del Valles, Barcelona; Escola Massana, Barcelona. First group exhibition: Salon de Maig, Barcelona, 1965. First solo exhibition: French Institute, Barcelona, 1971. Collaborated with Antoni Tàpies on six tapestries, 1973. Lives in Tarragona, Spain.

Niki de Saint Phalle	b. Neuilly-sur-Seine, Paris 1930

Lived in New York City, 1933–51. Education: Convent of the Sacred Heart, New York. First solo exhibition: Saint Gall, Switzerland, 1956. First major group exhibition: *Les Nouveaux Réalistes*, J Gallery, Paris, 1961. First team exhibition: *Hon*, with Jean Tinguely and others, Moderna Museet, Stockholm, 1966. Lives in Paris.

Salomé (Wolfgang Cihlarz) b. Karlsruhe, Federal Republic of Germany 1954

Education: Hochschule der Kunste, Berlin, 1974–80. First group exhibition: *Kunstpreis Junger Western*, Recklinghuasen, Berlin, 1975. First solo exhibition: Galerie de la Montzplatz, Berlin, 1977. Lives in Berlin and New York City.

Christian Schad Miesbach, Germany 1894–1982 Bessenbach-Keilberg, Federal Republic of Germany

Education: Akademie der Bildenden Künste, Berlin, 1913–14. Active in Zurich Dada movement. First Dada group exhibition: Galerie Wolsberg, Zurich, 1915. Contributed to Walter Serner's periodical *Sirius*, Geneva, 1915–16. Created first "Schadograms," which combined collage, photograms, and photomontage, 1918. Established painting studio, Berlin, 1927 (destroyed 1943). Resumed making Schadograms, 1960.

Egon Schiele Tulln, Austria 1890–1918 Vienna

Education: Vienna Academy of Fine Arts, 1906–9. First group exhibition: Abbey of Klosterneuburg, Austria, 1908. First solo exhibition: Galerie Hans Goltz, Munich, 1913. Began work in graphic arts under the tutelage of Robert Philippi, 1914.

Kurt Schwitters Hanover, Germany 1887–1948 Ambleside, England

Education: Kunstakademie, Dresden, Germany, 1909–13; Kunstakademie, Berlin, 1914; architectural studies, Hanover, 1918. First group exhibition: Galerie der Sturm, Berlin, 1918. First Merz collages, 1919. First solo exhibition: Galerie der Sturm, 1920. Lecture tour with Raoul Hausmann and Hannah Höch, Prague, 1921; with Theo and Nelly van Doesburg, The Netherlands, 1922. Published periodical *Merz*, 1923–32. Settled in Norway, 1937. Fled to England, 1940; interned there seventeen months.

Walter Serner Carlsbad, Czechoslovakia 1889–1927/28? USSR

Austrian poet, critic, and author of detective stories. Educated as a lawyer, Carlsbad and Vienna. Active in Zurich Dada movement. Edited periodical *Sirius*, Geneva, 1915-16; co-edited *Der Zeltweg*, Zurich, with Tristan Tzara and Otto Flake. Traveled to USSR, 1922; disappeared there.

Juan Serrano b. Cordova, Spain 1929

Founding member of Equipo 57, Paris, 1957. Participated in team exhibition, Galerie Denise René, Paris, 1957. Returned with team to Spain, 1957. Lives in Madrid.

Ned Smyth b. Duluth, Minnesota 1942

Education: Kenyon College, Gambier, Ohio, B.A., 1970. First group exhibition: 112 Greene Street Workshop, New York, 1973. First solo exhibition: 112 Greene Street, 1974. First team exhibition, with Brad Davis: Holly Solomon Gallery, New York, 1977. Lives in New York City.

Rafael Solbes Valencia, Spain 1940–1982 Valencia

First group exhibition, with Manuel Valdès: Ateneu Mercantil, Valencia, 1964. First Equipo Crónica exhibition: Galleria Il Centro, Turin, 1965.

Daniel Spoerri (Daniel Spoerri-Feinstein) b. Galati, Rumania 1930

Swiss. Moved with family to Switzerland, 1942. Studied classical dance, Zurich and Paris, 1950–54. Principal dancer, Bern City Theater, and choreographer, 1954–57. Included in *Movement Exhibition*, Hessenhuis, Antwerp, 1958. Published *Edition MAT* (Multiplication/Art/Transformation), Paris, 1959–60. Joined Nouveaux Réalistes, Paris, 1960. First solo exhibition: Galerie Schwarz, Milan, 1961. Lives in La Selle sur Lebied, France.

Georgii Stenberg Moscow 1900–1933 Moscow

Education: Stroganov Institute of Arts and Design, Moscow, 1912–20. First group exhibition: *Obmokhu*, Stroganov Institute, 1919. First team exhibition: *Constructivists*, Café of the Poets, Moscow, 1921. Together with brother, Vladimir Stenberg, active in poster design and book production, 1920s.

Vladimir Stenberg Moscow 1899–1982 Moscow

Education: Stroganov Institute of Arts and Design, Moscow, 1912–1920. First group exhibition: *Obmokhu*, Stroganov Institute, 1919. First team exhibition: *Constructivists*, Café of the Poets, Moscow, 1921. First movie posters with brother, Georgii Stenberg, 1923.

Sophie Taeuber-Arp (Sophie Taeuber) Davos, Switzerland 1889–1943 Zurich

Education: School of Applied Arts, Saint Gall, Switzerland, 1908–10; studied with Walter von Debschitz, Munich, 1911–13; Arts and Crafts School, Hamburg, 1912. Dancer with the Laban group, Zurich, 1916. Met Jean Arp, Zurich; participated in Dada activities, 1916–19. Collaborated with Arp and Theo van Doesburg in decoration of Café Aubette, Strasbourg, 1926–28. Member of Abstraction-Création group, Paris, 1931–36. Fled with Arp from Meudon to the south of France, 1940. Lived in Grasse, 1941–43, then fled again to Zurich, where she died accidently.

Jeannette Tanguy (Jeannette Ducrocq) French. Married to Yves Tanguy, 1927–40.

Yves Tanguy (Raymond-George-Yves Tanguy) Paris 1900–1955 Woodbury, Connecticut

American. Education: Lycée Montaigne and Lycée St. Louis, Paris, 1909–18. Self-taught as an artist. First group exhibition: Salon de l'Araignée, Paris, 1925. First solo exhibition: *Yves Tanguy et Objects d'Amerique*, Galerie Surréaliste, Paris, 1927. Immigrated to U.S., 1939; citizen, 1948.

Dorothea Tanning b. Galesburg, Illinois, 1910

Education: Knox College, Galesburg, 1928. First group exhibition: New Orleans, 1934. First solo exhibition: Julien Levy Gallery, New York, 1944. Lives in New York City.

Antoni Tàpies b. Barcelona 1923

Education: University of Barcelona, 1943–46. First group exhibition: Salon de Octubre, Barcelona, 1948. First solo exhibition: Galerias Layetanas, Barcelona, 1950. Collaborated with Josep Royo on six tapestries, 1973. Lives in Barcelona.

Walasse Ting b. Shanghai, China 1929

American. Self-taught as an artist. Lived in Paris, 1953–58. First solo exhibition: Galerie Paul Facchetti, Paris, 1954. Came to U.S., 1959. Major group exhibition: Carnegie International, Pittsburgh, 1961. U.S. citizen, 1962. Lives in New York City.

Jean Tinguely b. Fribourg, Switzerland 1925

Swiss. Education: Ecole des Beaux-Arts, Basel, Switzerland, 1941–45. First solo exhibition: Galerie Arnaud, Paris, 1954. Major team exhibition: *Vitesse Pure et Stabilité Monochrome*, with Yves Klein, Galerie Iris Clert, Paris, 1958. Joined Nouveaux Réalistes, with Pierre Restany, Arman, César, François Dufrene, Raymond Hains, Yves Klein, Martial Raysse, Mimmo Rotella, Daniel Spoerri, and Jacques de la Villegle, 1960. Collaborative projects include *Hon*, Stockholm, with Niki de Saint Phalle and Per Olof Ultvedt, 1966. Lives in Millet-le-Forêt, France.

Günther Uecker b. Wendorf, Germany 1930

Education: Akademie Berlin-Weissensee; Kunstakademie, Düsseldorf, 1953. First group exhibition: *Zero 1*, Düsseldorf, 1958. First solo exhibition: Galleria Azimuth, Milan, 1959. Lives in Düsseldorf.

Manuel Valdès b. Valencia, Spain 1942

First group exhibition, with Rafael Solbes: Ateneu Mercantil, Valencia, 1964. First Equipo Crónica exhibition: Galleria Il Centro, Turin, 1965. Lives in Valencia.

Remedios Varo (Remedios Lizarraga) Anglés, Spain 1913–1963 Mexico City

Spanish. Education: Academy of Fine Arts of San Fernando, Madrid, 1931–34. First group exhibition: Academy of Fine Arts of San Fernando, 1934. Exhibited with Logical Focus group, Barcelona, 1936. Moved to Paris, 1936; joined the Surrealists. Escaped from Vichy France to Mexico with then-husband Benjamin Péret via Emergency Rescue Committee, 1941. First solo exhibition: Galeria Diana, Mexico City, 1956.

Bernar Venet b. Château Arnoux-Saint Auban, Alpes de Haute Provence, France 1941

Education: La Villa Thiole, 1958–59. First group exhibition: *New York Art 1968*, Rochester Art Museum, 1968. First solo exhibition: Haus Lange Museum, Krefeld, Federal Republic of Germany, 1970. Lives in New York City.

Jef Verheyen b. Iteghem, Belgium 1932

Education: Académie et Institut des Beaux-Arts, Antwerp, 1947–52. Exhibited: Exposition Universelle, Brussels, 1958. Affiliated with Zero group, Düsseldorf, 1961. First solo exhibition: Galerie Ad Libitum, Antwerp, 1962. Collaborated with Lucio Fontana on painting commission, Knokke, Belgium, 1963. Lives in Antwerp.

Susan Weil b. New York City 1930

Education: Académie Julian, Paris, 1948; Black Mountain College, near Asheville, North Carolina, 1949; Art Students League of New York, 1950–51. First team exhibition: *Blueprint*, with then-husband Robert Rauschenberg, Museum of Modern Art, New York, 1951. First solo exhibition: School of Design, University of North Carolina, Raleigh, 1971. Lives in New York City.

Jorge Zontal (Jorge Saia) b. Parma, Italy 1944

Canadian. Education: Dalhousie University, Halifax, Nova Scotia, B.A., 1968. First General Idea team exhibition: *Concept '70*, Nightingale Gallery, Toronto, 1970. Lives in Toronto.

Bibliography

Annotations at the end of entries identify artists, groups, and movements discussed in particular publications where this information is not evident from the titles.

Abstract Art since 1945. Foreword by Jean Leymarie. London: Thames and Hudson, 1971.
Jean Arp / Camille Bryen

Ades, Dawn. *Dada and Surrealism Reviewed*. Exhibition catalog. London: Arts Council of Great Britain, 1978.
Walter Arensberg / Jean Arp / William Baziotes / Marcel Duchamp / Max Ernst / Exquisite Corpses / George Grosz / Raoul Hausmann / John Heartfield / Gerome Kamrowski / Jackson Pollock / Sophie Taeuber-Arp

Adolf Luther 1958-1969. Exhibition catalog. Leverkusen: Städtisches Museum Leverkusen, Schloss Morsbroich, 1969.

Alechinsky, Pierre. *(Roue Libre): Les Sentiers de la Création*. Geneva: Skira, 1971.

Alechinsky. Preface by Jacques Lassaigne. Exhibition catalog. Paris: Musée d'Art Moderne de la Ville de Paris, 1974.
Pierre Alechinsky / Christian Dotremont

Anna and Wolfgang Kubach-Wilmsen: Books of Stone. Preface by George W. Staempfli. Exhibition brochure. New York: Staempfli, 1981.

Anne and Patrick Poirier: Unstable Stability (The Falling Tower). Introduction by Paula Marincola. Exhibition catalog. Philadelphia: Philadelphia College of Art, 1980.

Anne et Patrick Poirier: Domus Aurea fascination des ruines. Exhibition catalog. Paris: Musée National d'Art Moderne, Centre National d'Art et de Culture Georges Pompidou, 1978.

Anne et Patrick Poirier: Falaises de marbre, Fragments d'une utopie. Nice: Galerie des Ponchettes, 1981.

Anne et Patrick Poirier Voyages et caetera 1969-1983. Exhibition catalog. Milan: Electa, 1983.

Antoni Tàpies: Exposición retrospectiva. Exhibition catalog. Madrid: Museo Español de Arte Contemporáneo, 1980.

Appel et Alechinsky: Encres à deux pinceaux, peintures, etc. Exhibition catalog. Saint-Paul: Fondation Maeght, 1982.
Pierre Alechinsky / Karel Appel / Christian Dotremont

Arp, Jean. *Arp on Arp: Poems, Essays, Memories*. New York: Viking, 1972.
Jean Arp / Four from Grasse / Sophie Taeuber-Arp

————. *Le Siège de l'air: Poèmes de Jean Arp: 1915-1945*. Paris: Quadrangle Editions Ville, 1946.
Jean Arp / Sophie Taeuber-Arp

Arshile Gorky: Paintings and Drawings 1927-1937, the Collection of Mr. and Mrs. Hans Burkhardt. Exhibition catalog. La Jolla, Calif.: La Jolla Museum of Art, 1963.
Hans Burkhardt / Arshile Gorky

Art in Process: The Visual Development of a Collage. Exhibition catalog. New York: Finch College Museum of Art, 1967.
Robert Rauschenberg / Susan Weil

Auping, Michael. "Helen and Newton Harrison." In *Common Ground: Five Artists in the Florida Landscape*, pp. 32-51. Exhibition catalog. Sarasota, Fla.: John and Mable Ringling Museum of Art, 1982.

Barrio-Garay, José Luis. *Antoni Tàpies: Thirty-three Years of His Work*. Exhibition catalog. Buffalo, N.Y.: Albright-Knox Art Gallery, 1977.

Barron, Stephanie, and Tuchman, Maurice. *The Avant-Garde in Russia, 1910-1930: New Perspectives*. Exhibition catalog. Los Angeles: Los Angeles County Museum of Art, 1980.
Kasimir Malevich / Mikhail Matiushin / Georgii and Vladimir Stenberg

Bernd and Hilla Becher. Introduction by Lynda Morris. Exhibition catalog. London: Arts Council of Great Britain, 1974.

Bernhard und Hilla Becher: Typologien industrieller Bauten 1963-1975. Introduction by Götz Adriani. Exhibition catalog, 14th São Paulo Bienal. Stuttgart: Federal Republic of Germany, 1977.

Blume, Dieter. *Anthony Caro*. Cologne: Galerie Wentzel, 1981.

Boué, Marie. "Interview with Pierre Alechinsky." *Flash Art* 111 (March 1983): 28-30.

Bozal, V., Llorens, T., and Yvars, J. F. *Equipo Crónica*. Exhibition catalog. Barcelona: Galería Maeght, 1981.

Breton, André. *Il Cadavere squisito, la sua esaltazione*. Edited by Arturo Schwarz. Exhibition catalog. Milan: Galleria Schwarz, 1975.

————. *Surrealism and Painting*. Translated by Simon Watson Taylor. New York: Harper and Row, 1972.
Exquisite Corpses

————, and Duchamp, Marcel. *Pierre à Feu*. Paris: Maeght, 1947.
Enrico Donati / Marcel Duchamp

Bronson, A A, and Gale, Peggy, eds. *Performance by Artists*. Toronto: Art Metropole, 1979.

Buckberrough, Sherry A. *Sonia Delaunay: A Retrospective*. Exhibition catalog. Buffalo, N.Y.: Albright-Knox Art Gallery, 1980.
Blaise Cendrars / Sonia Delaunay / Four from Grasse

Butor, Michel. *Jacques Hérold: Le surréaliste autre*. Rome: Edizioni Carte Segrete, 1982.
Exquisite Corpses

Cadavres exquis. Exhibition brochure. Paris: Musée National d'Art Moderne, Centre National d'Art et de Culture Georges Pompidou, 1981.

Celant, Germano. *Bernd and Hilla Becher*. Exhibition catalog. La Jolla, Calif.: La Jolla Museum of Contemporary Art, 1974.

Chipp, Herschel B., and Richardson, Brenda. *Hundertwasser*. Exhibition catalog. Berkeley: University Art Museum, University of California, 1968.

Clothier, Peter. "Venice: Collaborative Alternative Vision." *Artweek* 12 (October 24, 1981): 16.

Cobra 1948-1951. Paris: Editions Jean-Michel Place, 1980.

Collaborations: An Exhibition to Celebrate the Dedication of the Mary and Leigh Block Gallery and the Completion of the Fine and Performing Arts Center. Exhibition catalog. Evanston, Ill.: Mary and Leigh Block Gallery, Northwestern University, 1980.

Collaborations: Artists Working Together. Exhibition catalog. New York: Ruth and Harold D. Uris Center for Education, Metropolitan Museum of Art, 1983.
Frank O'Hara / Larry Rivers

Constantine, Mildred, and Fern, Alan. *Revolutionary Soviet Film Posters*. Baltimore: Johns Hopkins University Press, 1974.
Georgii and Vladimir Stenberg

Dada in Europa: Werke und Dokumente. Exhibition catalog. Berlin: Dietrich Reimer, 1977.
George Grosz / John Heartfield

Davis, Douglas. *Art and the Future: A History/Prophecy of the Collaboration between Science, Technology and Art*. New York: Praeger, 1973.

d'Harnoncourt, Anne, and McShine, Kynaston, eds. *Marcel Duchamp*. Exhibition catalog. New York: Museum of Modern Art, 1973.
Walter Arensberg / Enrico Donati / Marcel Duchamp

Diamonstein, Barbaralee, ed. *Collaboration: Artists and Architects*. New York: Watson-Guptill and the Architectural League, 1981.

Documenta 7. Introduction by R. H. Fuchs. 2 vols. Exhibition catalog. Kassel: D + V Paul Dierichs, 1982.
Bernd and Hilla Becher / General Idea / Gilbert and George

Douglas Davis: Arbeiten/Works 1970-1977, Berlin 1977-1978. Exhibition catalog. Berlin: Neuer Berliner Kunstverein, 1978.

Dupuy, Jean, ed. *Collective Consciousness: Art Performances in the Seventies*. New York: Performing Arts Journal Publications, 1980.

Eduardo Paolozzi. Exhibition catalog. London: Tate Gallery, 1971.

Ford, Charles Henri. *The Page as Alternative Space 1930-1949*. Exhibition checklist. New York: Franklin Furnace, 1980.
André Breton / Frederick Kiesler

Friedman, Mildred, ed. *De Stijl, 1917-1931: Visions of Utopia*. Introduction by Hans L. C. Jaffé. Exhibition catalog. Minneapolis: Walker Art Center; New York: Abbeville, 1982.
Theo van Doesburg

Fry, Varian. *Surrender on Demand*. New York: Random House, 1945.
André Breton / Exquisite Corpses / Jacques Lipchitz

Ghent, Henri. "Spanish Art in Transition." *Art International* 19 (October 15, 1975): 15–22.
Equipo Crónica

Gilbert and George 1968 to 1980. Exhibition catalog. Eindhoven: Van Abbemuseum, 1980.

Giralt-Miracle, Daniel. "Recording Reality." *Art and Artists* 12 (June 1977): 30–35.
Equipo Crónica

Glozer, Laszlo. *Westkunst Zeitgenössische Kunst seit 1939*. Exhibition catalog. Cologne: Dumont, 1981.
Four from Grasse

Glueck, Grace. "Dissidence as a Way of Art." *New York Times Magazine*, May 8, 1977, pp. 33–35.
Vitaly Komar / Alesander Melamid

Goldberg, RoseLee. *Performance: Live Art 1909 to the Present*. New York: Abrams, 1979.

Gray, Camilla. *The Great Experiment: Russian Art 1863-1922*. New York: Abrams, 1962.
Kasimir Malevich / Mikhail Matiushin

Gray, Cleve. "Print Review: Tatyana Grosman's Workshop." *Art in America* 53 (December 1965): 83–85.
Frank O'Hara / Larry Rivers

Grinten, Franz Joseph van der. *Kubach-Wilmsen: Skulpturen in Marmer en Hardsteen*. Exhibition catalog. Tilburg, The Netherlands: Galerie Resy Muijsers, 1982.

Grosz/Heartfield: The Artist as Social Critic. Exhibition catalog. Minneapolis: University Gallery, University of Minnesota, 1980.

Haenlein, Carl-Albrecht. *Dada Photographie und Photo-collage*. Exhibition catalog. Hanover: Kestner-Gesellschaft, 1979.
Raoul Hausmann / Hannah Höch

———. *Pierre Alechinsky: Bilder, Aquarelle, Zeichnungen, eine Retrospektive*. Exhibition catalog. Hanover: Kestner-Gesellschaft, 1980.
Pierre Alechinsky / Christian Dotremont

Hamilton, Richard, and Roth, Dieter. *Collaborations of Ch. Rotham*. Stuttgart: Edition Hansjörg Mayer, 1977.
Richard Hamilton / Dieter Roth

Hancock, Jane H. "Jean Arp's 'The Eggboard' Interpreted: The Artist as a Poet in the 1920s." *Art Bulletin* 65 (March 1983): 122–37.

———. "Form and Content in the Early Work of Jean Arp, 1903–1930." Ph.D. diss., Harvard University, 1980.

Hans Burkhardt, Basel. Los Angeles: Jack Rutberg Fine Arts, 1983.

Hartigan, Lynda Roscoe. *Joseph Cornell: An Exploration of Sources: Guide to the Exhibition*. Washington, D.C.: National Museum of American Art, 1982.
Elizabeth Voorh Benton / Joseph Cornell

Hérold, Jacques. "Les Jeux surréalistes." *XXe Siècle*, n.s. 36 (June 1974): 151.

Hobbs, Robert C., and Gail Levin. *Abstract Expressionism: The Formative Years*. Exhibition catalog. Ithaca, N.Y.: Cornell University; New York: Whitney Museum of American Art, 1978.
William Baziotes / Jackson Pollock

Huelsenbeck, Richard. *Memoirs of a Dada Drummer*. Translated by Joachim Neugroschel. New York: Viking, 1974.
Jean Arp / George Grosz / Raoul Hausmann / John Heartfield / Sophie Taeuber-Arp

Hume, Christopher. " 'The Problem of Nothing': General Idea Has Seen the Future and It Was Them." *Toronto Star*, April 23, 1983, p. F5.

Hundertwasser. Prefaces by Bruno Kreisky, Leopold Sedar Senghor, and Karl Ruhrberg. Exhibition catalog. Cologne: Museum Ludwig, 1980.

Hunter, Sam. *Larry Rivers*. New York: Abrams, 1969.

Intervision. Exhibition catalog. Paris: Galerie du Dragon, 1955.
Victor Brauner / Matta

Jackson Pollock. Introduction by Dominique Bozo. Exhibition catalog. Paris: Musée National d'Art Moderne, Centre National d'Art et de Culture Georges Pompidou, 1982.

Jean, Marcel. *History of Surrealist Painting*. New York: Grove, 1960.

———, ed. *The Autobiography of Surrealism*. New York: Viking, 1980.
Exquisite Corpses / Joan Miró

Jean Arp and Sophie Taeuber-Arp. Exhibition catalog. New York: Galerie Chalette, 1960.

Jensen, Robert, and Conway, Patricia. *Ornamentalism*. New York: Clarkson N. Potter, 1982.
Brad Davis / Ned Smyth

Joan Miró: Prints and Books. Preface by Evan H. Turner. Exhibition catalog. Philadelphia: Philadelphia Museum of Art, 1966.
Louis Marcoussis / Joan Miró

Jordan, Jim M., and Goldwater, Robert. *The Paintings of Arshile Gorky: A Critical Catalogue*. New York: New York University Press, 1982.

Kallir, Otto. *Egon Schiele: The Graphic Work*. New York: Crown, 1970.
Robert Philippi / Egon Schiele

Kaplan, Janet. "Remedios Varo." Ph.D. diss., Columbia University, 1983.
Exquisite Corpses

Kubach-Wilmsen: Steine zum Lesen. Exhibition catalog. Munich: Galerie + Edition A, 1982.

"Künstlerehen." *Kunstforum International* (Karlsruhe) 28 (April 1978): 14–266. Exhibition catalog.
Bernd and Hilla Becher / Anne and Patrick Poirier

Lambert, Jean-Clarence. *Dotremont: Peintre de l'écriture*. Paris: Centre Culturel de la Communauté française de Belgique Wallonie-Bruxelles, 1982.

———, ed. *Grand Hôtel des Valises: Locataire, Dotremont*. Paris: Editions Galilée, 1981.
Christian Dotremont / Asger Jorn

Lanchner, Carolyn. *Sophie Taeuber-Arp*. Exhibition catalog. New York: Museum of Modern Art, 1981.
Jean Arp / Sophie Taeuber-Arp

Lassaigne, Jacques. *Miró: L'oeuvre graphique*. Paris: Musée d'Art Moderne de la Ville de Paris, 1974.

Last, R. W. *Hans Arp: The Poet of Dadaism*. London: Oswald Wolff, 1969.
Jean Arp / Max Ernst / Sophie Taeuber-Arp

Law, Alma H. "A Conversation with Vladimir Stenberg." *Art Journal* 41 (Fall 1981): 222–33.

———. *The Stenberg Brothers Film Posters*. Brochure. New York: Ex Libris, forthcoming.

Levin, Kim. "Helen and Newton Harrison: New Grounds for Art." *Arts Magazine* 52 (February 1978): 126–29.

Lippard, Lucy R. "Dada in Berlin: Unfortunately Still Timely." *Art in America* 66 (March–April 1978): 107–11.
Louise Strauss Ernst / Max Ernst

Llorens, Tomàs. *Equipo Crónica*. Exhibition catalog. Barcelona: Galería Maeght, 1978.

Locus Solus (Lans-en-Vercors, France) 2 (Summer 1961).
Entire issue on collaborations

Lodder, Christina. *Russian Constructivism*. New Haven: Yale University Press, 1983.
Georgii and Vladimir Stenberg

McCabe, Cynthia Jaffee. *The Golden Door: Artist-Immigrants of America, 1876–1976*. Exhibition catalog. Washington, D.C.: Smithsonian Institution Press, 1976.

———. " 'Wanted by the Gestapo, Saved by America': Varian Fry and the Emergency Rescue Committee." In *The Muses Flee Hitler: Cultural Transfer and Adaptation, 1930–1945*, edited by Jarrel R. Jackman and Carla M. Borden, pp. 79–91. Washington, D.C.: Smithsonian Institution Press, 1983.

McShine, Kynaston, ed. *Joseph Cornell*. Exhibition catalog. New York: Museum of Modern Art, 1980.

Mansbach, Steven A. *Visions of Totality*. Ann Arbor, Mich.: UMI Research Press, 1979.
Theo van Doesburg

Marter, Joan M. "Three Women Artists Married to Early Modernists: Sonia Delaunay-Terk, Sophie Tauber-Arp, and Marguerite Thompson Zorach." *Arts Magazine* 54 (September 1979): 88–95.
Blaise Cendrars / Sonia Delaunay / Sophie Taeuber-Arp

Martin, Jean-Hubert. *Gilbert and George: Un entretien avec Jean-Hubert Martin*. Exhibition catalog. Paris: Musée National d'Art Moderne, Centre National d'Art et de Culture Georges Pompidou, 1981.

Matthews, J. H. *The Imagery of Surrealism*. Syracuse, N.Y.: Syracuse University Press, 1977.
Exquisite Corpses

Max Ernst in Köln. Exhibition catalog. Cologne: Kölnischer Kunstverein, 1980.
Jean Arp / Louise Strauss Ernst / Max Ernst

Mays, John Bentley. "The Poodle as Canada's Emblem." *Globe and Mail*, April 15, 1983, p. E8.
General Idea

Melikan, Souren. "The Baschet Brothers: The Sounds of Sculpture." *Artnews* 72 (October 1973): 70–71.

Millet, Catherine. *Bernar Venet*. Paris: Editions du Chêne, 1974.

Morschel, Jurgen. *Libri di pietra di Kubach-Wilmsen*. Exhibition catalog. Milan: Galleria del Naviglio, 1982.

Motherwell, Robert, ed. *The Dada Painters and Poets: An Anthology*. New York: Wittenborn, 1967.

Nathanson, Melvyn B., ed. *Komar/Melamid: Two Soviet Dissident Artists*. Carbondale: Southern Illinois University Press, 1979.

Newman, Amy. "The Celebrated Artists of the End of the Second Millenium A.D." *Artnews* 75 (April 1976): 43–46.
Vitaly Komar / Alesander Melamid

O'Connor, Francis, and Thaw, Eugene. *Pollock: A Catalogue Raisonné of Paintings, Drawings, and Other Works*. 4 vols. New Haven: Yale University Press, 1978.
William Baziotes / Gerome Kamrowski / Jackson Pollock

Paris/Paris: Créations en France 1937–1957. Prefaces by Jean-Claude Groshens and Pontus Hulten. Exhibition catalog. Paris: Musée National d'Art Moderne, Centre National d'Art et de Culture Georges Pompidou, 1981.
Exquisite Corpses / Four from Grasse / Nouveaux Réalistes

Pierre Alechinsky: Paintings and Writings. Preface by Leon Arkus. Pittsburgh: Carnegie Institute, 1977.
Pierre Alechinsky / Christian Dotremont

Quinn, Edward. *Max Ernst*. Boston: New York Graphic Society, 1977.
Jean Arp / Louise Strauss Ernst / Max Ernst

———. "Down and Out with Gilbert and George." *Art in America* 66 (May–June 1978): 92–93.

Rarae Aves 3. Brochure. New York: Ex Libris, 1981.
André Breton / Frederick Kiesler

R. B. Kitaj. Exhibition catalog. Hanover: Kestner-Gesellschaft, 1970.

R. B. Kitaj: Pictures with Commentary, Pictures without Commentary. Exhibition catalog. London: Marlborough Fine Art, 1963.

Richardson, Brenda. *Gilbert and George*. Exhibition catalog. Baltimore: Baltimore Museum of Art, 1984.

Richter, Hans. *Dada: Art and Anti-Art*. Translated by David Britt. New York: Abrams, 1978.
Jean Arp / George Grosz / Raoul Hausmann / John Heartfield / Sophie Taeuber-Arp

Rickey, George. *Bernard and François Baschet: Sonorous Sculptures*. Exhibition brochure. New York: Staempfli, 1980.

Rivers, Larry. "Life among the Stones." *Location* 1 (Spring 1963): 90–98.

Robert Rauschenberg. Text by Lawrence Alloway. Exhibition catalog. Washington, D.C.: National Collection of Fine Arts, 1976.
Robert Rauschenberg / Susan Weil

Rowell, Margit, and Rudenstein, Angelica Zander. *Art of the Avant-Garde in Russia: Selections from the George Costakis Collection*. Exhibition catalog. New York: Solomon R. Guggenheim Museum, 1981.
Kasimir Malevich / Mikhail Matiushin / Georgii and Vladimir Stenberg

Rubin, William S. *Dada and Surrealist Art*. New York: Abrams, 1968.
Jean Arp / Max Ernst / Exquisite Corpses / George Grosz / John Heartfield

———. *Dada, Surrealism, and Their Heritage*. New York: Museum of Modern Art, 1968.
Jean Arp / Max Ernst / Exquisite Corpses / George Grosz / John Heartfield

———. *Miró in the Collection of the Museum of Modern Art*. Exhibition catalog. New York: Museum of Modern Art, 1973.
Louis Marcoussis / Joan Miró

Russell, John. "Sound in Twentieth-Century Art." *New York Times*, December 6, 1981, p. D33.
Walter Arensberg / Marcel Duchamp

Rutberg, Jack V. *Arshile Gorky and Hans Burkhardt: Paintings, Drawings, Prints*. Exhibition catalog. Los Angeles: Jack Rutberg Fine Arts, 1982.

Salomé, Luciano Castelli, Reiner Fetting: Peintures 1979-1982. Exhibition catalog. Bordeaux: Musée d'Art Contemporain de Bordeaux, 1983.

Schmalenbach, Werner. *Kurt Schwitters.* New York: Abrams, 1977.
Theo van Doesburg / Kurt Schwitters

Schmied, Wieland. *Hundertwasser.* Preface by Werner Hofmann. Salzburg: Galerie Welz, 1974.

Schwartz, Ellen. "Ned Smyth/Brad Davis (Holly Solomon). *Artnews* 76 (November 1977): 260-61.

Schwarz, Arturo. *The Complete Works of Marcel Duchamp.* New York: Abrams, 1969.

————, ed. *1954-1964: Ten Years of Numbered Editions Illustrated by Original Engravings.* Exhibition catalog. Milan: Galleria Schwarz, 1964.
Walter Arensberg / Marcel Duchamp

Schwarz, Heinrich. "Die Graphischen Werke von Egon Schiele." In *Philobiblon: Eine Vierteljahrsschrift für Buch-und Graphik-Sammler* (Hamburg) 5, no. 1, suppl. (March 1961): 5.

Seitz, William C. *The Responsive Eye.* Exhibition catalog. New York: Museum of Modern Art, 1965.
Equipo 57

Selz, Peter. "Arte programmata." *Arts Magazine* 39 (March 1965): 16-21.
Gruppo N

————. "Helen and Newton Harrison: Art as Survival Instruction." *Arts Magazine* 52 (February 1978): 130-31.

Six artistes à Grasse 1940-1943. Exhibition catalog. Grasse: Société du Musée Fragonard, Musée Régional d'Art et d'Histoire, 1967.
Four from Grasse

'60-'80: Attitudes, Concepts, Images. Exhibition catalog. Amsterdam: Stedelijk Museum, 1982.
Gilbert and George / Daniel Spoerri

Soby, James Thrall, ed. *Arp.* New York: Museum of Modern Art, 1958.

Sonia and Robert Delaunay. Exhibition catalog. Paris: Bibliothèque Nationale, 1977.
Four from Grasse

"Speaking of Pictures: Blueprint Paper, Sun Lamps, a Nude Produce Some Vaporous Fantasies." *Life* 30 (April 9, 1951): 22-24.
Robert Rauschenberg / Susan Weil

Spies, Werner. *Max Ernst, Loplop: The Artist in the Third Person.* New York: Braziller, 1983.

————. *Max Ernst: Oeuvre Katalog.* Translated by James Emmons. 4 vols. to date. Houston: Menil Foundation; Cologne: Verlag M. Dumont Schauberg, 1975-.

Stellweg, Carla. "New Mirrors for a New Society: Seven Artists in Post-Franco Spain." *Artnews* 79 (March 1980): 63.
Equipo Crónica

Stiles, Kristine. "Helen and Newton Harrison: Questions." *Arts Magazine* 52 (February 1978): 131-33.

Sullivan, Edward J. "Structure and Tradition in Some New Images from Spain." *Arts Magazine* 54 (June 1980): 142-45.
Equipo Crónica

Tisdall, Caroline. "Performance Art in Italy." *Studio International* 191 (January-February 1976): 43.
Gruppo N

————. "Two Italian Kinetic Groups." *Studio International* 180 (October 1970): 132-35.
Gruppo N

TKO (London, Ontario) 2 (1983).
Entire issue on collaborative art

Tomkins, Calvin. *Off the Wall: Robert Rauschenberg and the Art World of Our Time*. New York: Doubleday, 1980.

Viennese Expressionism 1910–1924. Exhibition catalog. Berkeley: University Art Museum, University of California, 1963.
Egon Schiele

Vitali Komar and Aleksandr Melamid: A Retrospective Exhibition. Exhibition catalog. Wichita, Kan.: Edwin A. Ulrich Museum of Art, Wichita State University, 1980.

Von der Fläche zum Raum: Russland 1916–1924. Exhibition catalog. Cologne: Galerie Gmurzynska, 1974.
Kasimir Malevich / Mikhail Matiushin / Georgii and Vladimir Stenberg

Waldberg, Patrick. *Surrealism*. New York: McGraw-Hill, 1966.
Victor Brauner / Matta

Waldman, Diane. *Anthony Caro*. New York: Abbeville, 1982.

———. *Max Ernst: A Retrospective*. Exhibition catalog. New York: Solomon R. Guggenheim Museum, 1975.
Jean Arp / Louise Strauss Ernst / Max Ernst

Watt, Alexander. "Paris Letter: Nouveaux Réalistes." *Art in America* 49, no. 3 (1961): 106–12.

Wechsler, Jeffrey. *Surrealism and American Art 1931–1947*. Exhibition catalog. New Brunswick, N.J.: Rutgers University Art Gallery, 1977.
William Baziotes / Gerome Kamrowski / Jackson Pollock

———. "Surrealism's Automatic Painting Lesson." *Artnews* 76 (April 1977): 46–47.
William Baziotes / Gerome Kamrowski / Jackson Pollock

Wember, Paul. *Miró: Das Graphische Werk*. Krefeld: Kaiser Wilhelm Museum, 1957.
Louis Marcoussis / Joan Miró

Wescher, Herta. *Collage*. Translated by Robert E. Wolf. New York: Abrams, 1971.
Jean Arp / Max Ernst / George Grosz / John Heartfield

Yves Klein, 1928–1962: A Retrospective. Exhibition catalog. Houston: Institute for the Arts, Rice University; New York: Arts Publisher, 1982.

Zero. Translated by Howard Beckman. Cambridge: MIT Press, 1973.

Zero: Bildvorstellungen einer europäischen Avantgarde 1958–1964. Exhibition catalog. Zurich: Kunsthaus, 1979.